Travel with a camera

David Beal

Focal Press
London & Boston

Focal Press
An imprint of the Butterworth Group
Principal offices in London, Boston, Durban,
Singapore, Sydney, Toronto, Wellington

British Library Cataloguing in Publication Data

Beal, David.
Travel with a camera.
1. Photography
I. Title
770'.28 TR146

ISBN 0-240-51221-9

Library of Congress Cataloging in Publication Data

Beal, David.
Travel with a camera
Includes index.
1. Travel photography. I. Title.
TR790.B43 1984 778.9'991 84-4112

ISBN 0-240-51221-9 (U.S.)

First published 1985

Series designed by Diana Allen
Cover photography by Micky White
Photoset by Butterworths Litho Preparation Department
Origination by Adroit Photo Litho Ltd Birmingham
Printed in Great Britain by Robert Stace Ltd,
Tunbridge Wells, Kent

Contents

Introduction

No matter how far you travel, whether off the beaten track or into the heart of the teeming multitude, you can be pretty sure of one thing. Cameras of one sort or another will be in evidence wherever there are travellers. The camera has become such an accepted part of the travel scene that people seldom give it a second glance. This is not surprising. Few travellers venture far without this ingenious and reliable device, which enables the traveller to record cheaply, and with extraordinarily good quality, people and places and events encountered in faraway places.

The camera forms a desirable or even an essential adjunct to most travellers' equipment. For many it adds a significant amount of fresh interest and pleasure to travelling, and large numbers of tourists of every type have found that photography has opened their eyes so that they now observe rather than merely see. The knowledge that the best of photographs taken will later be a delightful stimulus to the traveller's own memory, recalling vividly all sorts of places, personalities and occurrences, provides a strong incentive to select viewpoints and to photograph scenes and events in every location visited. There is also the bonus that many of the photographs will prove pleasurable and instructive to others.

For the photographer, for whom the creative use of the camera is an absorbing pastime or perhaps a full-time occupation, travel provides continuing opportunities for the production of unique and valuable pictures. This is not to say that you have to travel to the ends of the earth in order to find photographic subjects; the observant eye can select these on the doorstep or even within the home. But there is a great fascination in the unfamiliar, and travel confronts us time and again with beautiful sights and remarkable experiences, worthy of recording on film; it offers unlimited scope for original pictorial creativity. Thus travel and photography are complementary activities; each can enrich the other to a remarkable degree.

The title of this book was intended to have a twofold significance. It is primarily a basic description of the book's theme. But it is designed at the same time to act as an encouragement to people who seek a rewarding recreation. Everyone should travel as much as possible and become more familiar with this wonderful and ever-changing world. Everyone in search of a creative hobby should seriously consider the claims of photography. But to get the best of both worlds: travel with a camera.

I am grateful to certain photographic enthusiasts for supplying some of the photographs for this book. Those photographs not individually acknowledged are my own. All are reproduced from 35 mm colour transparencies unless otherwise indicated. I also wish to thank my wife Ishbel for much invaluable assistance with research and editing, and also for helpful work in connection with the photographs.

I should like to conclude by wishing you every joy in your journeyings, be they rambles round your neighbourhood or expeditions to wild and faraway places – or something in between. I sincerely hope that travel with a camera brings as much pleasure to you and your friends as it has done to us. Good shooting !

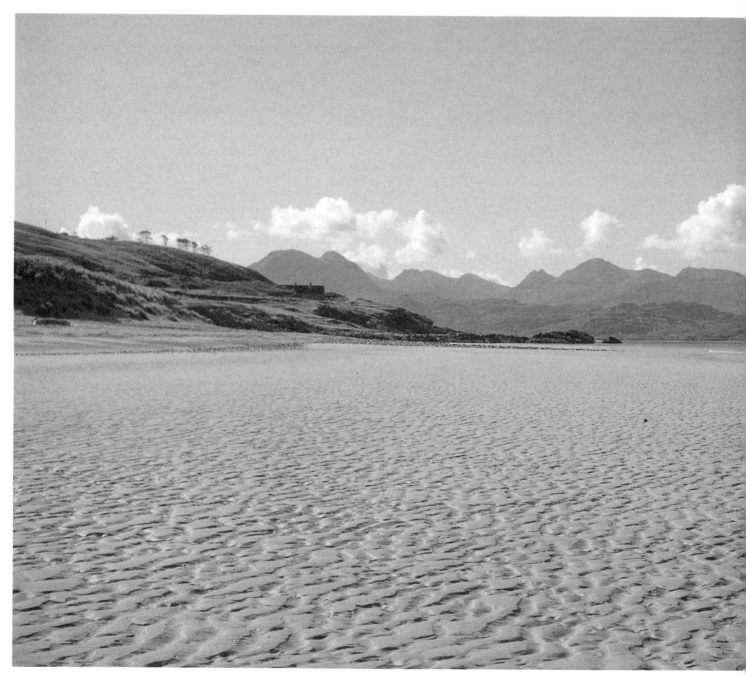

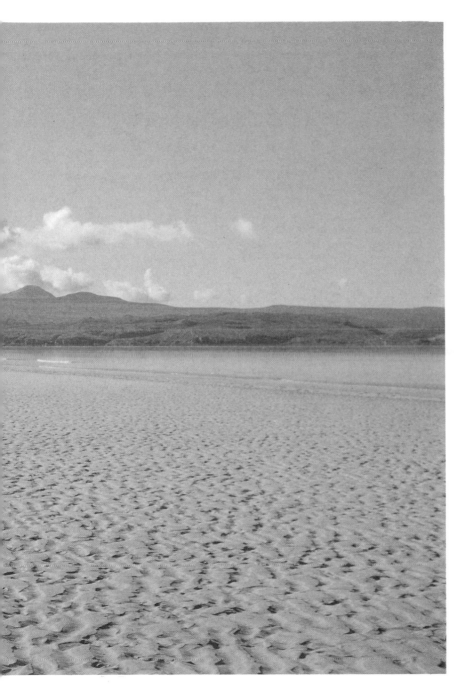

Holiday photography

There must be thousands of people who spend half the year eagerly anticipating their annual holiday, and the other half reliving it in retrospect and letting others know all about it, with the aid of photographs. Thanks to the camera, much of the atmosphere and beauty and excitement of the annual vacation may be captured. For the family, the photographic record of the periodical holiday trip serves a double purpose: the progress of the family in wisdom and stature gains added interest with beautiful or exotic backgrounds.

For large numbers of people throughout the modern world, photography forms an important part of the holiday. This applies wherever the holiday takes place: at home, in the immediate neighbourhood, in a more distant part of your own country, or in some faraway land; but especially in the last-mentioned instance. The very idea of setting out for a long trip to Hong Kong or Oban or San Francisco or Leningrad without a camera of some sort is generally out of the question.

There is no better kind of personal travel notebook than a pictorial one. In bygone days, many a traveller would delight in using a sketch-pad as an illustrated diary if he were artistic enough. Nowadays the pictorial diarist generally uses film as a medium rather than pencil and paper. The pleasure for the journeyer is twofold: in the creativity involved in selecting and forming each pleasing image, and in the eventual satisfaction of viewing the end-product.

For the considerable number of travellers who favour travelling by themselves, the camera may assume the role of a valued friend. The solitary photographic traveller can take as much time as he wishes in reconnoitring and in deciding on ideal climatic and lighting conditions. He can choose to

sit patiently on a wall, day after day, awaiting the possible arrival of an Israeli woman with her burden at one particular village corner in the sweltering heat of the midday sun; or he can (and I know someone who did) wait by a Highland loch on a cold winter's day for several hours for the ideal cloud effect to occur. In each case he will have no one to exasperate but himself.

There is no need for the camera to spoil your vacation. It is not necessary to face yourself with the alternatives of taking a camera or having a holiday. It is perfectly possible for a photographer, whether alone or with companions, to enjoy a trip thoroughly and participate fully in every activity while easily avoiding being ruled by the camera.

Some tourists deliberately select certain days during a visit, in advance, for photography, and other days for leaving the camera in the hotel; and there is perhaps something to be said for this. But on the whole it can lead to so many regrets for lost opportunities that most travelling photographic enthusiasts take as their watchword for every day: 'carry your camera'. The modern camera is so portable that little or no hardship is involved.

The camera and the home area
Anyone who is fortunate enough to live in a place inherently delightful, such as Chester or Vancouver or Pitlochry, can regard the vacation as a fine opportunity to explore his own neighbourhood in a way that was not possible during the working year, except at some weekends. A holiday at home can be used as a chance to discover or rediscover charming corners of your own town or village with the camera. Familiarity all too often breeds contempt, or at any rate indifference, and the usual swift progress through the home city or town, to work or for shopping, is not conducive to an appreciation of its partly-concealed attractions. A series of leisurely strolls through the side streets with a camera during a holiday can result in very rewarding shots, especially perhaps at an early or late part of the day when shadows are attractive and lighting is

pleasant. The old castle ruin on the hill, the little-used cart track, the huddle of houses in the old part of the city, the curious ancient carving outside the town hall, the three old men seated on the bench at the village green surveying the passers-by – this sort of feature can go unnoticed right through the working year and suddenly become during a holiday the makings of a striking photographic composition.

Holidays at home provide time for the creative photographer: time to look quietly at his surroundings with a seeing eye, to try out an original optical effect, to take an unfamiliar view of a familiar scene; in short, to exploit the artistic potential of the camera. Travel in this sense can signify a ten-minute walk rather than a trip across the world. If there is a special event in your village or town – a market day, gala day, traction engine rally, children's parade, visit by a VIP or protest demonstration – it would seem a pity to be away from home and miss the opportunity for vivid and colourful photography. In this case you will not be the traveller; other people will be the travellers, visiting your home town for the occasion perhaps, and you will find chances of capturing on film interesting or amusing characterisations involving some of these visitors.

A holiday at home is often modified to include, weather permitting, 'a day here and there'. If you live in or near an interesting area, there is everything to be said for setting out in the early morning, alone or in company, with your indispensable camera slung round your shoulder and your small rucksack, packed with food and flask, on your back. For many years it used to be a regular pleasure for my wife and myself to meet a few friends in the heart of Glasgow, get on a bus, and then, after a half-hour journey, set out from the terminus across the beckoning hills for the day. Cameras were a natural part of our equipment, and shots of Loch Lomond at Rowardennan, of the Firth of Clyde from the hills above Largs, of enchanting little Loch Arklet in the Trossachs,

Pages 6–7: rippled ridges of sand at Gairloch in the North-West Highlands of Scotland, with a backdrop of the Torridon Hills. Early morning provided two benefits: lateral lighting which moulded the sand ridges; and a complete absence of footprints. Automatic metering; 50 mm lens.
Right: a fine use of perspective and framing, on the suspension bridge over the River Thames at Marlow, Buckinghamshire. *Raymond Lea.*

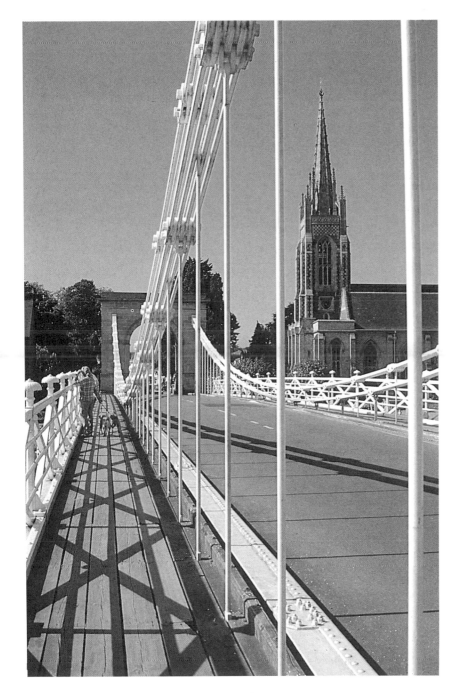

became typical treasured items in our photographic collections, to be brought forth and viewed on later occasions.

Your range can be extended considerably by cycling, with your camera stowed away in a pannier bag. I find that after an hour's run I seem to be in an entirely different country. Though it has doubtless all been seen before, this does not detract from its charm and freshness, and for the photographer there is always a new view of a bridge, or the play of the sunlight on a rivulet, or perhaps a bluetit perched on just the right branch, to make a delightful picture.

For the motoring enthusiast, the expression 'holiday at home' could quite well be a misnomer. If you want to get rapidly into a fresh environment, the car can be an invaluable means of escape: from city to mountains, from village to town, from farmhouse to seaside. A collection of photographs accumulated during a week of motoring day-trips from home can prove to be most varied and interesting, and some of my own favourite pictures were obtained in that way.

Plans and preparations

Most people look forward to the summer holiday in a rather different way. They anticipate it as a most exciting and welcome event – the glowing prospect of getting right away from the humdrum and stepping for a while into the unknown, even if this is still within the same country. Instead of an investigation of the unknown, it might be a return to a cherished spot which is in strong contrast to the home area, with attractions and perhaps personalities that have become pleasantly familiar year by year.

The National Tourist Office of each country or state is a fruitful source of free colourful publications, some extremely lavish and including first-class examples of expert photography, giving a reliable impression of the type of scene you are liable to encounter. It is always appreciated if the

9

applicant covers postage costs. Finely-illustrated booklets are available from the London tourist offices of many countries. From an artistic and photographic point of view, I find that brochures from Greece are particularly superb.

There are other matters to consider as a photographer during the months approaching your departure date. If your camera has been vegetating in a cupboard for some months – or even (perish the thought) ever since your last holiday a year ago – it would be wise to make sure it is in working order well before your departure.

There is a strong case for exposing a whole film – preferably a short one of 12 or 20 exposures – and having it processed before your holiday, in good time to allow for possible attention, such as an exposure adjustment, through your dealer. It is quite likely that there is an unfinished film in your camera, in which event you might only have to shoot off a few exposures before sending the film away for processing. A person who resolutely confines photography to holidays could quite well discover that in using up film material in this way he is compelling himself to look around his locality for worthwhile shots. This could be all to the good: it might, with luck, give him a taste for artistic creative photography.

It is a sad comment on reliability in this electronic age that even if your camera is a gleaming split-new model, perhaps purchased specifically for a long-awaited trip to an exciting destination like Singapore or Honolulu or Edinburgh, it is by no means certain that it will be in perfect working order. It is likely, but not certain. The time to buy a new camera is some months before you set out on an important assignment or journey. If you have bought it from someone of the calibre of my Paisley photographic dealer, he will ensure that the equipment you have purchased from him will be working immaculately before you leave home. But if, at the other extreme, your camera is a tried and trusted veteran which has served you faithfully,

dating back to the time when such pieces of equipment were built like miniature tanks, this unfortunately does not guarantee that it will keep on churning out good pictures for ever. There is something to be said for handing it in to a camera repairer for a good clean-up and an optical and mechanical test, or even for seriously considering the economics of trading it in and updating it for a model with facilities more applicable to travel photography.

As a general rule, it is more economical to buy your cassettes of film in long rolls rather than in short ones. If you do not think there is much in it, try calculating the cost at current prices, including processing and postage, of 100 exposures taken with 36-exposure cassettes of 35 mm film, as compared with 100 exposures with only 20 or 24 exposures per cassette. Admittedly there are arguments in favour of using shorter length film; obviously a strong one is the rapid viewing of your results. But it should surely be possible for the eager photographer to preserve his soul in patience until the end of each 36-exposure cassette is reached. The financial saving in a year can be surprising. It also means that you do not have to find a convenient shady or sheltered corner for film changing quite so often, and this could be critical if you are working in a difficult location in severe conditions.

Of course the photographer who intends on frequent occasions to alternate two kinds of film might well prefer to use the smaller lengths. However, an unfinished 36-exposure film can on occasion be wound back temporarily into its cassette and exchanged for a fast film. To replace the original film, assuming that your camera has manual exposure facilities, you would have to fit the lens cap, set a normal shutter speed, and then operate shutter and wind-on lever until you reach the stage in the film where you left off. With a purely automatic camera the process can be a trifle awkward, with each blank exposure lasting several seconds. In some cases, however, using a flash

Sparkling water against the light. A very short exposure and small aperture (1/1000 at *f*/22) was used, because of the strength of the reflections. As a consequence, the figure appears as a silhouette. Monochrome. *Robert Ashby.*

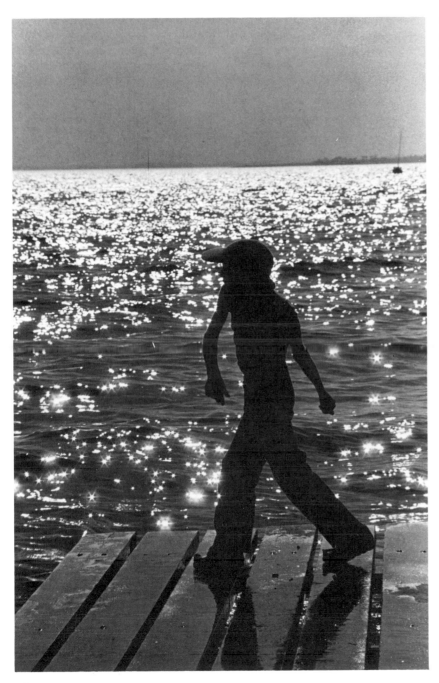

setting solves the problem. Alternatively, the experienced travel photographer who anticipates a good deal of both low-light and normal work – or colour and monochrome – during one excursion is quite likely to have invested in a second camera body, or an inexpensive compact camera, for quick and easy change of film type.

Before purchasing your film material for use abroad, it is wise to make enquiries about comparative costs and act accordingly. If you find that film prices are significantly lower at home than abroad, you will doubtless stock up with the maximum supply you think you will need, as far as permitted by customs regulations. Unused film will no doubt find a use later, as long as the dates stamped on the packages have not expired. A basic choice is made at an early stage by every travel photographer. Colour film and not monochrome is accepted the world over as standard; and monochrome, if it is considered at all, is regarded (quite unreasonably) as an esoteric medium used by a few hardened old-timers and darkroom buffs. Colour quality these days, of both prints and transparencies, is remarkably high, and results satisfy the vast majority of users. The colour medium can convey information totally absent from a monochrome print.

Nevertheless the expert who regrets public lack of interest in monochrome photography is right when he points out that the same casual public accepts the use of black-and-white photographs in publications of all kinds without a qualm. Many a subtle nuance, he insists, can be expressed only in a monochrome enlargement; and artistic creativity is all too often obscured by garish hues, which get in the way of shape, shadow and texture.

However, the fact remains that the average travel photographer demands colour as a matter of course, protesting that we live in a world filled with colour, vivid and spectacular or else restrained and subtle, and often heart-stopping in its beauty. What possible advantage, he asks, could there be in

excluding from your photography this essential aspect of human vision?

Straightforward shooting

There is a strong temptation on arrival at your holiday destination to sally forth with your camera and begin taking pictures. In my early years with a camera, I wasted a good deal of film material in that way. However, I soon began to make a practice of confining the first few days of vacation to relaxing with my family and getting to know the new environment, ignoring the camera altogether. Many photographers regard this as a sensible practice. Disappointing pictures easily result from snapping away wildly in a new area. The practice of restraining yourself photographically for a few days can be specially applicable in places like Norway, the Himalayan foothills, the Austrian Salzkammergut and the West Highlands of Scotland, where the weather can be very variable, to put it mildly (though you could also have weeks of summer sunshine). In such places you often have to wait for several days for suitable conditions for photography.

Of course, you cannot always bide your time. If your first visit to an attractive beauty spot occurs on a dullish day, you will be tempted, as I usually am, to take some photographs even though the weather is not at its best. It might even be raining. This is merely an insurance policy, for fear the weather does not improve. With luck, your second visit later in the week will be in conditions of brilliant sunshine with admirable fleecy clouds scudding about, and you can retake the best shots you took on the first day. If on the other hand the weather persists in being gloomy, you at least have a record of the place. There could also be a bonus. I went through this once at Pollensa market in Majorca; the shots taken between torrential showers of rain had an attractive sparkle all their own. At another time, pictures I took at the spectacular Quiraing in Skye actually benefited atmospherically from the fact that they were taken in conditions of low cloud and relentless rain.

The advice about biding your time before rushing into holiday photography also applies, for the opposite reason, to those fortunate lands like Sri Lanka and California and Tunisia, where in the holiday season the sun shines obligingly every day. On the lovely Yugoslav island of Korcula, there was no particular reason for us to rush out on the first morning, after our balcony breakfast, and take dozens of photographs, or even one. The sun would be back tomorrow, and the day after. A better plan was to spend three or four days at the start of our holiday getting pleasantly and soporifically steeped in the bewitching atmosphere of the old Venetian walled town, discovering those corners which were most attractive, and also noticing the times of day when lighting and colour made them look their best. Later in the week the camera was used at leisure.

It is assumed here that you are fully conversant with the operation and facilities of your camera. In the event of its being a brand-new model, you will doubtless have studied the instruction manual thoroughly. This advice may seem self-evident or even patronizing to readers who are seriously interested in their equipment; but I still vividly recollect, during the ten years when I was a college lecturer in Audio-Visual Media, how often I had to remind perfectly intelligent students of the maxim: 'If all else fails, read the instructions'.

If your camera is a basic sub-miniature fixed-focus model, using cassette or disc, or perhaps a rather larger but still compact 35 mm camera with only a few extra controls to be concerned about, then you doubtless have no lofty aspirations about producing award-winning photographs while on holiday. Your photographic efforts will extend to collecting pictures forming a valuable souvenir of a happy vacation.

This modest aim, of course, does not imply that you can afford to be slapdash. You will first choose the best possible viewpoint and frame the subject carefully in the viewfinder, whether that subject is

human or scenic or both. You will make certain that the sun is not shining directly into the lens. You will ensure also that you are not too close to your subject for the capabilities of the lens. Finally you will hold the camera very still and squeeze the trigger gently to avoid camera shake. If you carry out this procedure every time, there is no reason why your photographs should not be satisfactory.

On the other hand, your camera might be of a more advanced design, in all probability using 35 mm film. Perhaps it is one of superior quality, but of a type much less in favour nowadays than it was at one time – the kind fitted with viewfinder and rangefinder separate from the lens, and maybe with a facility for the fitting of alternative lenses of differing focal lengths. With such a camera you can be somewhat more ambitious.

It is more likely these days, however, that your camera is a single-lens reflex model, designed so that you can view and focus through the lens, or through alternative lenses, thus avoiding parallax problems (caused by viewing and taking from separate places on the camera). In this case you will be taking the whole business of photography more seriously, and you will want to exploit the full potential of a skilfully designed piece of apparatus. Many of the examples and suggestions in this book are offered with the owner of such a camera in mind, and further details about equipment will be found in the final chapter of this book.

Many holiday photographers often seem to be aiming at two things at once when they take a photograph. The usual way is to ask the subject to sit or stand there, looking at the camera, with an impressive building or statue or waterfall or mountain peak forming a memorable background. The resulting photograph probably turns out to be neither one thing nor another.

On the whole, with straightforward shooting on holiday, a pretty good rule is to take one photograph at a time, rather than be tempted to get

two for the price of one. This applies especially when you are photographing people. Get in fairly close and focus carefully on the tightly-framed human subject; then later compose separate shots of distant buildings or scenery, making any passers-by in the foreground subsidiary to the main theme. Bear in mind the usefulness of a limited depth of field: sharp detail in all parts of a picture is not necessarily desirable, and can in fact lead to a cluttered effect. Try focusing sharply on the main motif, allowing nearer or more distant objects to become less clear-cut and hence less distracting. Only when you feel that background and foreground are both significant should you have the whole scene sharply in focus.

On the beach
It is ironical that the average snapshotter on holiday at a seaside resort takes most of his photographs at the place where photography can be somewhat tricky – on the beach. This is only to be expected where the main subjects are to be members of the family, particularly juvenile ones, as this is where most of every fine day will probably be spent. Unfortunately, beach photography is fraught with minor dangers and difficulties. Sand is all-pervading, and no matter how careful you are with your camera, grains of sand can work their way in as if the camera had a fatal fascination for them. It goes without saying that the camera must be kept, with lens cap fitted, in its closed case, during the whole time when it is not being used at the beach. Some play safe by putting camera and case inside a polythene bag for additional protection, and bringing the camera out for a little while before use to avoid possible condensation. Despite everything, an occasional examination of the camera body and lens will probably reveal tiny grains of sand, which should be very gently brushed off with a lens brush, preferably one with a blower. Lens-cleaning tissues should be used only now and then, and very gently. Sand is not the only thing to contend with. Salt water spray is potentially harmful to photographic equipment, and your shots of the wild waves dashing in should if

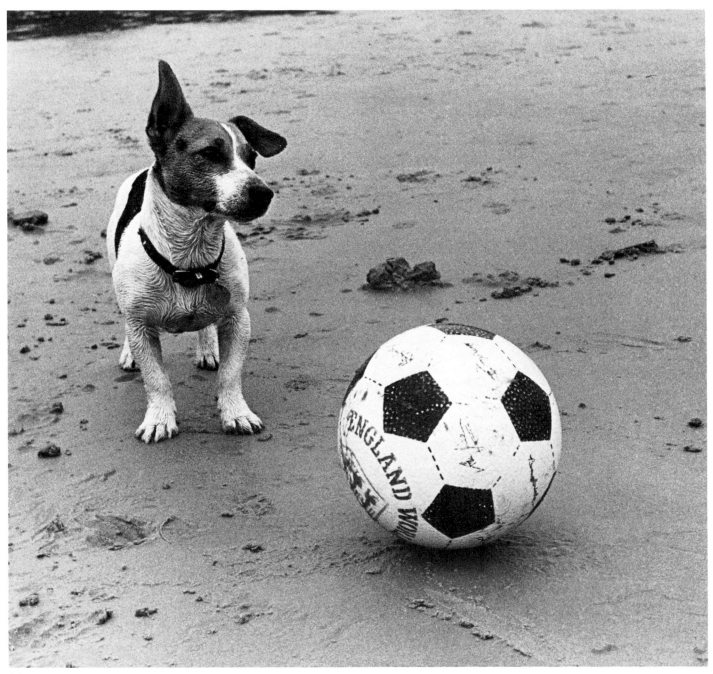

An appealing animal study on the beach. The photographer has caught the dog's attitude, one ear up and one down, at just the right moment. Monochrome; 1/500 at f/11. *Neville Newman.*

possible be taken from some distance with a telephoto lens, or with a zoom lens at a long-focus setting.

If you are having the weather you hoped for, your photography on the beach will have to take account of the brightness of the sunshine reflected by the sand and sea. With an automatic integral exposure system, a photograph of the beach scene will not necessarily be correctly exposed: there is a tendency for the extreme brightness of the sand to cause underexposure, giving an unnaturally dark image. If your camera has a plus or minus film-speed control, you would be well advised to adjust this, giving perhaps one stop extra. Alternatively, with a camera having manual override, you could expose for the palm of your hand, mentally note the setting, and fix the exposure manually at that.

To play safe with a scene on the beach which you think might be a winner, 'bracket' a few shots at slightly differing apertures or shutter speeds, assuming that your camera has manual controls. One of the bracketed exposures should be exactly right; perhaps two or even three will be quite acceptable. The latitude or tolerance of modern colour film is not particularly wide, but a difference of one stop either way can still give reasonable results. It is generally found that for reversal colour film it is better to err in the direction of underexposure, which gives slightly more intense colours, while for negative colour film you can afford to overexpose slightly, giving a pastel result. Another point to consider on the beach is the effect of ultra-violet light above the sea on the colours in your picture. There is likely to be a slight blue cast over distant scenes, and to avoid this you could fit an ultra-violet filter over your lens or lenses.

For family photographs on the beach, as indeed elsewhere, there is nothing to beat near shots. A general view of children making a sand castle is not so attractive as a near shot of a boy or girl intent on the constructional work and oblivious of the camera. The expression 'near shot' is here used

quite loosely to refer to a picture taken from as near a distance as the normal lens will allow; genuine close-up shots, taken from a shorter distance, call for the use of so-called 'macro' lenses, extension tubes, supplementary lenses or bellows, and these will all be dealt with later. There is a distinct difference between a photograph showing a child busy with some ploy or other, with the camera eavesdropping, as it were, and the all-too-common type of picture for which a somewhat self-conscious boy or girl has been persuaded to smile at the camera. On the whole, even for a family photograph collection, it is as well for you to keep camera-facing pictures of people of any age to a minimum, and try in addition to capture your subjects preoccupied with some activity, strenuous or mild. There is ample opportunity for this on the beach.

When a human subject is directly facing the camera at the seaside, the effect of the bright sunshine on the face has to be allowed for. On the beach it is generally best to avoid having the sun in the traditional position for colour photography, namely behind the photographer's back. This sort of flat lighting is favoured for reversal colour photography because it brings out hues and minimises shadows, but it is far from obligatory. In portraiture it causes the subject to seem inhibited, especially in a bright area like a beach, and that person tends to screw up his or her eyes unnaturally. If the sun is to one side or even almost shining into the lens, the facial expression will be more relaxed and pleasant. The brightness reflected from the sand should take care of lightening the shadowed face.

One of the most satisfying types of beach picture is that taken against the light (contre-jour) when the sand is wet. Suitable conditions occur when the tide is out and a stretch of firm sand has regular ripples, each filled with water left by the receding sea. When you are taking a contre-jour photograph, make sure, by careful scrutiny through the reflex lens, that repeated images of the lens elements are

15

not going to appear in your final picture – unless you want that kind of effect. To help avoid this lens flare, always use a hood.

It is worth remembering that there are not many places more attractive for the light-fingered camera thief than the seaside. There, in the nature of things, the camera owner is likely to be intermittently sporting around in the water, especially if he is in a place like the Adriatic coast or Waikiki beach, where the climate during the holiday season is conducive to repeated immersion. It is up to you to devise some method of equipment protection if you are worried about its safety. You might have to fall back on the idea of taking it in turn to keep a casual eye on the property. But perhaps you prefer to avoid the attentions of the madding crowd, and to seek out a secluded and somewhat inaccessible beach like Myrtiotissa on the west coast of Corfu – possibly the loveliest beach on the entire Mediterranean, and into the bargain gratifyingly distant from hordes of other holidaymakers, with the exception of a few groups of carefree naturists.

Most travelling holidaymakers have favourite beaches, but of course only some shores renowned for swimming perfection are equally rewarding photographically. Three of my own favourites from both points of view are Paleokastritsa in Corfu, Lindos in Rhodes and Oldshoremore in north-west Scotland.

Seeing the sights

The average holidaymaker with a camera wants to give people at home a good idea about what the holiday resort was like, and at the same time record some of the exploits of himself and perhaps his companions or family. It is surprising how many sets of holiday pictures – especially slides, for some reason – are exclusively concentrated on scenery, with humanity conspicuous by its absence. Some other holiday photographers, often those using negative colour film, seem to confine their shots to relations and friends, with little or no impression of other inhabitants, or of where each photograph was taken. And as we have seen, you don't necessarily achieve a happy medium by placing a group of your travelling companions in front of Piccadilly Circus or the Niagara Falls and asking them to smile at the camera. A better way is to seek out attractive artefacts or natural phenomena and let human figures play a part in the composition, adding life and a sense of proportion: not standing posed awkwardly in front of a massive rock or statue or harbour or church, but just 'being there'. Often the best results are carefully composed as far as architectural and natural objects are concerned, but at the same time unposed and uninhibited with regard to people.

On your first visit to Paris, you might consider yourself faced with a dilemma if you take your photography seriously. There is a strong urge in most tourists on their initial visit to that captivating city to take in, photographically, all the sights. And why not? Notre Dame and the Sacré Coeur and Montmartre and the banks of the Seine are simply demanding to be photographed. The fact that they have been pictured hundreds of thousands of times matters not at all; your own photograph of any one of the justly famous sights of the city will be much more important to you than a commercial picture postcard or slide bought on the spot. It could even be superior, and in fact your aim will probably be to make it so.

One way is to seek a completely fresh angle. You can get away from the conventional view by looking up or looking down, by climbing up or kneeling. A picture taken from the normal height with the camera held level can be quite acceptable, but ringing the changes in viewpoint often proves most refreshing to a person seeing your photographs. My best pictures of the Eiffel Tower taken on our first visit to Paris were not so much of it as from it: looking up from the base of one of the massive feet of the tower; looking down at the gardens from the first platform; looking through the mesh of girders at the city and the river from half-way up; looking straight down from the top at

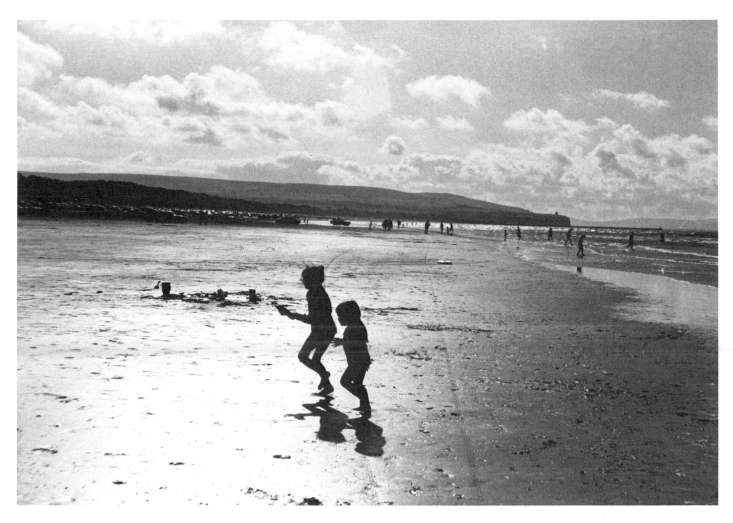

Contre-jour beach scene.
The camera was used in
automatic mode, resulting
in a pleasing silhouette
effect. Monochrome.
Robert Ashby.

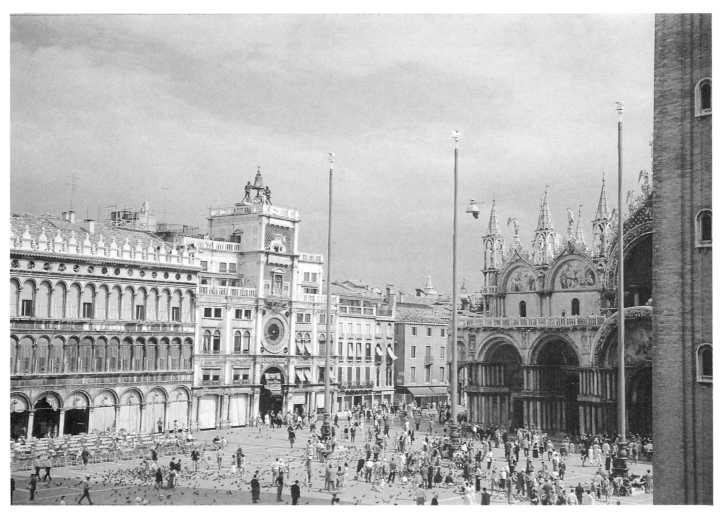

St Mark's Square in Venice.
Keystoning effect is very
slight, owing to the elevated
position of the
photographer (up in the Art
Gallery). Pigeons and
people add interest and life
to the scene. *Edward
Archer*.

the ant-like people below. It is worth trying the effect of varying focal lengths in a case like this, if you can. There is a tremendous contrast between a view from the top looking down through a 35 mm lens and the same at a focal length of 100 mm or more. You could contrive a distant shot of that dominating edifice with the sun peeping through the lattice-work of the first platform, and the whole tower in silhouette.

Another much photographed location in Europe is St Mark's Square in the unique city of Venice. Once you have made a few exposures from your normal eye-level viewpoint, the thing to do is to try for something different. The tame and approachable pigeons, for whom the tourists with bags of food are an essential part of their way of life, are seen to much better advantage from their own level, or near it. From a crouching or kneeling position, with the lens carefully focused, three or four pigeons become almost personalities in their own right, especially when they gather round a little Venetian girl who offers a handful of nuts.

Another excellent viewpoint could be from the campanile high up above, looking almost straight down at the same pigeons, using a long-focus zoom setting, and incorporating perhaps fifty birds strutting about in a veritable swarm. But normal pictures taken from human eye level in the square could well be without any special merit. One attractive procedure is to frame your image. There are arcades in the same Venetian square providing excellent archways through which to compose more interesting pictures than those taken conventionally out in the open.

Turning to a sharply contrasting example, a view of Ben Lomond in Scotland, a mountain more shapely and more easily accessible than Ben Nevis, will be acceptable enough, simply taken on its own from one of the excellent parking-places on the west side of the long and beautiful loch. But to make it more than merely acceptable, you should give thought to the foreground. Fortunately, there are plenty of

trees growing right down to pleasant little sandy shores, and now and then an obliging small boat will pass by. The difference made to the picture by a well-placed birch tree at one side, with its branches and translucent leaves pleasingly (though conventionally) curving down from above and partly occupying the sky, can be most appealing. Alternatively, if you are viewing from a higher position, and thus allowing the blue water of the loch to take up the foreground, a small boat entering the scene is a great help. The boat should be approaching the centre of the picture, otherwise it will look as if it is sailing out of the scene, giving an uneasy impression.

Paris, Venice and Loch Lomond are all deservedly famous places, and they demand as such to be recorded on any holidaymaker's film. There is no need for a photographer, no matter how accomplished, to 'act contrary' on a first visit and deliberately ignore the sights. A much-travelled critic may scornfully castigate your pleasing records of familiar sights like Scotland's Stirling Castle, Switzerland's Matterhorn or East Africa's Victoria Falls as being simply clichés or 'old hat'; but to you and to your friends at home the whole point is that you were there. Your association with each memorable scene will be brought back nostalgically to you at each time of viewing. Nevertheless, there is every reason for you to avoid the over-familiar, and search for a viewpoint or lighting situation different from that used by countless others who have been seeing the same sights. This is where your personality can enter into your photography. Once you have had a good look round your holiday base, and duly recorded on film those scenes which particularly appealed to you, it is time to explore the place more thoughtfully and make visual discoveries.

Portree harbour on the Isle of Skye has been photographed, I suppose, many thousands of times from the self-same spot on the high road beyond the shops. The resulting picture, a favourite in pictorial calendars, with the far Coolins forming a

fabulous backdrop and that convenient tree acting as a pleasing frame in the foreground, has doubtless delighted countless viewers worldwide. But go down through the town to the lower car park, and you will find another aspect of the Coolins, not nearly so obvious, from near the water's edge. With luck there will be an old boat beached in the foreground. It makes a charming and unhackneyed photograph. A focal length of around 100 mm will bring the Coolin ridge up to pleasing proportions.

Up and away

The major growth area in modern tourism has been that of package holidays, which are there to be exploited by any photographer wishing to broaden his canvas with the minimum of fuss and previous planning, and often at remarkably cheap rates. The idea of linking transport with accommodation has clearly been a highly successful one, and the package holiday abroad is the annual choice of multitudes of people in many countries of the world. For my wife and myself, on every one of our package holidays abroad the opportunities for photography and film-making have been frequent and felicitous, giving results which have provided us (and others, we hope) with enduring pleasure.

For the photographic enthusiast, a package holiday by air can be ideal, provided that he has no particular inclination to record on film many scenes and events during the actual journey, but intends to concentrate his photographic efforts on the holiday destination. The home airport itself is a place with a distinct aura of its own and with some photographic potential. An airport often has a 'viewers' gallery', generally one floor up, where it is common to see photographers taking pictures. Aspects of the busy tarmac scene can be photographed from there; the challenge is to spot something occurring which is out of the routine.

Before you launch forth on an air package holiday abroad, with photography as one of its motivations, you have to note certain rules and restrictions. Each country which accepts tourists

(and these days very few actively discourage the holidaymaker) has its own code of regulations and permissions, but none of these should give the potential tourist real grounds for worry. Some, however, might cause a raising of eyebrows. It seems that you may take two cameras and 25 films to a certain destination in Asia, but only two cameras and two films to one in North Africa. For several places, you are allowed only one camera, which must not be brand new; for one African country your camera (again one only) has to be at least three years old. For some countries you are allowed two cameras as long as they are of different formats. Experience alone will tell you just how seriously the customs officials actually regard these and other curious regulations concerning camera and film.

Fortunately for the traveller who likes to use two cameras – and there can be valid reasons for this – these restrictions apply to each person, and as most tourists travel in company, there will probably be no difficulty. The restriction on film material, however, is more worrying, and you would be well advised to enquire in advance about how many films you are permitted to take, and then take the maximum number you think you might require within that limit. With a 35 mm camera you will probably choose 36-exposure cassettes, since the rules seem to ignore the number of exposures in each cassette.

One worry in these dangerous days confronts every travel photographer at the airport. You have to pass through an X-ray device designed to detect the presence of metals in luggage. The purpose is to protect the traveller against the possible use of bombs or other weapons by terrorists, and few photographers wish to complain about this search practice in principle, which is in operation at most international airports. The trouble in the past was that high-dosage X-ray machines were employed, which were liable to harm photographic film in certain circumstances. Things have improved to the extent that most countries now use low-dosage

machines. With these, damage is unlikely to occur unless the film material is passed repeatedly through X-ray devices in several airports, and this is not likely to trouble the average package holidaymaker. Fast film is more vulnerable than slow. A good way out, if you are likely to take your film material through several customs barriers, is to carry your film in hand baggage and ask for a hand search. Security officers in many countries will agree to this. For travellers who are really concerned, shielded bags are available from photographic dealers for protection of films against X-rays.

There are certain rules about the use by passengers of equipment, including cameras, while airborne, and it is advisable to ask your friendly hostess about this. The temptation is to take shots through the window, especially when the scene is really spectacular. My friend Archie Reid took remarkable shots from an aircraft over the Nile valley at sunrise on one occasion, with the sun's rays dramatically striking the river. When my wife and I were returning from Greece one year we passed low over the Alps, and skiers were distinctly visible on the snow slopes; the weather chanced to be sparklingly clear and cloudless, and several passengers took the opportunity of trying to capture the exciting view. Photography from an airliner can sometimes lead to disappointment, as the windows are never as transparent as they ought to be. But I have had satisfactory results from the windows of aeroplanes flying low over the Antrim coast of Northern Ireland, over the Mull of Kintyre in Argyllshire, and best of all over the Hebrides on the way to Stornoway.

The package holiday which uses rail transport is still quite popular, and many people firmly prefer it, for several good reasons. It is generally quite a bit cheaper, and train-lovers insist that there is a great deal less hassle and delay in a station than in an airport. And of course some people heartily dislike the very idea of flying. More positively, the train takes you through places at close quarters,

often very beautiful and spectacular places. The amazing railways of Switzerland are legendary. From the train you can really see the places you pass through, and indeed photograph them. Results, especially using a wide-angle lens and a shutter speed of perhaps 1/500 or 1/1000 second, can be excellent. Where possible, you should photograph through an open window, and in the direction of travel, rather than at right angles to it. More reliable shots can be taken when the train is at a standstill. I had plenty of opportunity for unusual snow scenes one Easter when our transalpine express bound for Lugano was held up for three hours by an avalanche.

Once you have arrived at your destination, you have to remember that many countries have strict rules about photography. When we landed at attractive Dubrovnik airport in Yugoslavia one year, I was just reaching for my camera when I remembered that photography was not permitted within that airport. This is quite common in various countries, especially in airports which are used by military aircraft. To avoid having your film removed from your camera, it is advisable to do as you are told.

Organised tours
A large number of people are attracted by a touring holiday in a luxury coach, and photography generally plays some part in this sort of holiday. Whether the coach tour is within your own country or abroad, the system is generally that of driving along highways for part or most of the day, with a stop every two or three hours. In most cases the driver has no choice about places for breaks, but often the tour is carefully planned so that each meal stop is in a picturesque town or at a restaurant situated near a beauty spot or place of interest. In fact, intermediate halts are often scheduled, some of which may even be announced, somewhat condescendingly, as 'stops for photography'.

To certain serious-minded photographers taking coach tours, these stops are more a source of

embarrassment than anything else: there are those who shrink from joining the line of earnest camera-toters focusing in unison on the appointed view. But maybe this is an over-reaction. If your bus halts for a 'scenic break' on the Black Mount between Glasgow and Skye, it would seem a pity to remain in the coach simply because so many others photograph the undeniably superb view of Loch Tulla far below. This applies just as cogently to the famous vista further north, of Glen Garry from the high car park. On the Isle of Skye, the grass is worn thin at the cliff edge at the point where bus parties by the hundred have focused on the Kilt Rock, the waterfall and the distant view of the Torridon Hills.

A coach tour has its unavoidable frustrations. All too often, if the coach halts for a brief moment, the halting-place will be in the middle of a forest or beside a warehouse. While you are in motion during a tour across the Rockies or into the hills of Malaysia, the temptation is very strong to photograph breathtaking views from a side window. Only now and then will photographs from a moving bus prove to have been worthwhile. Side windows are often tinted to reduce glare. The front window is more promising, if you can get the opportunity to use it, but there is still a lack of clarity in most cases, sometimes caused by the nature of the safety glass; and the vibration of the bus may be too much for your fastest shutter speed to cope with.

Nevertheless, I did manage to capture striking shots from the open window of the bus during our journey down the hair-raising road to Riva del Garda in the north of Italy; and one or two places on the wild road from Bolzano to Cortina in the Dolomites had such terrific views that it would have been a pity not to have a try at them despite the movement of the vehicle. This is where the focal-plane shutter of an SLR camera comes into its own: if you have at your command a shutter speed of 1/1000 second, you will naturally be more likely to achieve a crisp image. The customary 1/60 or 1/125 second usually will not do.

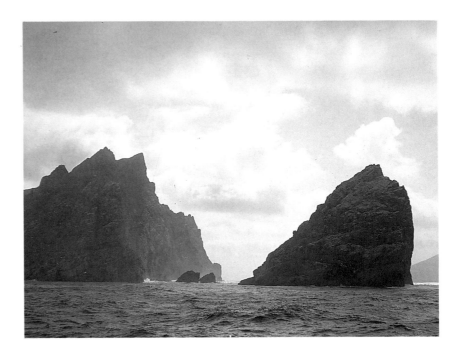

The organised tour by coach, train or aeroplane is a far cry from another popular type of touring holiday, once regarded as only the prerogative of the élite, namely the ocean cruise. In this case the means of transport forms a major part of the holiday in itself, and indeed some participants, incredibly enough, regard the ports of call as being of minor interest. For the keen photographer, on the other hand, a cruising holiday is most worthwhile if the locations visited are outstandingly attractive and not too infrequent.

Our one-week Mediterranean and Adriatic cruise on a fine Yugoslav ship was ideal from a photographic point of view, as the stops were lengthy enough to allow a leisurely look at each of six fascinating places. Every port of call cast its own individual spell, and to have remained on board at any one of them (as some did), or to have travelled without a camera, would, we thought, have been almost tragic. Periods of sailing across an empty sea were quite limited, and took place mainly during

The starkly dramatic rocks of St Kilda in the North Atlantic, seen from a cruise ship. *Glen Aitken.*

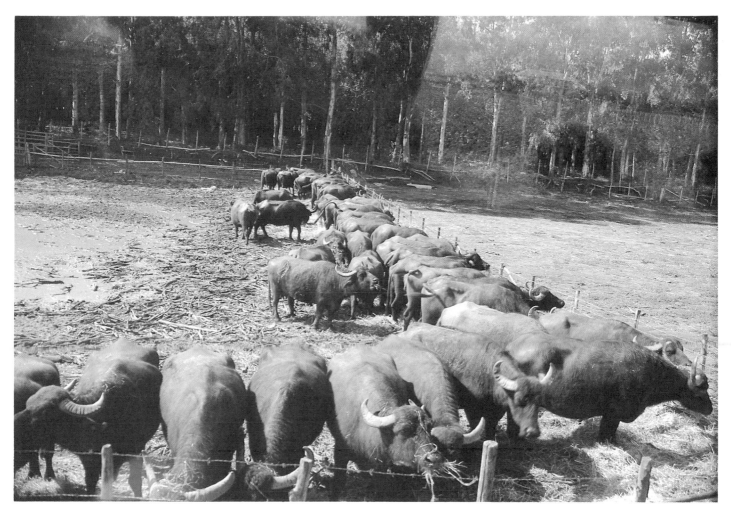

Domesticated water buffalo in a field near Amalfi, Italy, which I photographed from within a stationary bus. A faint reflection on the glass window is just noticeable at the right-hand side. Zoom lens at about 60 mm setting.

the night. There were many occasions when views from the ship's rails were full of visual interest – dolphins tumbling among the wave-crests, yachts and caiques and steamers passing by, beautiful tree-clad Greek and Yugoslav islets sliding past in the morning sun.

The long-focus lens comes into its own when you are passing an interesting island or boat or town. Where a standard 50 mm lens might produce an adequate scene, a telephoto setting of 100 mm or

more will concentrate on the main subject and can transform a general record into a fine picture. Views of harbours from an upper deck before or after disembarkation are generally full of activity and colour, but it is very likely that your best photographs will be taken during shore excursions.

In a rather different category is the cruise which takes place on a wide river. There is something particularly pleasant about being taken in comfort along a great and busy waterway such as the Rhine

or the Danube, with places to enjoy and photograph at every turn. Some of the finest aspects of castles and vineyards are from a Rhine cruise ship, and here again a moderate telephoto lens can prove invaluable. Further east, interesting cruises are operated along three of the great rivers of the Soviet Union – the Volga, the Don and the Dnieper. A distinct variation on this is provided by a cruise along parts of Norway's spectacular coastline, and views from a small ship in fiords such as the Hardanger are enchanting.

One of the most memorable of all cruises is on the River Nile, generally starting at Cairo and taking in the inevitable Sphinx and Pyramids, which I suppose everyone should see once in a lifetime. From Luxor the holiday usually becomes a coach tour, and the sights you see include the unforgettable temples of Luxor and the tomb of Tutankhamun. To many visitors to the United States, an essential part of the holiday experience is a trip on an old-time stern-wheel paddle steamer on the mighty Mississippi, following the trail of Mark Twain and Huckleberry Finn. For the really adventurous, there is the journey along the exotic Amazon, completing the trio of the world's longest rivers. All these freshwater cruises have one thing in common. In each one, subjects for photography are legion, and in each case the most satisfying pictures are likely to be long-focus shots, perhaps taken when the boat is at a standstill, concentrating on human activities and on characteristic features of the region.

Many holidaymakers who are interested in photography like to combine their vacation with some kind of activity. For instance, you could become involved with botany in southern Spain, or geology on the Brittany coast, or bird-watching in the Carmargue, or archeology in the Orkneys, or train-spotting in India. This can be on a purely individual basis, with your camera as an essential adjunct to the activity. Alternatively there is a very wide selection available in many countries of holiday courses and activities run on an organised

basis for people of all ages, and photography can often be involved according to the wishes of the individual. There are holidays combining photography with nature study, for example. In some instances participants are asked in advance to be prepared to take photographs as they go along. Indeed, there are specific courses in photography, at locations which are congenial and perhaps very scenic, so that the experience is both a holiday and a course of camera instruction with experienced tutors.

The independent holiday

Many photographers contemplating a holiday desire above all to have complete freedom of action in their choice of sites and subjects. If you wish to be able to change your location – maybe at a moment's notice, or perhaps (as once happened to us) after steady rain has persisted inexorably on the north side of the Alps and you have heard reports that continuing sunshine is forecast to the south – then probably an independent holiday is for you. This could be an entirely unplanned event. You could do as a friend of mine sometimes used to do: he would suddenly grab camera, passport and chequebook, leap into his car and drive off southwards, making for Dover and Ostend and then whatever places took his fancy on the way to the sunshine. Another method is to take a flight from London to Athens, then step aboard the first passenger vessel you see at Piraeus, and disembark for an unspecified period at the first Greek islet that looks as if it had the requisite quantity of charm and photographic potential. Superficially this scheme – or perhaps lack of a scheme – looks most exciting and attractive; but the fact is that the haphazard way can sometimes involve waste of time and effort, with blind alleys and missed chances. Some degree of planning and investigation beforehand is almost certainly beneficial, especially if you are aiming at worthwhile photography.

If you aim to secure as many chances as possible for good photography during your vacation, but don't want everything to be cut and dried, camping or

The prominent dome of a 15th century Mameluke mosque, photographed from a high position in Cairo, Egypt. *Edward Archer.*

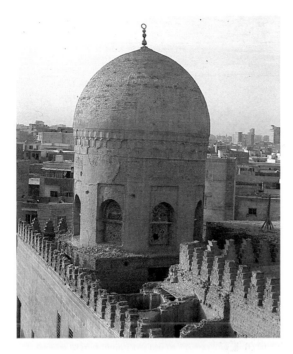

versatility consistent with compactness. Your holdall case should be a small one, in which there will nevertheless be room for sundry other items, such as lens brush, lens hood, extension tube and spare cassettes of film.

If you want to be very mobile and contemplate some rough scrambling or perhaps mountaineering, you could use instead a standard lens, and keep camera and lens in an ever-ready case. If you want to keep weight and bulk to an absolute minimum, you might decide on a really tiny 35 mm compact camera, despite its lack of versatility.

A splendid alternative to hiking is cycling, and indeed in several ways it has distinct advantages. There is not the same need to cut your photographic equipment down to the bare essentials, for instance, as your load is carried by the bike and not your protesting back. You could certainly take a flash unit and two lenses instead of one, with definite benefits in versatility: on many occasions I have been heartily glad I brought two zoom lenses on a holiday. However, the cyclist can't take to the hills quite as readily as the backpacker can.

There are of course many thousands of examples of attractive sites all over the globe, but certain instances stand out in my own memory. One site at Dinan, for example, in the north of France, has a delightful situation in a very pleasant town with a river to add interest photographically. Many sites in Austria, Switzerland and Italy seem to be planned almost with the photographer in mind. From the Natterersee site in the Tyrol our tent was up on a ledge facing the mighty and imposing Hafelekar ridge over the treetops, with the little lake in the foreground. Many others, such as those by Lake Lucerne, Derwent Water, Loch Morlich and the enchanting Lago di Ledro in Italy, are close to water, with fine photographic potential. But for sheer spectacle it would be hard to surpass the many fine sites in the far west of Canada and the USA.

caravanning will probably suit you. Although occasionally – as in our camping trip to the fascinating but busy area of Carnac in Brittany – you are well advised to make a prior booking at a camp site, the thought in the minds of most camping or caravanning photographers is that at any time you are at liberty to move on, perhaps to a place recommended by someone at the camp site.

Most camping holidays use the private car for transport. For real independence, though, you could try backpacking – walking alone or in company, with a good modern rucksack and a light tent on your back, and relying for long-distance transport on trains or buses. You might opt for using a choice from the splendid chains of Youth Hostels instead of a tent. As a backpacker you should keep your photographic equipment down to a minimum, for basic reasons of weight and bulk. You could omit a flash unit, and take one lens only, fitted to the camera – perhaps a small zoom ranging from 35 mm to about 70 or 105 mm for maximum

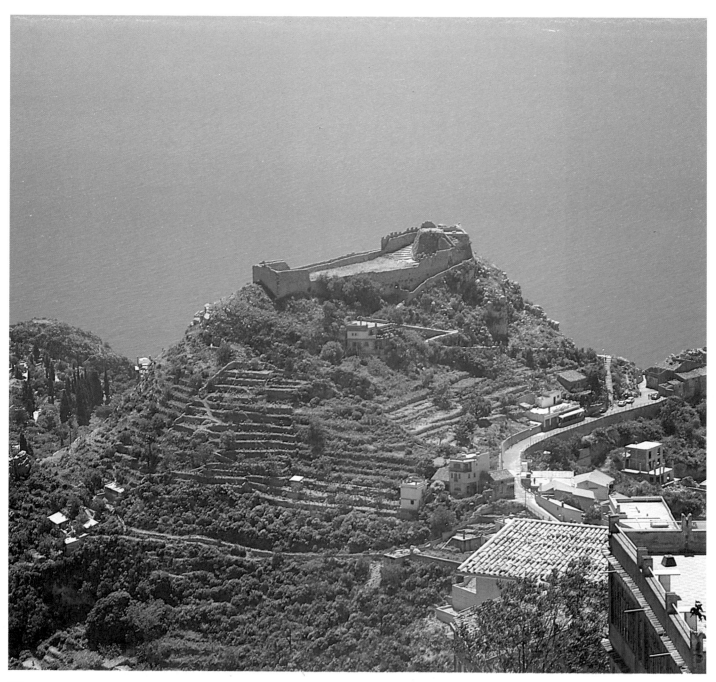

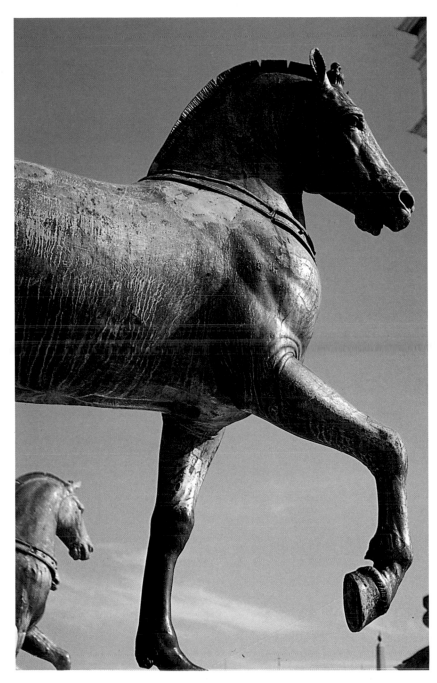

Scenes and places

To the purposeful traveller, a road is primarily a convenient and civilised way of arriving at the desired destination. The road itself might be pleasant or tedious, scenic or dull, but generally it is a means rather than an end. To the purposeful photographer, however, a road can be something quite different – a pleasing and effective element in the structure of a visual composition. Naturally the travel photographer sees a road as a bit of both.

Roads and the landscape
Many of the Alpine and Norwegian passes have been conquered by road designers in a way which arouses admiration and sometimes awe in the spectator, and photographs of these lofty highways, with their hairpin bends and their utilisation of steep hill slopes and glacial moraines, can be extremely striking. Generally speaking, the attraction of the road for the photographer lies in its curving shape. This applies particularly to the type of minor road which winds from side to side amid hilly country. You do not have to travel from Britain to the wilds of the Andes to find such a road. The Lake District of England is famous for its haunting beauty and majesty, but also for a few well-nigh impassable roads. Many a striking photograph has been taken in the area of the Hardknott and Wrynose Passes, and the twists and turns of the roads normally feature as a prominent part of each composition.

Oddly enough, it is not easy to find a road of comparable difficulty for motorists in the Scottish Highlands, but those in search of lofty spectacle for photography should certainly undertake the road from Kishorn to Applecross. There is also my own favourite, the winding and climbing way over the hills and down to the enchanting village of Diabaig. I would defy any photographer to drive on down the final bend on a sunny day without first stopping

at the side of the road to photograph the little cluster of cottages grouped round the jetty far below, with the road winding down to it.

There is something delightful about many of the single-track rural roads which still exist. The ones I always like best, and those which I think appear most pleasing in my photographs, are those old narrow roads which have grass growing in the middle. Many a pleasant composition involves such a road leading the eye into the picture from the foreground and perhaps winding on into the hills beyond, with maybe a crofter's cottage in the middle distance and a thread of peat smoke curling up from its chimney. Minor roads curving through trees have their own attraction, and the quieter they are, the better the photographic potential.

Other attractive roads in various countries are specially constructed for the needs of forestry. The tendency in Britain nowadays is for the Forestry Commission to go to some trouble to provide deliberate breaks in the woodland for amenity purposes, with picnic areas at delightful viewpoints. It would be a pity for a photographer not to use them. Try Mam Ratagan in the Western Highlands. The delight of many a lover of the countryside is the road which is so narrow that car drivers are warned to avoid it altogether. It is indeed fortunate that many of the most beautiful countries in the world are well provided with bridle tracks and footpaths, marked or unmarked. These offer constant opportunities for the travel photographer in search of enchantment. The combination of a twisting track, trees or grass or heather on each side, a human element, and the light of the early evening sun can produce many a winning photograph.

Among innumerable fine examples in the British Isles, it is perhaps worth mentioning – though this is an arbitrary choice from thousands of treasures – the delightful woodland path in Yorkshire beside the River Wharfe to Bolton Abbey, and in Scotland the splendid and challenging Highland Walkway

from Glasgow to Fort William, which uses in part the old rough and grassy drove road.

It is a delight to wend your way up a Greek mountain donkey track through olive trees, with photographic opportunities all along the way. Many an Alpine lake has wonderful footpaths too, with trees efficiently paint-marked here and there to guide the wanderer up to enchanting vistas among the hills. Perhaps the most exciting of all

Page 26: we found the old Sicilian town of Taormina full of photographic opportunities. Its hilltop setting, surmounted by the ancient castle, is matchless. Page 27: a well-composed low-angle shot of horse statues in Venice, with subtle rendition of colour. *Glen Aitken.*

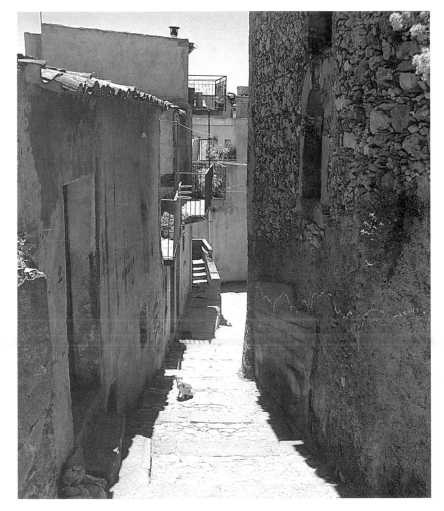

bridge made all the difference to the pleasant scene which I photographed in that very lovely place. In most cases, though, it is the human factor which completes the bridge picture – a solitary person gazing dreamily at the water below, or perhaps a quiet fisherman knee-deep in the river beside the arch. Hair-raising bridges are still used in the Andes and the Himalayas, and a photograph of one of these with the turbulent torrent below is likely to be most effective, especially if it includes people crossing.

Holland is a country with an enormous number of bridges of all shapes and sizes crossing the canals. Some lifting bridges are strongly redolent of Van Gogh paintings, and the photographer would be quite justified in taking one of the master's compositions as a pattern for a photograph.

Many of the 400 bridges across the canals of Venice are firm favourites with painters and photographers. The fateful Bridge of Sighs, leading from the Doge's Palace to the prison, somehow manages to convey a message of foreboding. In contrast, the Rialto Bridge with its shops can be the centre-piece of a pleasantly lively scene (reminiscent of Canaletto) including people on the canal bank and a few colourful boats. Other attractive covered bridges exist in various countries, notably the unmistakable one in Lucerne and the Ponte Vecchio in the beautiful town of Florence. Mostar, an old town in Yugoslavia, has a remarkable bridge soaring high over a turquoise river, with mosques and a minaret supplying an exotic Turkish background.

A photograph of a section of the massive and magnificent Forth railway bridge, looking up from a boat in the estuary, can be very impressive, and for a wider view the graceful suspension road bridge alongside in no way detracts from its splendour. The fine San Francisco bridge can be effectively photographed so as to include a structural detail, such as the end of one of its massive cables.

Above left: drizzly day in Norway; no sun, hence pleasing rendering of facial expressions. *Glen Aitken.* Above: siesta time in Forza d'Agro, near Taormina, Sicily. Sunbaked steps reflect enough light to illuminate wall shadows. Automatic exposure; 35– 105 mm zoom set at 40 mm.

tracks, however, are the steep rocky trails amid the breathtaking beauty of the great canyons and mountains of North America.

Bridges

Bridges, large and small, have always been favourite photographic subjects. A live element in a bridge photograph adds interest and a sense of proportion. At the mouth of the Ord river in Skye, the half-dozen sheep sauntering across the old

London's Tower Bridge also captures the imagination, and can be the focal point in an atmospheric river picture. For sheer romance, however, the legendary bridges of Paris can hardly be surpassed: from the bank of the Seine, a view of the leafy park on the Ile de la Cité with Notre Dame and the bridge is quite irresistible, as is a view of the wrought-iron Pont des Arts at sunset. Finally, nothing could be more graceful than one of those enchanting footbridges in a Japanese garden.

Cities and towns

The photographer arriving at a city in any part of the world is confronted by a bewildering proliferation of photographic subjects. It is quite possible to be so caught up in the whirl and scurry of traffic that you end up by not taking photographs at all. This would seem a great pity, as most cities are full of superb subjects. The problem is chiefly one of selection. There are two main methods of approach to city photography. You can set out with your camera and the minimum of equipment and be prepared to capture the fleeting moment; or else you can work out in advance a plan for a theme or a series of coherent pictures, and then perhaps use several lenses and a tripod. Either method is valid and can be most rewarding, and they have in common the aim to capture on film something of the character of the city. That character is sometimes quite indefinable, and stems from an interaction between people and places.

A series of city photographs could begin with some sort of general view providing a background for the more detailed and intimate studies which are to follow. Many of the world's cities have a vantage-point, or several vantage-points, from which can be taken wide-angle views of the metropolis. If the city is a modern one, an elevated view sometimes makes it look more pleasing, with patterns emerging where at a lower level these were submerged by featureless office blocks.

To many of us, it is a matter for deep regret that recent architectural trends have brought hundreds

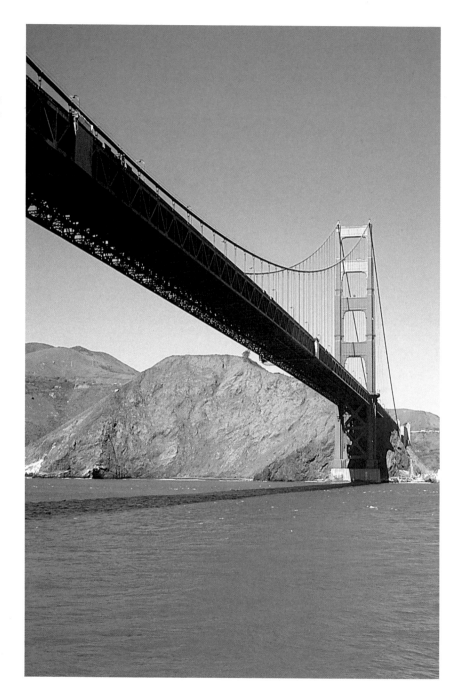

Left: low-angle view of San Francisco's Golden Gate bridge, USA, from the deck of an excursion boat.
50 mm lens, 1/250 at *f*/22, automatic exposure. *Gerald Dorey*.
Right: the 'bridge over the Atlantic' joins Seil Island to the mainland of Scotland. I photographed the bridge, with its graceful arch, from the island.

A totally different kind of archway, photographed in Samarkand, USSR. The ornamental glazed-brick design demands colour film. *Archie Reid*.

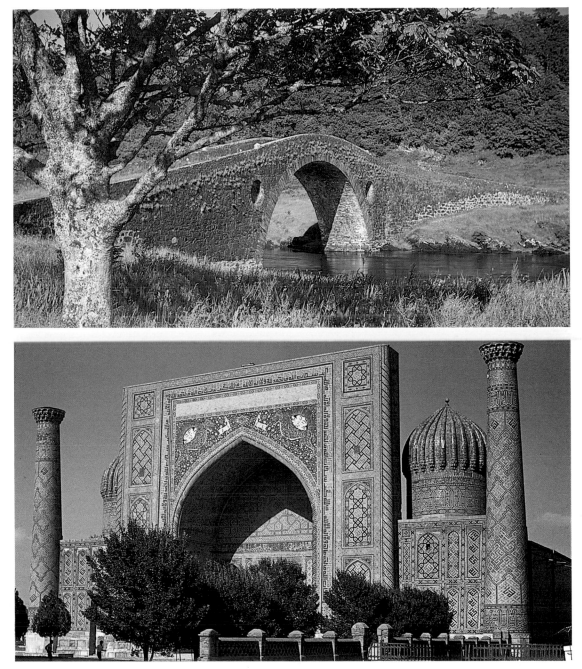

of large towns and cities to a sad sameness in aspect. Again and again we see the inevitable high flats rearing up like tombstones to break the line and detract from the character of the place. Many photographers take on the task of searching for the elusive characteristics of a city and recording them with the camera. You can find striking contrasts within one city between traditional and modern architecture, often within one view.

Fortunately, there are a good number of cities which have retained their beauty, and this sometimes owes a good deal to their setting, often best seen from a high viewpoint. Rio de Janeiro with its marvellous Sugar Loaf mountain and its splendid bays, San Francisco with its fine hills and impressive coastline, Hong Kong with its swarming islands and harbours, Venice with its beautiful buildings and delightful waterways, Edinburgh with its main thoroughfare facing that dramatic backdrop of rock and castle – these and many other imposing cities are provided by nature or by man with vantage-points from which the photographer can observe and record a design unique to each one. This applies just as much to smaller conurbations. Dubrovnik, Yugoslavia, from the splendid ramparts of the town wall becomes a glorious mosaic of red-tiled roofs with inhabitants and visitors strolling around in the open spaces, and from the higher natural viewpoint to which you are taken by cable-car the scene becomes quite breathtaking.

It is when the photographer comes down to earth and contemplates the city or town streets from eye level that photographic problems begin to arise. The bustling crowds are not particularly fond of being photographed, and the thronged pavement is not normally a good point from which to capture the street scene with the camera. However, modern civilisation has its enlightened aspects, for which many a photographer is grateful. There is the splendid concept of the pedestrian precinct, the area in the very heart of the pulsating city which has been fenced off partly or completely from motor traffic, and where benches and floral beds and grassy patches and open-air cafés have been established for the delectation of citizens and visitors. More important, there are many fine parks in most cities, notably London, which are refuges of peace and serenity where people can relax and some small wild creatures can roam. These havens should be exploited by the travel photographer for all he is worth, as they effectively dispose of one major inhibiting factor in city photography – the automobile.

All too often the photographer visualizes an effective city photograph – perhaps looking down a street with its tall buildings hemming him in as if in a canyon – and things are made impossible by the motor traffic. Vehicles grind past incessantly in both directions, blocking every attempt at photography. (Of course, if your city location is Shanghai or Kuala Lumpur or Singapore, the traffic could include exotic trishaws pedalled by round-hatted Orientals, and hence could constitute your main subject.)

Parked cars often seem to take up every centimetre of each side of a city street, and these are bound to occupy much of the foreground of any photograph and distract the eye, especially if they are luridly coloured. I found the parked-car syndrome to have practically taken over the wonderful city of Amsterdam, to the extent that it was just about impossible to photograph from the pleasant canal bank without including parked cars all along both banks – not two or three but twenty or thirty. There is one way of avoiding the parked-car nuisance. Take your street photographs at a time when the drivers have removed their vehicles to suburbia for the night. If you want a daylight picture, this may involve the chore of getting up at an unearthly hour of the morning. It is surprising that people forget how quiet things are in many of the world's cities in the early hours of a Sunday, when you can have the place to yourself, and when the scene is revealed without distractions and with a very special atmosphere.

A startling example of graffiti in the West Indies, ironically juxtaposed. *Jim Standen.*

inconvenient to carry around, and sometimes leaning against a pillar, or propping the camera on a low wall, is almost as satisfactory.

While experimenting with telephoto settings, you will make discoveries about detail and texture and materials in the buildings, statues, railings, streets and pavements. Some of this detail can form the basis of a striking picture. Don't neglect the printed or painted word: colourful shop signs, unusual traffic notices and even original forms of graffiti can be photographed, maybe in witty juxtaposition with some artefact or animal or person.

It is really astonishing how much is concealed by the sheer size of a city. Look for little things like door-handles, window-boxes and stone cornices – not to mention the hands and faces or shoes of the people who give the city much of its character. Try to reveal the unnoticed, making full use of light, colour, haze, pattern, shape and line.

Many a city has at least one splendid and imposing open square, probably with the town hall on one side, and this can be a location for fine photography. In a large number of city squares, like those in Brussels and Prague, there is evidence of sensible planning to provide a pleasant amenity for the citizens. The photographer can in such places relax and look around and think carefully about the type of picture he wants.

In many cases the secret of success lies in the kind of lens used. With a long telephoto lens setting, you can obtain attractive cameo pictures of the denizens of the benches in the square without risk of offending them, or of disturbing their cogitations or alfresco meals or after-lunch naps. Wildlife too, in the shape of pigeons or gulls or the occasional stray dog or cat, can much more easily be photographed in that way. Depth of field is rather limited – because of long focus – so focusing is critical; and some sort of resting-place for the camera is desirable. A tripod or monopod is ideal but often

Exploring villages

Villages have personalities of their own, often intriguingly revealed in photographs. A person might be inclined to choose a bright sunny day and to use the camera in a village when the sun is at its highest. This is all too often a mistake, and photographs taken under those circumstances can appear bright but somewhat featureless and lacking in impact. The pictures miss a certain solidity and moulding, owing to the virtual absence of shade. It is generally much better, as in the city, to get out and about in the early morning sunshine, when slanting shadows add a great deal of interest to most village scenes. In addition, there will probably be an attractive soporific air about the place. Perhaps there will be a rather special morning haze, adding significantly to the atmosphere.

If you are in a location where the sunlight is normally very intense, as in Turkey or Morocco or Mexico, the shadows cast by the houses are bound to be hard, and the picture will have a high degree of contrast. This brings problems with regard to

exposure. If the camera aperture can be set manually so that the sunlit area will be correctly exposed, then the walls in shadow may be too dark to register detail; whereas if you expose for the shadow, the sunlit region will be pale and washed-out. If the camera exposure system is trusted to strike a happy medium, there is the possibility that neither the wall nor the street will be acceptably exposed.

Fortunately, however, modern colour film is able to cope with quite a bit of contrast. Things are helped in this instance by the fact that the walls of village houses in hot countries are very often white, or at least light-coloured. A great deal of brightness is reflected by the sunlit wall and by the dusty street itself on to the shadowed wall, with the result that more often than not the automatic exposure system gives a satisfactory rendering.

Many English villages are highly picturesque. This applies to the layout of the village as well as to the attractive design of the houses themselves. Sometimes the village follows the pleasant curve of a stream, as in Upwell in Cambridgeshire; many villages are grouped delightfully around the common green, as in Finchingfield in Essex; fine trees can pleasingly punctuate the village scene, as in Kirklington in Oxfordshire; the texture of the houses themselves can be an attractive feature, as in Whittington in Gloucestershire; and the pleasure can lie in the winding, narrow, cobbled streets, as in Dent in Yorkshire. Scotland has its own village delights: Dirleton in Lothian is very beautifully set out at the bottom of a castle hill, and Coulter has a most pleasant setting among the hills of southern Strathclyde. In Wales, Betwys-y-Coed is one of the loveliest of all villages. And in Ireland, Carnlough in the north and Cong in the south are among many villages well worth a photographic visit.

Villages beside the sea are particularly attractive to photographers. Usually grouped around a little harbour, these are often highly picturesque. It is worth taking plenty of time to find a spot where the

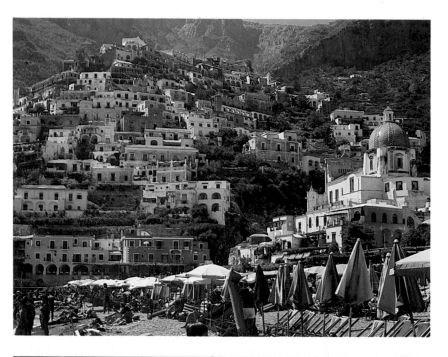

view is striking and unusual in some way; often a small boat comes to the rescue, so to speak, to form a shapely and colourful foreground, with the bay curving round to the pier. Crail, on Scotland's east coast, has many delights apart from its fine little harbour; the immaculate old buildings, narrow alleys and wide streets are of the highest merit, and you could spend an entire day in Crail photographing details such as lamp-posts, cobblestones, window panes, crow-stepped roofs, stone stairs, the market cross and many a winding lane.

A special type of village is the kind without motor traffic. This is part of the matchless enchantment of Lindos on the Greek island of Rhodes, where there are innumerable photographic possibilities involving white-walled villas, flower-decked arches and courtyards, patient lace-making women and even more patient plodding donkeys, sparkling turquoise bays and the splendid citadel above.

Alpine villages have an attraction all their own, partly due to their seductive situation amid the grandeur of those snow-capped peaks, but partly also due to something special and characteristic about the wooden chalets, winding streets, lovingly tended flower-boxes and grassy meadows. Many photographers welcome the quiet and peace of Wengen and Zermatt (preferably off-season), where they have freedom to stroll around and take time about composing a picture without vehicular interruption, apart from the occasional horse-drawn cart. To convey the appeal of an Alpine village, avoid featuring too many items at once. Aim at balance and visual contrast, and remember the value of a small splash of natural colour. Perhaps you could get fairly close to a chalet and let the overhanging roof frame a distant peak; or maybe a drinking fountain or clump of flowers or tiny pond could take up your foreground, not too centrally placed.

In the Asian high places, there are unrivalled opportunities for the camera to capture a

fascinating and often colourful way of life. From the delightful resort of Darjeeling you can photograph spectacular Kanchenjunga flaunting its majestic beauty against an azure sky, with red-roofed village houses dotted about among the trees in the foreground.

Photographing buildings

Among the most interesting subjects which the photographer comes across in his travels are houses. Time-honoured regional variations in the design of people's homes, sometimes within one country, owe far more to the availability of materials than to the whims of fashion. If a cottage has a thatched roof, this is because the material of which it is composed has long been readily available in the area, as in many parts of southern England. Further west or north, local stone such as limestone or slate has been used because it was plentiful there. House walls also differ greatly from one region to another. They can be of wood, stone or brick, and in many cases the texture and shape of the outer walls can be elements of striking subjects for detailed colour or monochrome photography.

Sometimes it is not easy to include the whole house in a photograph. It all depends on whether you can move back far enough and whether your widest lens angle will accommodate the building. The temptation often is to tilt the camera back a little in order to include the roof and perhaps to exclude an unwanted foreground. If you do this, however, you will encounter the stumbling block of converging verticals, otherwise known as keystoning. The vertical lines of the building will appear in your photograph to taper towards each other at the top. With the naked eye you are not generally aware of this perspective effect, as the brain makes an automatic allowance based on experience, and the lines appear parallel; but of course the camera makes no such adjustment.

With a wide-angle lens the tapering effect is more noticeable. This is not (as is sometimes suggested) because the short-focus lens somehow changes the perspective of a picture. For a given subject-to-camera distance, there is no alteration whatever in perspective, no matter what focal length is used by the camera. With a wide-angle lens you can and generally do move in closer to your subject, and this change of viewpoint is what exaggerates the perspective. The converse applies too: with a telephoto lens you tend to photograph your subject from further away, with the result that verticals do not converge so much in the final picture.

There are several ways of dealing with this little problem. You can just ignore it and take your full picture of the house from the furthest practicable distance, from as high a viewpoint as possible (perhaps from a high window in a building opposite), and at the shortest possible focal length. The convergence of the verticals could be so slight as to be unobjectionable. If you do your own enlarging of either monochrome or colour film, it is possible to tilt the paper at the base of your enlarger so that converging verticals in the negative or transparency become parallel. This is of course not possible if you show your photographs as slides on a screen.

There is a good deal to be said for avoiding converging verticals by directing attention to a part rather than to a whole. This is analogous to taking a head-and-shoulders portrait rather than a full-figure or three-quarter-length photograph of a person. Try to move in quite close, or use a telephoto lens setting, in order to isolate an interesting detail on the lower part of the house, or to compose an intriguing shape, or to reveal a contrast in surface texture. One shop-front in an old-world street, say in York or Norwich or St Andrews, can have a friendly charm all its own, which is lost if you take in the whole building. The problem of verticals can be avoided in a different way, perhaps using a standard or long-focus lens setting. If you tilt your camera right back to take in the top of the building, and at the same time bring the camera round obliquely, you will obtain a boldly dramatic tilted effect which is far from

Page 34, top: the highly picturesque and much-photographed village of Positano, on the enchanting Amalfi coast of Italy, viewed from down on the shore. *Archie Reid.*
Page 34, bottom: an earnest conversation outside a village taverna near Paleokastritsa in Corfu, Greece. I avoided disturbance by setting my zoom lens at 105 mm and photographing from a distance. The waste-basket seemed to add a homely touch.
Page 35: plenty of reflected sunlight provides shadow detail in my study of an old house-front in the fine old town of Taormina, Sicily. Automatic exposure; zoom set at 45 mm.

Right: mausoleum and garden statue at Pangbourne, Berkshire. Wide-angle lens gives good depth of field. *Raymond Lea.*

unpleasing – in fact the effect is cherished and deliberately chosen by many photographers. The vital thing is to make it quite evident in your composition that the effect is intentional.

A windmill is a fine subject for a photograph: a tall building with an intrinsic picturesqueness. For a Dutch or English windmill scene, it is quite likely that you would use a vertical format. But instead your picture could quite well be horizontal: you could place the windmill at one side, with perhaps rolling downs to complete your landscape and balance your composition. A windmill can look really striking if you photograph it from a low angle as a stark silhouette against a dramatic sky. Windmills, like houses, vary from country to country. A windmill at Rhodes harbour has an indisputably Greek flavour about it which is characteristic of that delightful part of the world. A windmill in Norfolk is completely different from one in Portugal. In general, windmills have a pleasantly restful and placid air.

The other obviously vertical building is the lighthouse, almost invariably an attractive edifice, with a clean white outline and nearly always in a superb situation for the photographer. Often the best position to take up for photography is far below, perhaps on the rocky shore with a grey cliff soaring up to the base of the white lighthouse and a deep-blue sky overhead. The latter can be emphasised by the use of a polarising filter if you wish to make the scene more dramatic.

The setting of any building is often of major importance to a photograph, and it is worthwhile to try to include part of the surroundings, to set it off and give character to the scene, whether the environment is a New England coast road or a grassy Black Forest hillside.

Into the past
Scattered all over certain parts of Europe are countless mysterious stone monuments, generally huge in size and oddly ominous in aspect. These

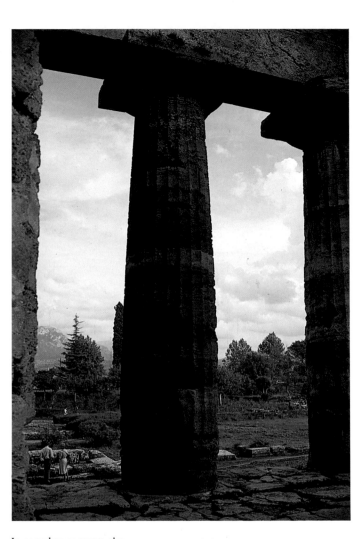

An Egyptian red granite obelisk in Luxor – a fine example of good framing and well-placed light and shade. The lateral position of the sun clarifies the elaborate carvings. *Edward Archer*.

In complete contrast, the gently swelling shape of the pillars of the magnificent ancient Greek temple at Paestum, Italy. With my Olympus OM20 camera, I used a manual setting, midway between the exposures indicated for foreground and exterior.

The earliest major pyramid of Egypt, at Saqarra, with its distinctive stepped shape. The tiny human figures give a sense of proportion. *Edward Archer.*

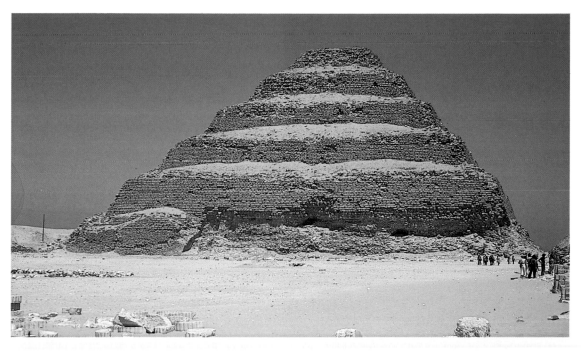

megaliths can form rather strange and haunting photographic subjects. In Britain, for example, there are large numbers of isolated monoliths, over 900 meticulously designed stone circles, and a thousand ancient tombs. In France, the Carnac area of Brittany is renowned for its unique alignments – 2730 enormous menhirs, in long lines stretching across country and over the horizon. It is strongly advisable to include some means of scaling, such as a person standing or sitting beside a stone, as the tremendous size of the megaliths is such an important feature.

For the photographer it is sometimes a challenge to find a good vantage-point which conveys in a picture something of the ominous atmosphere which seems to emanate from the megaliths. Nearly always a strong side light at a late or early part of the day contributes to the effect, and often an oblique angle looking upwards is better than a straight front view. A group of megaliths can be photographed so that they appear as silhouettes on or near the crest of a hill against a dramatic sky, perhaps at sunset.

Undoubtedly the British stone circle most favoured by the photographer is Stonehenge. The vast scale and concept of this amazing monument has really to be seen to be appreciated. It has been photographed from every angle in every kind of weather at every possible time of day – from a distance in its isolated grandeur; from ground level with a stray sunbeam shooting past the edge of one of the massive lintels; through a thin and ethereal haze; or at crack of dawn on Midsummer Day with robed latter-day Druids in attendance. You can use wide angle and small aperture for maximum depth of field to include part of one megalith close by and some others curving away out of the picture, or you could simply show two towering monoliths and their capping lintel with a fallen stone lying in the foreground. At Stonehenge the creative photographer can have a field day.

The ancient sites in Greece are a treasure trove for the travel photographer, combining splendour of form and layout with grandeur of situation. A visit to Knossos on the Greek island of Crete is an unforgettable experience. The archeologists' painstaking use of colour to reinforce the feeling of stepping into the ancient past can lend a spectacular living quality to your colour photographs. In many cases the indoor treasures, too, can be taken using available light, and for this, faster film is an advantage. Oblique angles and strong side lighting will help greatly with exterior subjects on the site.

The world-famous and magnificent edifice, the Parthenon, owes not a little of its splendour to its lofty position above the sprawling city of Athens, and fine wide-angle pictures can be taken from some distance, particularly in early morning or late afternoon. There is scope on the site for the use of many of the facilities of the modern reflex camera. Try long-focus shots with differential focusing, then wide-angle shots from pillar bases looking up, then close details of the carvings, including the replica Caryatids patiently holding things up. The ever-present tourists will provide scale, and add a living touch and a splash of colour. Long ago another Greek site, Olympia, was a deeply venerated place. It is a site much favoured by photographers, partly owing to the greenery of the trees interspersed among and softening the harshness of the great pillars, many of which were felled by violent earthquakes and lie there prone like rows of dominoes.

Probably the brightest gem of all the ancient sites in Greece is Delphi. There is something completely magical about its setting, with hundreds of thousands of olive trees down in the wide valley far below and the majestic Mount Parnassus towering above. When you photograph the stones and inscriptions, you can almost catch their striving to speak. Other places not to be missed by the photographer are the cleansing Castalian spring, the splendid Treasury, the Arena, and the place of the Oracle.

Strangely enough, to find the perfect complete ancient Greek temple, you have to travel to Italy. At Paestum, just south of the gorgeous Amalfi coast, stands the Temple of Neptune, built by Greek colonists in the fifth century BC, breathtaking in its elegant majesty. There are many ways of photographing those graceful and gently swelling columns. For instance, you could bring parts of two columns right up to the camera, and include in your picture a distant impression of one of the two other magnificent temples nearby. One warning should be given about those impressive shots of temple columns with bright-blue sky between and above them. An automatic meter system in that region is liable to be so strongly affected by the bright light from above that the foreground is almost certain to be underexposed. It is necessary to increase the exposure, unless you want only a silhouette.

A rather different way of stepping into the distant past in Italy was made possible by the demonic fury of Vesuvius almost exactly 2000 years ago. To walk along the preserved and excavated streets of Pompeii and Herculaneum and to enter the splendid houses is a memorable experience. In both of these sites there is great scope for the photographer, using various focal lengths, angles of view, weather conditions and times of day.

Discovering civilisations

The activity of archaeologists and their assistants on an excavation appeals as a subject to many photographers. In fact, the camera plays a most important part in almost every dig, and experts point out that the whole success of an archaeological expedition may depend on the work of the official photographer. This, of course, is a somewhat different matter from the casual shots taken by a travel photographer who has happened to come across the archaeologists at work. However, unofficial status should not deter anyone from securing excellent photographs of an excavation in progress. Permission should first be obtained from the Site Director.

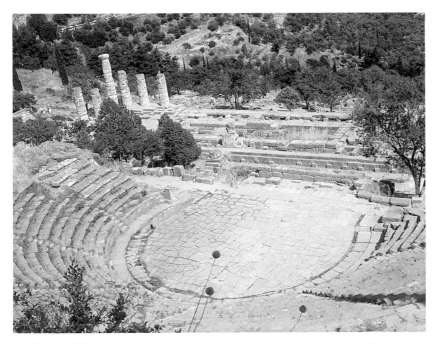

The Theatre at the fabulous Greek site of Delphi, looking down from the rear of the arena towards the olive forest in the valley. Also visible are the pillars of the Temple of Apollo. *Edward Archer.*

person, preferably someone actually at work and not looking at the camera. If what is being uncovered includes carvings on stone, care should be taken to have fairly strong side-lighting to bring out detail. On the other hand, deep and wide shadows in large areas such as doorways or trenches should be avoided if good detail is to be included.

Many important and fascinating relics of the recent past come into the category of industrial archaeology. In some countries there are industrial collections with excellent subjects for the travel photographer in search of something different to photograph. Vintage cars, locomotives and aircraft are to be found on show, and can make most attractive and colourful pictures. Close-ups of gears and pulleys and wing-struts can be pleasing and impressive. The sheer beauty of certain British engineering products can be exemplified if you photograph the famous iron bridge over the Severn, the oldest metal bridge in the world, with its graceful arch reflected in the water.

It is necessary to bear in mind certain special circumstances which arise during a dig. Extra care is needed to avoid an ever-present danger of dust entering the camera, especially if – as is often the case – the dig is taking place in a hot country, such as Mexico or Turkey or Spain or Crete. It is wise to keep the lens covered with a haze or ultra-violet filter all the time, and in addition cover the lens with its cap the moment photography ceases. Detail is especially important in excavation photography, and if a photograph is to show clearly (and perhaps dramatically) what has just been discovered – significant strata, a coin from ancient days, carved lettering, a fragment of a fine jar or painting – the discovery should be dusted by a member of the archaeological team and the area tidied up before the photograph is taken. It is also important to include in most pictures at a dig some way of conveying the size of what is seen. An official photographer would probably do this by placing a scale in the scene, but for the casual travel photographer the pleasing way is to include a

We live in an age of growing awareness of our ancestors and their accomplishments. People travel far and wide to see certain ancient relics which are numbered among the wonders of the world. Anyone who visits the Middle East is confronted with the problem of producing a photograph more worthwhile and less conventional than, say, the very familiar general view of the Sphinx and the Great Pyramid of Gizeh – though of course such a photograph is itself worth taking. North Africa and the Tigris-Euphrates valley are rich in magnificent statues and reliefs, some truly enormous, which can be pictured from all angles and distances, using focal lengths ranging from 28 mm to 500 mm and more. The Temple of Deir-el-Bahari in Egypt, for instance, has a highly dramatic setting in front of massive cliffs which can be included in a wide-angle picture; but every bit as dramatic would be a series of photographs of details of the richly decorated pillars and arches.

Just as awe-inspiring as the pyramids and temples of the Middle East are those of Latin America, which today are visited and photographed by thousands of travellers every year. The Great Pyramid of Teotihuacan in Mexico can be ascended by a tremendous wide stone staircase up the face of the pyramid, and the staircase itself can be the subject of impressive photographs. The top of the pyramid can then be a magnificent viewpoint for further photography.

Fortifications and temples at Cuzco in Peru are full of superb subjects for dramatic photography. Probably the favourite venue for the many photographers who are fascinated by the pre-Columban civilisations of America is the breathtaking mountain stronghold of Machu Picchu. The setting is truly incomparable, and most photographers try to include wide shots of the environment as well as close views of the remarkable stonework.

Rulers of nations long ago often found it necessary to be protected from raids by great walls along their borders. One of these barriers that is familiar to many in Britain is Hadrian's Wall, which was intended to protect the Roman conquerors from the Caledonians. Good pictures of the wall can be taken from many points, such as Housesteads. Generally these walls are punctuated by solid towers for defence, and sometimes one of these towers can act as a splendid viewpoint for the photographer.

The most famous and wonderful of all, the Great Wall of China, is now comparatively accessible to the travel photographer, since the opening up of the Chinese People's Republic to tourism. It is a tremendously impressive spectacle, and has the advantage from the pictorial point of view that it winds its way over wild and mountainous country, generally following contours, with the result that a photograph from one of the square watch-towers is likely to show the wall twisting snake-like from side to side through the hills.

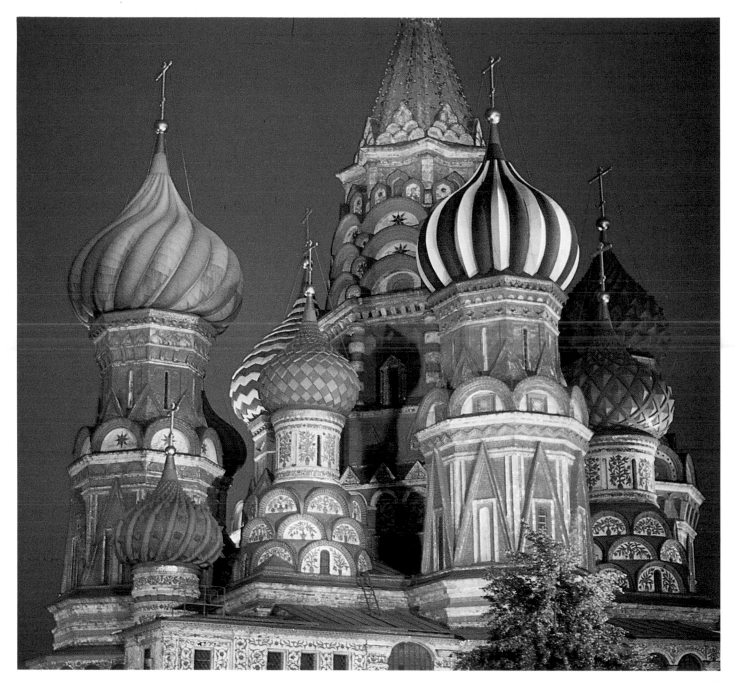

In bygone times a high wall was sometimes built right round a town for purposes of defence, and the photographer will often find that a distant view, where possible, is highly effective, with a clear contrast between the crowded buildings huddled within the walls and the straggling houses beyond the perimeter. Walled towns worth a journey to see and photograph include Caernarvon in Wales, Carcassonne and St Malo in France, Avila in Spain, York in England, Rhodes in the Mediterranean, and Dubrovnik on the Adriatic coast of Yugoslavia. The wall of Constantinople, modern Istanbul, is one of the finest in existence.

Photographs of a town wall, looking along it or down from it, can be very pleasing, especially if, as I found in Rhodes, you can manage to include splashes of natural colour from foliage and palm trees and wild flowers. An added bonus with some of these walled towns is a partial or complete absence of motor traffic. Often an arched gateway into the town can provide a satisfying frame. The tiny and delightful Venetian walled town of Korcula, on the Yugoslav island of the same name, is entered by a grand and stately staircase and then through a fine archway. At night the quiet little town itself is reminiscent of a stage set for 'Romeo and Juliet'.

Castles and churches
In its heyday a castle was usually either a place of domination or a place of refuge. We see castles constructed within the sharp bend of a deep river, on the edge of a vertical cliff facing out to the ocean, on a sea-girt isle not far from the coast, on a tidal peninsula, on an island in the middle of a lake, or perched high on a towering rock. Many countries have castles in settings like these, and in Scotland they may be exemplified by Neidpath, Tantallon, Eilan Donan, Tioram, Loch Leven and Stirling respectively.

As with most architectural subjects, the first necessity is to find viewpoints which enable the photographer to see the structure at its best. The

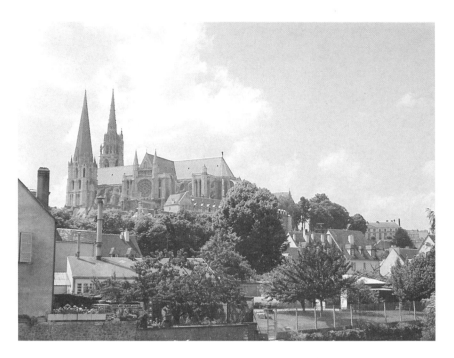

impregnability of a castle often contributes towards a certain ease in photography, as there is probably a considerable space between the castle and its immediate surroundings, making it possible for the photographer to stand well back. It is as well to investigate the best time of day for a good picture of a castle. As with other buildings, slanting shadows help greatly to add an impression of solidity, and you can make use of any of the various techniques already outlined to avoid converging verticals.

However, in the case of a castle many photographers find that there is every reason to heighten the sense of drama, and one of the best ways is to get in somewhat closer to the castle walls and point the camera obliquely upwards, taking in a good section of sky. Here a fine cloud display would be a bonus. On the other hand, an unusual and effective view of a ruined castle might be obtained by climbing to a high viewpoint on a rampart and viewing diagonally down through the vacant roof-space.

Chartres Cathedral, France, pleasantly dominating the town. *Edward Archer.*

Page 42: a 19th century iron water-wheel at a Cornish tin mine: a good example of English industrial archaeology. *Edward Archer.*
Page 43: illuminated golden domes in Moscow, USSR. Long exposure (over 1 second), handheld; taken at night. *Archie Reid.*

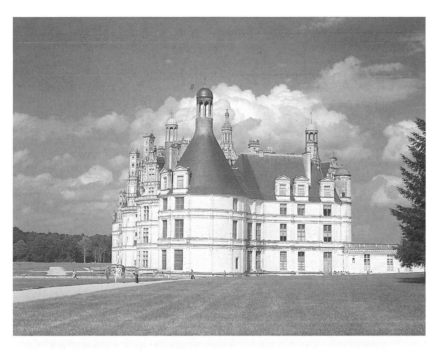

Chambord Chateau, France, with its distinctive towers and strong contrast between grey and white of the exterior. *Edward Archer.*

In England among the most imposing castles are Bodiam and Ludlow. Conway Castle in Wales looks highly romantic with its imposing position above the town. Among many other fine examples of castles in Europe worth quite a journey to photograph are those on the banks of the Rhine. There is also Neuschwanstein, the fantastic dream-like concoction of the highly eccentric King of Bavaria; the latter castle can be photographed spectacularly from a nearby hill with the Schwansee, a gem of a lake, in the background. Spain, Switzerland and Austria have many splendid castles too, which are well worth exploring for photographic themes. The chateaux of Central France, those masterpieces of the Renaissance, of which more than 120 are open to the public, are splendid photographic subjects. Among the most picturesque are those at Blois, Chinon, Chantilly, Chambord and Usse, and Chenonceaux is especially beautiful with its graceful five-arched bridge over the river.

The abbeys of Britain have long been favoured by photographers, and the fact that many of these are partly or wholly in ruins does not seem to detract from their appeal; quite the reverse, in fact. The Scottish abbeys near the English border are particularly delightful, and many fine pictures can be taken from viewpoints on the grassy floor of a ruined abbey such as Melrose or Jedburgh. For a photograph within a ruin, much depends on lighting for the general effect, and a 'haunted' atmosphere can be captured if the sun is shining in from one side through the open roof. Tintern Abbey is a fine example of a beautiful Cistercian ruin which can be the subject of a misty study; Bolton Abbey in Yorkshire was justly described by Ruskin as 'more beautifully situated than any other ruin in this country'; and Fountains Abbey is a real treasure in a splendid setting.

There are certain difficulties in photographing a church or cathedral. In many cases a large number of houses have been built in a pleasantly haphazard way close around the building. This can be

Many castles in various parts of the world have dramatic outlines, and a shot almost against the light, using the camera's normal automatic exposure system, can provide an excellent silhouette. If you want more detail, you will have to expose for the shadowed walls, overriding the automatic setting. Alternatively, you could contrive that the sun is just concealed and no more by the edge of a rampart, so that its rays emerge dramatically. A castle also looks satisfactorily mysterious and menacing in conditions of haze or mist, or even light rain. With many castles there is a particular feature which distinguishes the structure – perhaps a number of defensive crenellations on the ramparts, or narrow slots in a wall, or the unusual shape of a corner tower, or an elaborate drawbridge over a moat. The creative photographer might wish to make such a feature the basis of a picture. In suitable climatic conditions a moat can provide a fine dreamy reflection of the castle tower from a certain angle. A portcullis can act as a grimly effective frame.

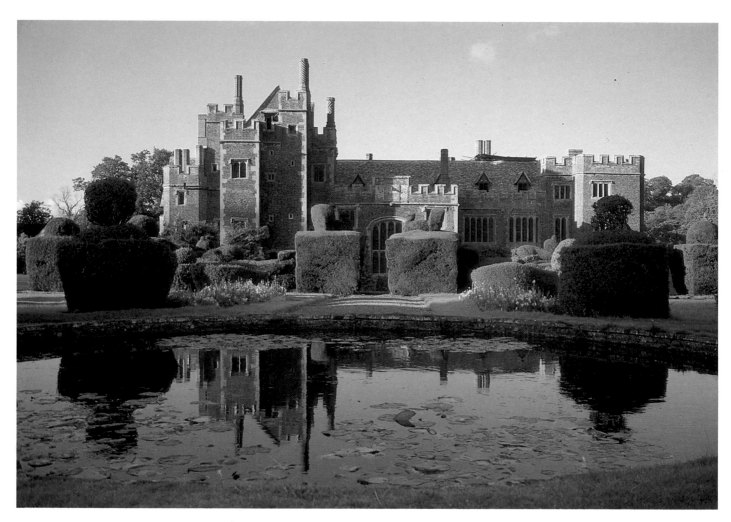

picturesque, but does not leave the photographer much space to get back and take in the whole of the tall church itself. Hence it is often best to concentrate on detail rather than try to include the entire impressive front aspect. Here a long-focus lens is very useful, especially in view of the fact that many of the finest features of a cathedral are likely to be high up. Splendid examples of cathedrals abound in England, notably York, Winchester, Lincoln, Salisbury, Ely and Canterbury. In continental Europe among the finest cathedrals and abbeys are Ulm and Cologne in Germany, St Stephen's Cathedral in Vienna, Chartres in northern France, and the vast and beautiful St Peter's in Rome.

Among many monasteries which are fine photographic subjects, frequently with awe-inspiring settings, are Melk in Austria and Mont St Michel on the north coast of France. The Greek monasteries of the Meteora are spectacularly perched on basalt pinnacles, and the Greek

The Tudor mansion of Compton Wynyates, Warwickshire, England. To obtain the foreground effect, the photographer lay on the grass. Automatic exposure. *Raymond Lea.* Opposite: inside tomb of Menna in the Valley of the Kings, Egypt. 50 mm lens, handheld, 1/15 at *f*/2.8. *Edward Archer.*

monastic republic of Mount Athos is elusive and strangely fascinating (though unfortunately women photographers are forbidden).

In the Soviet Union there are many fine examples of a rich architectural heritage, cherished and carefully tended, from the almost legendary Kremlin, with its ornate onion domes clustered together, to the superbly decorated mosques of Tashkent and Samarkand. Colour film is here almost essential: every photographer visiting those places will wish to record on film the intricate colourful detail.

The visitor to the Far East is likely to find many beautiful examples of artistry in religious buildings and monuments of many kinds – temples and pagodas, mosques and minarets, shrines and tombs. The temple town of Madurai has some of the best examples of Indian architecture, and Hyderabad has an extraordinary temple with four tall minarets, dwarfing the people in the street below. Jaipur, the rose-red city, has a palace with incredibly intricate carvings on its facade.

Regarded by travellers as the most overwhelmingly beautiful building in the world is the incomparable Taj Mahal in Agra. Artists and photographers never tire of portraying its magnificently peaceful front aspect, with its shapely dome and graceful towers. It is also worth spending time searching for less conventional viewpoints: from across the river, for instance. If you can contrive to be in front of the building when the water is still, the mirror image can complete an unforgettable picture. As the visitor draws closer, he marvels at the gorgeous bejewelled marble screen, a perfect contrast to the pure-white marble of the main building. As in many aspects of travel photography, a close approach is highly rewarding.

Inside historic buildings
The travel photographer visiting a large building, be it castle, chateau, mansion, temple, cathedral or village church, will probably not be satisfied with

photographing the exterior. Photography within a spacious building involves a fresh set of problems, but fortunately none of these is insurmountable. An indoor subject of this kind may be approached in one of two ways. You can use the light that happens to be available, whether this is daylight through the windows or the rather weak artificial light that is provided. Alternatively you can employ some sort of photographic lighting, probably in the case of the average travelling photographer a single electronic flash unit.

You will first of all have to ascertain whether you are allowed to take photographs inside the building at all, and if so, whether you may use flash or a tripod – or both. It is advisable, if you are going to use available light, to load your camera with fast film, perhaps ISO 400/27° or the recently introduced ISO 1000/31° film. In order to achieve the maximum possible depth of field, you will want to use a reasonably small aperture, and only fast film or a long exposure will make this feasible. If you are employing available light which is predominantly artificial, you might decide to work with artificial-light film, or else a conversion filter, so that the colour balance is correct.

You will probably find that indoors your movements are restricted. For a general photographic impression of the interior of a cathedral, you would require a wide-angle lens setting, 35 mm or smaller. At the same time you would have to bear in mind that the resulting picture could appear surprisingly distorted, owing to your unavoidably close proximity to the subject. You can take photographs of the ceiling, avoiding the keystoning problem, by placing the camera on the floor pointing straight up and setting it to operate by delayed action.

If you wish to use beams of sunlight from outside to provide a sort of ethereal illumination to the scene in a cathedral, it is not generally advisable for these rays to be harsh and bright. Diffused sunlight on a day with thin cloud will make the image less

contrasty. The sun's unobstructed rays are much brighter than the interior of the building, and the film will not be able to cope properly with both. You might find that the available light on such a day is sufficient for even a hand-held exposure. If the indicated shutter speed is 1/30 second or even 1/15, you could still obtain a reasonably sharp image by carefully leaning the camera against a convenient pillar, or perhaps placing it on top of a pew or table. But you would certainly be safer to use a tripod or other camera support (and delayed action) to eliminate shake.

A really slow shutter speed with a small aperture will certainly give better depth of field. The only trouble is that if you are using a slower speed than 1/10 second, reciprocity failure occurs. With colour film this means that the colour balance will alter slightly, and also your pictures will be somewhat underexposed. In general it is advisable to bracket several exposures of different durations. You could try using the 'B' setting with a couple of minutes' exposure, then a little more and a little less. One interesting effect of using very long exposures in these circumstances is that it will not be so important to choose an occasion when no-one else is in the building. If your exposure is long enough, say a minute and a half, a person walking through your scene will not be recorded by your camera, and the building will appear empty in the final photograph.

Taking photographs within the building at a closer distance is a rather different matter. If flash is permitted, this will solve the illumination problem, and there is the advantage for the travel photographer that he does not have to change to fast film. If your unit has 'bounce' facility – that is, if you can tilt the head back – this could be useful, giving a less contrasty result, but only if there is a fairly low light-coloured ceiling (or else a reflector) to bounce the light back on the subject. A better way, if your camera allows it, is to operate the flash from one side, with a synchronising cable.

Trinity College antechapel, Cambridge. A good example of the depth of field obtainable with a 28 mm wide-angle lens. *Neville Newman.*

If you contemplate using flash in a photograph of a larger part of the interior of a church, you are faced with more serious problems. A single flash unit fitted to the shoe of the camera would not be suitable, as your results would be illumination of near objects but deep and impenetrable gloom further away. Experienced photographers in these circumstances make use of a 'painting with light' technique. With one flash unit only, this calls again for a separation of the unit from the camera, this time without a synchronising connection. It also calls for co-operation with obliging church authorities.

To 'paint with light' using open-flash technique in a church or cathedral, fit your camera to a tripod, set a fairly small aperture for good depth of field, and release the shutter at the 'B' setting. During the exposure, lasting a minute or more, aim the flash unit at various dark areas and set it off several times. You have to ensure that the flash unit is pointed away from the camera each time.

Stained-glass windows are highly attractive subjects, but they pose special problems. Again diffused sunlight is ideal if you are photographing one of these windows during the day within a cathedral. It is important not to rely entirely on an automatic-exposure system, but instead, using a separate meter or a manual-exposure system on the camera, to expose for the translucent glass itself, and not for the whole scene including the surrounding sections of wall.

Small interiors are much easier to cope with than large ones such as churches. Many items in museums and galleries can be subjects of valuable photographs. Museums such as the superb one at Heraklion in Crete, and those in Delphi, Athens, Naples, Rome, Paestum and so on, have treasures which many travellers with cameras want to photograph. In Greece and some other countries it is necessary first to obtain official permission. Elsewhere it may be found that the authorities have no objection to photography as long as it does not obstruct or distract. I have obtained very satisfactory transparencies, using ISO 400/27° and 64/19° film and available light only, in well lit rooms in Italian museums.

Understandably, visitors are discouraged from using flash, especially where coloured paintings are on display. This is because the cumulative effect of thousands of flashes would be damaging to pigments in a precious painting. At the fine museum at Paestum I obtained very acceptable photographs of the unique ancient paintings, using the available light from diffused sunshine through the windows. A standard lens with its usual wide aperture may be preferred for many interior available-light shots, rather than a zoom lens, which has a smaller optimum aperture. Nevertheless, the photographs of the Paestum paintings were taken with an *f*/4 zoom lens.

People and personalities

It would be strange if the photographer who travelled in company ignored his fellow-travellers completely in his photographs. To put it no higher, a travelling companion can be a very convenient item to complete a pictorial composition. Unquestionably the human factor adds a most valuable element to many a photograph. Local characters are not always available and willing to pose, and clearly your travelling companions should and probably will appear in some at least of your photographs.

Travelling companions
Friends or relations accompanying the travel photographer are likely to form ideal subjects for photographs. The fact that your friend or spouse is accustomed to your photographic ways and knows you well should make that person a natural and uninhibited element in some of your photographs. Occasionally, however, your companion's anxiety to please and to be part of your photographic scheme of things detracts from natural behaviour, and he or she could appear somewhat stiff and self-conscious. The main thing is to avoid a too-obviously stilted pose.

Many have found that the best procedure is to cultivate patience. Wait till your friend happens to take up a good position in the scene you intend to photograph, rather than direct him or her to stand at a certain point looking in a certain direction. This applies to facial expression as well as to stance. The practised photographer has learnt through experience the value of relaxation, for both subject and himself. He is ready with his camera for the right moment to crop up, so that when his subject's position and expression are just right, the photograph can be taken casually and without a moment's hesitation. It may be, however, that you have decided at one point in your travels to set

about obtaining a more deliberately planned photograph of one of your travelling companions. Perhaps this is in an especially interesting or congenial setting.

There are distinct advantages in taking portraits outdoors. Fine backgrounds are available in most locations if what you want is an appropriate setting for a portrait of your friend. The lighting in the open is much brighter than indoors, and is generally easier to handle. If the midday sun is blazing down on the beach, there might well be pleasant tree-shaded spots not far off, with reflected light from the sand modifying the shade. If the sun is shining from a low angle, the opportunity might occur for a delightful contre-jour study with the light attractively illuminating your subject's hair from behind. Oblique directional lighting from above is usually best for portraiture, and this is one reason for the success of so many portraits taken out of doors.

If the day is hazy, then the lighting for your portraiture will probably be ideal. This sort of illumination is excellent for portrait purposes, and can occur when the morning mist has not yet cleared, or when the sky is thinly overcast. Diffused lighting is also generally preferred by the subject, making for comfort and relaxation. The soft shadows are flattering to the features, with a pleasant absence of forehead wrinkles, hard nose-shadow and screwed-up eyes. At the same time, diffused light is advantageous from a technical point of view. It can result in a less-cluttered picture. Even in a head-and-shoulders portrait, the background might well be significant; but if it is in sharp focus it can become just too significant. Dimmer general lighting makes it easier for the photographer to widen the camera aperture, and this in turn reduces the depth of field. A rather busy and colourful floral background can thus become quite vague – appropriate but not distracting, as long as the lens has been carefully focused on the subject. Some meticulous photographers focus on the subject's eyes.

If the photograph is taken from a little further away, with the full figure appearing in the picture, it is often advisable for the subject to be concerned with some mental or physical activity. There is something about a photograph of a person reading a book under a tree, or tying up a boat, or kneeling to examine a wild flower, that can be more pleasing than a picture of the same person just sitting. A full-figure study of a friend is likely to benefit by the inclusion of recognisable and pleasant surroundings.

Whatever proportion of your subject is to occupy the frame, you will have to consider the matter of subject-to-camera distance. With a basic short-focus camera, you will not have much choice. You will take your picture from a distance which provides the most pleasing composition through the viewfinder. If you want to avoid meaningless space around your subject, you will have to get in rather close, bearing in mind the minimum distance for a sharp image. Your subject might be put off by your proximity, and self consciousness could enter into his or her expression. This is where the single-lens reflex camera is the ideal instrument. A moderate telephoto lens would be superior to one of standard or short focal length in several ways. To my mind, a zoom lens of good quality, extending at least as far as 100 mm, would be better still. One that I like to use for portraiture has a range of 35 to 105 mm.

With the zoom lens you can take up your position at a comfortable and uninhibiting distance from your subject and test the field of vision over the full range of focal lengths. Very quickly an ideal width and composition will be found, with the subject taking up a pleasing proportion of the frame. This rapidity of action with the zoom lens, as compared with the time taken to change fixed lenses, pays dividends again and again in naturalness of expression, since your subject should not be expected to wait more than a moment before the picture is taken.

Page 50: a Peruvian bugle call. The 24 mm lens encouraged the photographer to move close to the subject, resulting in exaggerated perspective. In this instance the humorous theme makes it perfectly acceptable. *Jim Standen.*
Page 51: photomontage grouped round a vintage camera. Taken in Lima, Peru, using a 24 mm lens. *Jim Standen.*
Opposite, top: a shaded open-air café in Kassiopi, Corfu. As only Ishbel is aware of the camera, the other figures blend into the background, although there is sufficient depth of field on this sunny day to provide overall sharpness. Bottom: a scene in St George's Bay, Corfu. My fellow-passengers are using a wooden ladder to disembark.
Above: our sons Alasdair and Richard (at an early age) show interest in the contents of a boathouse in the attractive seaside village of Crail, in Eastern Scotland.

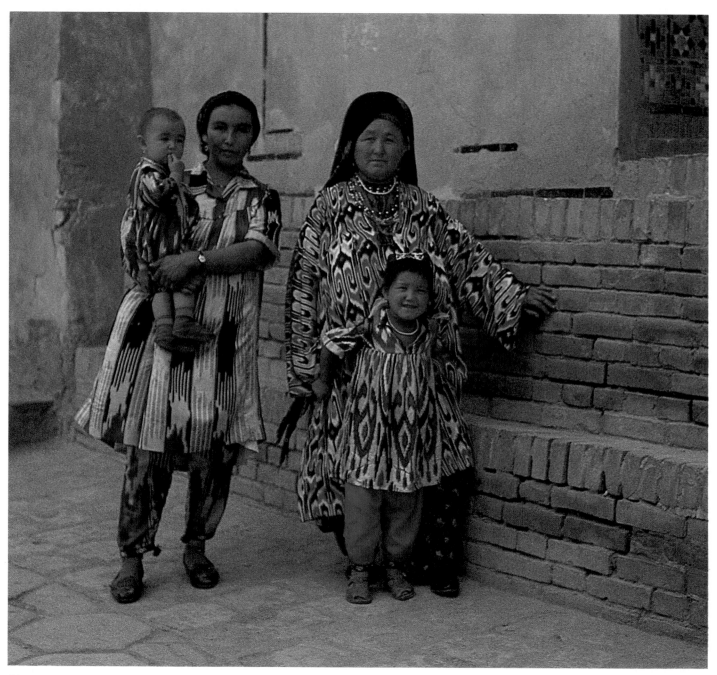

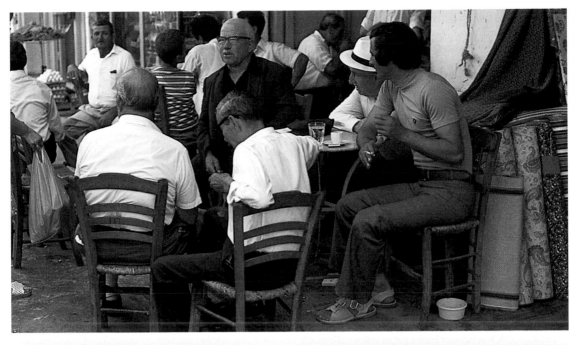

Left: members of a family in Samarkand, USSR, pose for a picture, proud of their colourful costumes. *Archie Reid.*

Right: a highly typical café scene in Greece: the all-male group at their morning coffee and water, putting the world to rights, unaware of the camera. *Archie Reid.*

Another advantage of the long-focus lens is its indirect effect on perspective. A close shooting position distorts normal perspective, and a wide-angle lens encourages this proximity. With portraiture this matter becomes absolutely vital, and wide-angle portraits from close range, even of infants, are often grotesquely distorted, with huge noses, prominent ears and bulging foreheads. A long-focus lens has the opposite effect. It encourages the photographer to distance himself from his subject, and magnifies a small section of what is seen with the naked eye. The foreshortening effect of the magnified distant view reduces the prominence of noses, and this is usually regarded as complimentary to the subject. At the same time, the fact that a telephoto lens limits the depth of field means that the background loses sharpness, with a consequent emphasis on the main subject.

Photographing small children successfully is difficult unless they are fully occupied with something. My earliest attempts at photographing our granddaughter Janet were none too satisfactory. She was always completely fascinated by the camera, and if I crept up to her with it she promptly stopped doing what she was doing, ceased smiling, and stared wide-eyed at the lens. When she reached the age of two, seeing a camera pointed at her was the signal for a spirited sprint towards the photographer. Focusing in such circumstances was well-nigh impossible. Here we see a case for automatic focus. A growing number of photographers have found that this system, no matter what principle is involved in its operation, can solve the problem of focusing on a too-active child. It is for the individual to decide whether the purchase of an auto-focus camera is justified for the photographic situations he has in mind.

Local characters

For the travel photographer, who is generally anxious to capture in his pictures the feeling and atmosphere of a locality, the vital factor very often is the relationship between places and people. Men,

women and children are frequently the product of their environment, and conversely the milieu which persons inhabit has often been affected or transformed or even created by the inhabitants. This two-way inter-relationship is the concern of many travel photographers, who strive in their pictures to convey aspects of the association. The harbour forms a much more interesting picture with a couple of fishermen at one side mending sails or nets; the Alpine hillside pasture gains appeciably in attraction if an aproned girl is seen haymaking; the Indian village road comes to life if there are two brown children seated on the ground engaged in earnest conversation.

A person in a photograph need not be predominant. A wide landscape can be brought to life by the inclusion of a distant human figure. This can easily be demonstrated if you cover up with your finger a small human figure in a photographic landscape. Suddenly the scene alters, perhaps becoming more lonely and less inviting. Not only do figures in a landscape add interest, they perform the sometimes vital function of conveying a sense of scale. With local characters the emphasis should be on casual behaviour, in both photographer and subject. Local people in a scene are representatives of their neighbourhood, and their activities and attitudes and dress make them an integral part of the photograph; but they will not appear as part of the picture if they display self-consciousness.

People may be just passing by. In this case the photographer has the slight problem of how to photograph them without disturbing their natural behaviour. Anyone who has tried photographing folk on a busy pavement knows that if passers-by are conscious of the photographer's presence, they often react in unfortunate ways. They may turn away from the camera, or stare at it as they pass, or raise a hand towards the lens in protest. They may even stop in their tracks and then obligingly move aside to avoid spoiling your picture, when all you want is for them to act as if you were not there – in other words, to be part of the scene.

If you are looking for a general impression of a busy place such as a city street, a good plan could be to set your zoom lens at a moderate wide-angle position such as 35 mm (or fit an appropriate short-focus lens), fix the focus at three or four metres, and shoot now and then without taking too much time in viewing – or even without viewing at all. If you are working with a fixed-focus camera, the lens will probably be a wide-angle one anyway, designed to give acceptable results at any distance beyond a couple of metres.

For more deliberate pictures of local characters, it is advisable for the owner of an SLR camera to take advantage of its versatility and fit a moderately long-focus lens, perhaps 100 or 150 mm. This will enable you to move off and take your pictures of individuals at your leisure without disturbing their activity – or inactivity. An excellent alternative is a zoom lens covering a modest long-focus range. From your reasonable distance, made possible by the long-focus lens, you can view your subject (probably an unwitting one) and take very natural full-frame studies bringing out personality and character. You have to be careful sometimes with reflected light in a street, especially if a wall which reflects sunlight into a shade is not white in colour. Human faces lit by sunlight reflected by a blue wall can take on a rather strange blue tone. Similarly, beside a reddish wall a person may seem to be blushing, and intense green foliage can make a person look rather unwell.

Travellers in a foreign country often like to photograph some of the local inhabitants together with tourists. At the end of a happy holiday, for instance, it has become common practice for guests and a few local friends to line up for a photograph. If you want to include yourself, find a convenient wall or table and make use of the camera's delayed-action facility. Probably a superior way of involving local inhabitants and visitors in souvenir photographs is to take these at some function where all are involved. To photograph waiters and fellow-travellers participating in Greek dancing at

A well-composed study
taken at Windsor Castle on
a foggy day, when most
people are not thinking of
photography.
Monochrome. *Raymond
Lea.*

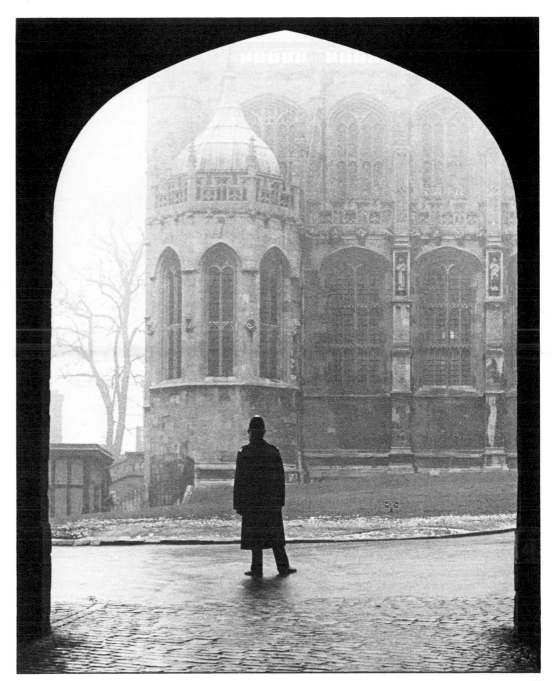

the taverna, simple on-camera bounce flash can give reasonably satisfactory results, as long as the people photographed doing the Syrtaki are sharply focused and also fairly close to the camera. Auto focus could again help in this case.

The thoughtful travel photographer will bear in mind, when considering local characters, the advantage of using some sort of frame. Curving trees, stone archways and open gates can often form a most attractive border round the human figure who is the main subject of the picture. One of my favourite Rhodes photographs is of a shoemaker working away, framed inside the open doorway of his shop in the picturesque old town. Naturally I took the picture at a long-focus setting from a position halfway across the quiet street.

Spontaneous shots

One of the pleasures and challenges of travel photography is the capturing on film of events as they happen. During a journey, especially in an unknown region, the photographer should be prepared for anything to occur. Some of the most successful photographs taken during travels are those which record totally unexpected events, or photographs which document fleeting expressions or brief and ephemeral moments of beauty and wonder. There is admittedly a special joy in meticulously preparing a fine visual composition, taking all the time over it that is necessary, and feeling a near-certainty that you have a winner on your hands. But there is just as much pleasure to be gained by seizing the opportunity of capturing on film an event which is over in a flash and will never recur.

This recording of actuality raises technical problems. If something worth photographing suddenly begins to happen, you surely can't whip out your camera and press the shutter release? Isn't the resulting picture bound to be out of focus, badly framed and wrongly exposed, and certain to suffer from camera shake caused by haste and excitement? Look at all those futile photographs of

flying saucers and Big Foot and the Loch Ness Monster: not a single one is sharp and clear. Assuming charitably that such manifestations exist, it is obvious that extraordinary events are often too much for the photographer to cope with. In the heat of the moment there simply isn't time to get ready, and excitement makes things worse.

Strangely enough, the owner of a cheap and cheerful sub-miniature fixed-focus and fixed-aperture pocket camera, using disc or cassette, might seem here to have the advantage over the expert user of a sophisticated and comparatively expensive reflex camera with manual override, interchangeable lenses, alternative focusing screens and the rest. The snapshotter is accustomed to casual photography: all he needs to do is point and shoot, sublimely confident that the processing house will do the rest. His camera has a wide-angle lens with a small aperture, set for optimum results on a sunny day for object distances ranging from about 1.5 m to infinity. Long experience has shown

Above: a delightfully natural study of children, taken in Thailand. The young people are conscious of the cameraman, but are friendly and uninhibited. *Archie Reid.*
Right: Independence Day in Haurez, Peru; 135 mm lens. A striking picture, revealing how children can be exploited and corrupted by militarism. *Jim Standen.*

that in a remarkable number of cases this works well enough to please the users. It can work, too, in a sudden eventuality.

This, of course, is making the big assumption that less-than-perfect picture quality and strictly limited picture size is all that the user expects, and that he doesn't mind the possibility of inaccurate exposure, distorted close-ups and poor framing of the subject. The fact is, as any SLR camera owner knows, that even the most advanced and versatile camera can easily be set in advance to meet sudden contingencies. If your aperture-priority 35 mm camera has a standard 50 mm lens, for instance, you can keep the camera at the ready on a sunny day with the aperture set at $f/11$ and the focusing ring at 5 m, secure in the knowledge that anything or anybody photographed at any distance from 3 m to 15 m will appear sharp and correctly exposed in a photograph. Better still, if you set the aperture at $f/16$, the depth of field will extend from about 2.5 m to over 100 m. With a wide-angle lens of 35 mm focal length, at $f/11$ and a focus setting of 5 m, your depth of field will extend from just over 2 m to infinity. Of course these figures apply equally well to the use of a moderate zoom lens at either of these focal-length settings.

There are other ways of dealing with spontaneous shots. The event which you half-expect to happen at a certain place gives you more time to consider, and takes away some of the hit-and-miss element. If a child is gently whirling round and round on a playground roundabout, you can set your focus accurately during one circuit as the child passes you. If you are using a zoom lens, you should normally do your focusing at the maximum telephoto setting. Owing to its limited depth of field at top focal length, focusing is critical and positive, and you can subsequently bring the focal length down to what is appropriate. All this takes less time than it takes to tell. The same procedure applies if you are expecting a person or animal to appear in a doorway or at a street corner. Focus accurately on the doorway or corner itself, set your focal length,

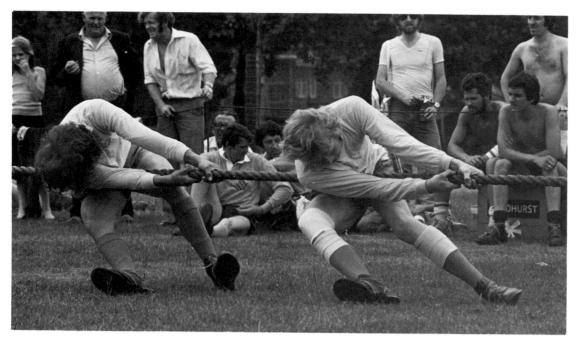

Left: a strenuous shot of participants in a tug-of-war contest. Taken with a 45–125 mm zoom lens at a long focal-length setting. Monochrome. *Brian Gibbs.* Right: a low-angle action shot of a water-ski jumper, taken with a 300 mm lens. Manual override necessary to overcome the effect of the bright sky. Monochrome. *Brian Gibbs.*

and wait. Of course, if you haven't a zoom lens you will frame your expected image in advance by moving bodily backwards or forwards.

All sorts of situations can involve you as a travel photographer in rapid decisions. Sometimes these can be in a quite calm atmosphere. In an open-air café on a Paris pavement there is plenty of opportunity for planning quietly while your friend is busy with her pâté de foie gras. Move away to a few metres' distance and focus on her from there, using the maximum telephoto zoom setting. Then widen your framing angle a bit and choose a pleasant moment for shooting. The slightly wider angle will ensure a greater amount of sharpness in front of and behind your subject.

It will be clear that the use of a moderate zoom lens is favoured here for spontaneous shots. Of course, this does not imply that a lens of fixed focal length (standard or wide-angle or medium telephoto) is not usable for these swift circumstances. It is merely

suggested that any one of these lenses is not necessarily the best one for every situation, and that it takes time to change. For example, if a man used a 28 mm wide-angle lens to photograph his wife at a café table from his seat opposite her, he would get few thanks from her when the uncomplimentary picture came up on the screen at home. Close-up wide-angle portraits are not all pleasing. Similarly, a telephoto lens on its own would not be suitable if you wanted a shot of the general restaurant scene.

Two different kinds of zoom lens are available, and each has its protagonists. The more traditional type has two operating rings: one for focus and one for focal length. At maximum focal length you set your focus through the camera lens, then you adjust your framing of the image by means of the focal-length ring. The other type of zoom lens is the so-called 'one-touch' kind, which you operate in one movement of one hand. Some people are inclined to favour the older system, as with it they feel more confident that the focus is going to stay put while

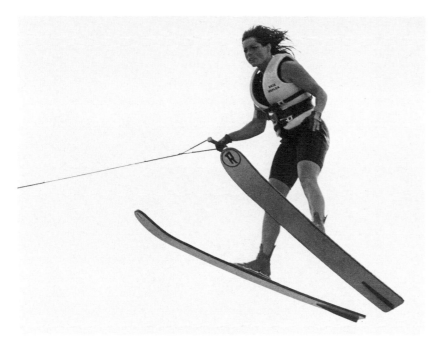

they adjust the focal length. However, there is slightly more speed of operation with the one-touch zoom, and with care the focus should stay in place. Another helpful refinement is the automatic-focusing facility already mentioned, and the owner of an AF camera has one adjustment taken out of his hands. In many cases this works admirably, and leaves you free to concentrate on the artistic and personal aspects of your photography.

Action photography

On many occasions the travel photographer may have to cope with events which are not only unpredictable but also very fast-moving. Action photography, or photography of a person or object moving rapidly, is a fascinating aspect of the hobby, and one which claims the attention of many travel photographers. You will frequently find rapid movement taking place when you are watching a sporting event. Where people predominate, as in football, skating, swimming, golf, athletics and so on, the most interesting aspect

for many spectators and for viewers of photographs is the physical effort expended by the participants. The travel photographer who comes across a swimming event in California, a cricket match in Corfu or an athletics meeting in Germany may find the protagonists' facial expressions fascinating, striking or sometimes comical. If you are attracted by the idea of isolating some of these fleeting glimpses of human endeavour, you will really need a long-focus lens.

Your camera should ideally have a shutter-speed range extending as far as 1/1000 second, and it might be as well for you to use fast film, perhaps ISO 400/27° or 1000/31°, rather than the conventional ISO 25/15°, 64/19° or 100/21° type. Fast shutter speeds will help you to freeze the action, if necessary, and fast film will enable you to use a small aperture, thus increasing your depth of field and easing the sharpness problem.

The advantages of a telephoto lens for personal action photography are obvious. It is unlikely that you as a spectator with a camera at an outdoor event will get anywhere near the faces of the contestants. At a football or hockey match, spectators are generally permitted to photograph from the grandstand and perhaps even from the touchline; but with a fairly short-focus lens as fitted to a compact camera, or with a standard lens on an SLR, facial expressions will seldom come up clearly enough, even if you enlarge the picture many times. A zoom lens would be very convenient in such a situation, and in this case a wide-ranging zoom, with focal lengths extending from, say, 80 to 200 mm or more, is most useful.

It is all too easy to convey in your action photographs an impression of speed. You can simply hold the camera still and allow the moving figure to slip past indistinctly. Alternatively, you could concentrate on keeping the running subject sharp and let the background subside into a blur. Although either procedure effectively gives a feeling of rapid movement, most people prefer to keep the

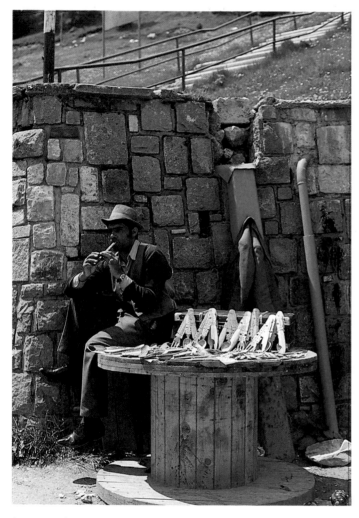

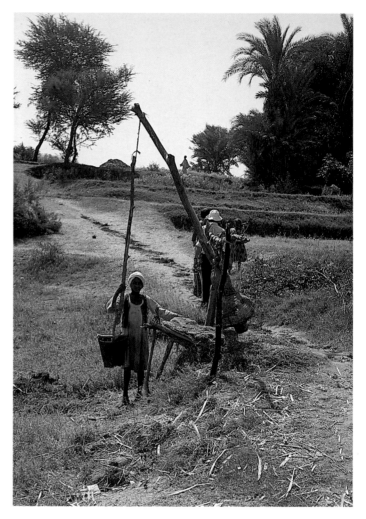

A street trader in Romania playing his flute to attract customers. His wood carvings are on display beside him. *Glen Aitken.*

Luxor, Egypt: the shaduf in a banana plantation; a primitive method of irrigation still widely used in the Third World. *Edward Archer.*

A low-level shot of a window-cleaner at work in Mexico City. Interesting architecture enlivened by the human touch. Long-focus lens. *Jim Standen*.

contestant sharp rather than the background. To do this, pan your camera smoothly with the runner, gently press the release at a suitable point in the action, and follow through – that is, continue to pan a little after the exposure. Frame your subject so that there is more space in front of him than behind, and he will not seem to be running out of the picture.

When planning to photograph any sort of action event, a good procedure is to prefocus your photographs. If you take up a position where there is a strong likelihood of strenuous action, say at a football goalmouth or at the bend of a race-track, you can focus your lens carefully during an early stage in the event, and the wait in readiness for something to take place at that position. With a telephoto lens or long-focus zoom lens, this prefocusing is advisable because of the limited depth of field involved. Any event which is repetitive, such as show jumping or a gymnastics display, can easily be prefocused. An athletic action often has a peak point, and the photographer can sometimes concentrate on this. There is the moment when the high jumper seems to pause for a split second above the bar. If you prefocus and watch a few contestants first, you will be able to see just when that moment occurs. It is usually a good idea to anticipate the moment very slightly, releasing the shutter just before the peak point rather than exactly at it: this allows for the time taken to press the button.

Some experienced photographers prefer to do things the hard way and 'follow focus'. They get accustomed to keeping one particular contestant in view and controlling focus through the viewfinder all the time. The result can be a most interesting series of studies of one person in action.

Many of these procedures can be used with such mechanised events as car racing, motor cycling, water-skiing or tobogganing. Here higher speeds are involved, and the photographer has to be on his toes if he wants to capture participants in the act.

If the event you wish to photograph is indoors, your best hope of well-exposed pictures is if the lighting is very intense, or if you have a wide-aperture lens and a steady camera support. Medium telephoto is here preferable to long; the latter type of lens has an aperture smaller than $f/4$ as a rule, and this makes low lighting harder to cope with. Portable flash in a large interior, despite the fond faith of a surprising number of snapshotters, is almost bound to be useless, and irritates spectators into the bargain.

Many kinds of action photography lend themselves to a series of pictures in rapid sequence. This can apply, for instance, to the final length of an exciting swimming race, or to a tug-of-war contest. It is not normally easy to carry out this kind of swift-motion photography. However, designers have come up with two solutions. The rapid winder is the simpler of the two. This device, battery-powered, releases the shutter and immediately winds the film on. With it you can portray the changing expressions and positions of, say, a wrestler or a weight-lifter every two or three seconds. The motor drive is a more versatile unit. It is capable of exposing up to five frames a second, and the resulting images represent a continuous action rather than stages in a process.

People at work
The traveller, whether in his own country or in a foreign land, sometimes neglects one of the most fruitful sources of good photographs. In his anxiety to do full visual justice to places of interest, and to his travelling companions and off-duty local characters, it is a pity if he omits reference to daily tasks. People at work reveal much about the character of a country. In addition, a person busily occupied can form the subject of a fine photographic study which is pleasing in itself.

Possibilities in the open air are endless. At the harbour there is the boatman pouring fuel into the tank of his motor boat; the fisherman hanging up a net to dry in the sun; the boat repairer

sandpapering a plank outside the boathouse. In the park there is the gardener tending a cactus plant, or wheeling away a barrowload of autumn leaves, or watering the flowers in the evening light. In the village there is the vanman balancing a board of fresh loaves on his head; the workman clambering up a high ladder to reach the church steeple; the woman feeding chickens or washing the doorstep; or the man painting a fence or sawing logs. These conventional facets of everday life tend to be overlooked by many of us when we are strolling through a foreign town or village with a camera. Nevertheless there are fine pictures latent in many a conventional situation, and it is surprising how many excellent photographs involve merely a man or woman at a day-to-day task.

On the farm the occupations are rather less familiar to the average person than in the town. Very often the relationship of the farm people with the land and with the animals is the key to a whole series of absorbing photographs. As in so many other aspects of travel photography, a close approach – or better, the use of a long-focus lens setting from a fair distance away – can be a secret of success. Although some of the sheer poetry of the harvest field, with the farmer's entire family at communal work, seems to have gone with the onset of mechanisation, there is still plenty of scope there for the photographer with a seeing eye.

The modern mechanical age has had its effects also on craft workers, who rely so much now on machines to perform tasks at high speed and with little scope for romance. However, the photographer often feels grateful that there is a lively trend towards the retention or revival of some of the more picturesque of the old crafts – not least because it is being belatedly discovered that the hand-made product often turns out to be a superior one. The man working with a knife on a piece of wood, or beating out a red-hot door hinge, or blowing a wineglass, easily becomes the object of our attention, and a close study of his involvement with his materials and tools looks well in a photograph, especially if the man is apparently unaware of the fact that he is being watched and photographed. Even an extra-close shot of his hands at work can form a first-rate picture. A photograph of a blacksmith hammering at the hoof of an uncomplaining horse was at one time an all-too-familiar cliché; nowadays the scene is so rare in developed countries that a picture of the man at work in the red glow of his forge can hardly fail to be attractive.

From the main street of Sorrento my wife and I noticed that every day a man was working at the construction of some of those fine inlaid tables which are the specialism of that town. The attractive thing was that the man worked in the open air, pleased to let the whole world see his work in progress. In Rhodes we enjoyed watching men making shoes, and women at their intricate lace-making, not in factories or even in workshops but in open doorways and in shady corners of the streets. Photographs of these and many other crafts are nearly always worth taking.

Even if a craft has long ago undergone a small measure of mechanisation, the solitary worker at the machine can be fascinating to look at. One example of this is the spinning wheel, to many an object of beauty in its own right, and completed by the presence of the countrywoman working with it outside an Irish cottage. Simpler machines, but hardly less ingenious in their way, such as the Archimedes screw and the shaduf and other irrigation devices, are often found in operation in North Africa and the Indian sub-continent. Most pictures of craftsmen and women at their work benefit by being photographed in the open air, or partly indoors, by available light rather than with the aid of flash. There is a naturalness about existing light which suits the subject of a person at work, especially when that work is traditional; and a sort of chiaroscuro can be an apt feature of the photograph. I found several opportunities of this kind in Holland; good shots of the making of cheese and clogs can be obtained with ease.

If you go right into a workshop for the purpose of photographing work in progress, if the available artificial light is adequate for the workers it should be enough for the photographer with a good camera and fast film, without the aid of a tripod which might get in people's way. With fast colour film and a maximum zoom lens aperture of $f/4$, I find that I can obtain successful photographs at a shutter speed of 1/30 second in such circumstances if I lean my camera or my arm against some support such as a pillar or bench. To photograph in a workshop you might find it impossible to squeeze in the general scene with a standard lens, and a lens of 35 mm or even 28 mm focal length could be necessary for that kind of wide shot. On the other hand, to fill the frame with one worker at a skilled task, you would require to have a medium telephoto lens, in order to avoid disturbing people or getting too close to a process involving danger or discomfort for yourself.

It could be that your approach to photographing industry is a totally different one from that of simply recording how things are done. Sooner or later many travel photographers begin to get tired of the photographic cliché – of picturing people and places conventionally from usual viewpoints. Instead of contenting yourself with recording people at work in a factory or in a workshop, you might want to show in your photographs the impression the place made on you. You begin to look for things like line, texture and modelling; you search for subtlety in viewpoint, angle and lighting; you find original ways of bringing out characterisation in face and figure; you learn how to dwell lovingly on an unexpected juxtaposition of colour and detail and shadow. You are discovering the joy of pictorial creativity. Even parts of machines, without the workers, can look extraordinarily fascinating, and many creative photographers look for intriguing patterns and balanced shapes in mechanised subjects.

The trouble, however, is that the artistic photographer's spurning of the conventional cliché

can turn out to be surprisingly unpopular with people in general who view his efforts. A majority of the public undoubtedly enjoy looking at conventional views on picture postcards. In many cases people are only bewildered by a photographer's experiments in self-expression and creative interpretation. Indeed, most of us can derive a good deal of pleasure from browsing through a coffee-table book of conventional portraits and landscapes embodying no great pretensions to subtlety. But occasional abstract studies have their place in travel photography.

This is a matter for the individual to decide. Do you wish to please large numbers of viewers with pleasant and maybe predictable vistas and portraits, or do you prefer to express yourself freely with your camera, come what may? One thing is certain. Travel provides plenty of scope for both.

Markets and fairs
All over the world the great regional gathering-place has always been the weekly market or the annual fair. The travel photographer has reason to be grateful that markets and fairs still exist and that they will doubtless continue into the foreseeable future. You probably do not have to travel very far from your home to reach a market of some kind. Across the road from our house is an old-established livestock market, and a visit to it on any market day cannot fail to be a fruitful source or lively, unusual, amusing and colourful scenes. There are trailers, small vans and massive juggernauts being unloaded. The loads can vary from large sacks of potatoes to entire flocks of sheep; from crates of chickens, ducks, turkeys and guineafowl to open boxes of turnips, apples and bananas; from prize-winning bulls to second-hand bedsteads. It would be surprising if from all these treasures the photographer at a market was unable to see much to record on film.

Then there is the bull-ring. This rather ancient circular building in Lanark market houses a circus-like arena where the animals are brought in

A splendid study of two
Swiss men in national
costume relaxing after the
parade. Taken from a low
angle. *Archie Reid.*

one by one to fall (metaphorically) under the hammer of the auctioneer. The glass-windowed roof allows in quite sufficient sunlight for available-light photography, and from a seat in a back row above the arena you can obtain a variety of splendid shots. At a wide-angle setting of your zoom lens you can just take in the entire ring, with the young lad driving the massive brown-and-white beast round and round: you can capture the scene while the bull is well placed in your viewfinder, and also while the auctioneer is in full vocal flow, hand raised in anticipation of a final bid.

Some other interesting shots are the closer personal ones. Many farmers are full of character. A group of them, healthy faces alive with interest or even excitement, is at the front railing of the bull-ring. You can sidle down unobtrusively alongside them, a fair distance away. Point your camera here and there from time to time, and while you are at it, set your zoom at the telephoto end and focus on the group. Then when a glance reveals that the men in the group have become particularly animated, with their eyes on the animal which is being demonstrated, raise your camera casually and take a shot, or perhaps several. One at least is bound to be worth having.

Other buildings and open areas in the livestock market will repay a visit. There is the area where pigs are penned, and the cliché shot of six piglets at dinner is an irresistible one. This time, try the short-focus end of the zoom range, and get in really close. The vast sow, her magnificent snout raised, will not object to a bit of photographic distortion caused by the short camera distance, and that amount of distortion will add humour to an already amusing situation. Then there are the calves, the motherless lambs, and so on.

Colourful markets abound all over Europe. I have been specially pleased with shots taken at markets in Korcula, Dubrovnik, Cavtat and Mostar, all fascinating places in Yugoslavia. In Korcula the open-air market is at the foot of the grand staircase,

and is highly colourful and attractive. Dubrovnik market can be well photographed with a wide-angle lens setting, in an almost aerial view; it is an animated scene, chock-full of interest. The market at the attractive seaside village of Cavtat is delightfully placed under the trees, and is notable for the hand-made garments hanging enticingly from the lower branches. Mostar, the Turkish-flavoured inland town, has a market with rather exotic spices on display: here I found a macro lens allowed me to get in very close to an open tray of spice with a suitably undecipherable label.

Holland has its famous cheese markets at Alkmaar and Gouda, with people milling about in traditional dress; Venice has markets with particularly vociferous salesmen and women; Amsterdam has a market specialising in flowers, with the distinction that the stalls are on boats in the canal; and we found the street market at Heraklion in Crete to be one of the most boisterous of all, teeming with cameos – a man carrying a side of beef on his shoulder; a boy pushing a trolley with a dozen suits of clothes; a plump barman carrying a barrel of wine in two hands with swift determined stride. Subjects for candid photography are everywhere in such a market. In Paris we found splendid markets in several parts of the city. One featured cheeses of wondrous hues and at various stages of decomposition, and also fish on slabs with unprepossessing wide-open jagged-toothed mouths. But the market that absorbed us more than any other in that matchless city was the one at Montmartre, where hundreds of sketches and paintings were on sale, products of the renowned artist's quarter – some garish and tawdry, some quite superb.

The traveller to faraway places will find endless possibilities in the markets. In West Africa very often the market is practically the major part of the town, and seems to extend for miles. The Souk in North Africa is filled with animation and argument and remarkable characters flourishing hands and money. Thailand's fabulous floating markets

should not be missed by the visitor to that enchanting Oriental land: fine photographs can be taken of the laden boats from high positions on the shore. Fresh produce is sold daily in the floating markets, where farmers and dealers and shoppers amicably congregate. Bangkok and Damnoensaduak floating markets in particular throb with life, and the boats group themselves into fascinating patterns and shapes. The start and finish of a market day are equally worth recording. Many interesting shots can be taken of effort expended during the erection of stalls, and an atmospheric picture can be based on the rather desolate windblown scene after the last buyer has departed.

The slight danger for the travel photographer is that in his enthusiasm to capture a multitude of aspects of the ever-changing scene, he neglects to take time to think about techniques. A general shot prominently featuring a stall crammed with flowers of every hue can turn out strangely unsatisfying. The trouble is that all too often there is just too much colour. The camera at a wide-angle setting takes it all in at one go, and often the varied hues of a market stall can be just too much for one picture. The remedy is to use a longer focal length, or else get in closer. Confine one picture to just a few colours, and if possible colours that blend easily and do not clash. Quite possibly the orange and green striped awning over the flower stall clashes violently with the red and blue flowers below, and with the stallkeeper's brown apron. In fact, some of the most jarring colour clashes occur when man-made materials come up against colours of nature.

The annual fair can have even more photographic potential than the weekly market. Traditionally this has always been an occasion for sideshows and general jollification as well as for the exchange of goods, animals and sometimes servants. Every year in New Lanark that historic village relives the past in a Victorian Fair – a splendid occasion for the photographer. Everyone visiting the village for the afternoon is expected to enter into the spirit by wearing Victorian costume. There are toffee-stalls, roast-potato merchants, pilloried miscreants, fortune tellers, mischievous urchins offering to blacken your boots, and so on. You can run through a film in no time.

Folklore and festivities

The globetrotting photographer usually regards it as a distinct bonus if during his travels a festival or procession or celebration of some kind takes place. Villagers and townsfolk alike love to seize the opportunity to don their regional or national costumes and take part in the event. The passing photographer will likewise seize the opportunity to record something out of the ordinary, involving extravagant pageants and big parades and lively merriment.

In Britain there is a proliferation of festivities throughout each year. To pick on a few quite arbitrary examples from hundreds: in April there is a Jousting Tournament in Kent; May sees the Spalding Flower Parade; in June Lanark has its famous Lanimer Day procession; in July there are at least twenty Highland Gatherings in the north of Scotland; in August there is the world-famous National Eisteddfod in Wales; and September is the month of the great Edinburgh Festival of Music and Drama, with memorable indoor and outdoor events. People everywhere love a celebration, especially if their everyday lives tend to have a certain sameness; and the alert photographer travelling through any country will find a multitude of opportunities for securing bustling, colourful and often extraordinary pictures when a festivity is on.

Costumes in a festival are designed to looked at, and may be superbly preposterous or tastefully neat and bright. When a parade is in progress, a zoom lens is extremely useful. You may wish to capture the massive sweep of the long procession winding its way down the main street, occupying it from side to side; you may also, perhaps in the same

moment, want to obtain a cameo shot of a small child in the crowd at the opposite pavement's edge with a face full of laughter and ice cream. A couple of seconds are all that is needed for a swift push of the zoom to maximum telephoto and a sharpening of focus, and you have got both pictures with little effort.

The great thing about a Gala Day is the fact that inhibitions are everywhere cast aside; folk are at their ease and determined to let nothing spoil their fun; and no one cares whether you are pointing a camera or not. The real difficulty at times is to obtain a good view of proceedings in the street from your position in the crowd. Tall photographers have the advantage, and if you are of only average height you might have to resort to second-best subterfuges such as holding your camera up high, at a wide-angle lens setting, and shooting blindly over people's heads, with the camera held as steadily as is possible. Certainly there is a reasonable amount of goodwill around on a festive day, and maybe people will let you squeeze past them to the pavement's edge for your pictures.

Everyone has favourite festivals. For sheer bonhomie and brotherly affection, I should say that the Munich Oktoberfest is hard to beat; but a lover of the Channel Islands would press instead the claims of the Battle of Flowers, while those who are fond of Italy would suggest the many spectacular processions and street races which are annual and eagerly-anticipated events in that country. Spain and France have their renowned religious festivals, and the Shetlanders' Up-Helly-Aa is quite unforgettable, with its great nocturnal burning-boat spectacle.

Among the finest festivals of all are those of India — the fantastic 'car festival' at Puri, the snake-boat races of Kerala, the striking Republic Day Pageant in Delhi, the wonderful Floating Festival at Madurai, and the amazing Kumbh Mela, with its seething throngs of participants, which takes place every third year. Thailand and Bali have their own

famous celebrations which are breathtakingly spectacular, some with gigantic home-made rockets, others with monstrous effigies, and one, the Loy Krathong, with incense-burning lanterns floating like lotus flowers along the rivers.

Many photographers wish to take full advantage of these and other splendid celebrations. As with sporting occasions, the main thing is not to be swept away by the excitement of the event, and to remember accurate focusing and steady hand-holding all the time. The modern automated SLR camera will certainly look after exposure with remarkable consistency as long as you play your part by attending to the lighting and the framing. If some of your shots include a good deal of sky, take time to decide whether to open up by a stop or two or whether you want a silhouette and perhaps a sunbeam effect. Take plenty of individual pictures of people, preferably using long focus, and bearing in mind the fact that at a telephoto setting, focusing is more critical and camera shake more likely.

Dancing is one of the most popular and enduring of all folk traditions, and it has the added attraction for the photographer that very attractive costumes for both men and women are a feature of most traditional dancing displays, often held in the open air in an evening. The main difficulties are freezing the action and making sure that there is enough light. Unfortunately these two factors tend to work against each other: to freeze the action you will want to use a fast shutter speed like 1/500 or 1/1000 second, and this necessarily involves the use of a wide aperture, which reduces your depth of field. The peril is that you will get your dancers out of focus. If the light is fairly low, on the other hand, you will want to set a slower shutter speed, and this will not let you get a clear image during the swift movement of the dance. One remedy is to use fast film. A film with a sensitivity of ISO 400/27° or 1000/31° will give you a much better chance of using a reasonably fast shutter speed together with an aperture that is not too wide for good depth of field.

Many amateur photographers automatically seem to regard the folk-dancing display, especially in an evening, as an occasion for the use of flash. One evening in Plat, a resort near Dubrovik, there was a special dancing display which we watched from across the open-air swimming pool after dinner. The show was colourful, skilful and quite splendid, but was marred to a certain extent by a dozen over-enthusiastic photographers who kept creeping up round the pool towards the platform and flashing away unceasingly with their electronic units. Apart from the fact that all that flashing of lights was disturbing to the dancers, I very much doubt if the light provided by the basic on-camera equipment used by all those snap-happy photographers was going to make any difference to the eventual photographs.

On some public occasions, flash photography is naturally forbidden. Its effect on a theatrical performance, for instance, would be intolerable, apart of course from the fact that the light it provided would be woefully inadequate for the photographer's purpose. In a circus, flash could have a dangerous effect on performing animals, or indeed on acrobats. As a matter of fact, it is quite possible to obtain acceptable colour photographs from a circus seat by available light, with ISO 400/27° film balanced for artificial light, and a zoom lens ranging up to perhaps 105 or 150 mm, using a shutter speed of 1/60 second. It is easier still with ISO 1000/31° film. Choose moments when the performers are reasonably static, and you will not have to worry about freezing the action. The lighting in a circus is fairly bright, as it is for many stage performances, particularly lavish costumed musicals. In the theatre it is sometimes possible to obtain special permission to take photographs by available artificial lighting on the occasion of a dress rehearsal.

The personal factor
The photographer who is interested in people rather than in places is frequently faced with problems which do not trouble the landscape photographer. There is a special relationship between the person behind the camera and the person being photographed, and this sometimes calls for diplomacy, tact and tolerance on the part of the photographer. Many people whom you come across in your travels are only too delighted to be photographed. In a lonely Tyrolean valley an elderly lady, a solitary traveller, came up to us with her camera and asked in French if I would take a picture of her. In an olive grove in Greece several women working there saw us passing; one of them indicated my camera and pointed to her companions, and they all seemed delighted to be photographed at their work. At a stall in Lindos village in Rhodes, my wife had just completed the purchase of a dress when the stallkeeper, a plump and cheerful lady, posed arm-in-arm with Ishbel and asked me in Greek to take a photograph while she beamed endearingly. Many of us have experienced this kind of happy situation. It is easy to understand the eagerness of the person who hands you a camera; it is a little more difficult to follow the motivation of the stranger who wants to appear on one of your photographs which he or she will never see.

It is rather surprising how tolerant of the camera people living in out-of-the-way places can be. There must be few areas now where the camera is an unknown quantity, and in regions of scenic beauty the local inhabitants are usually only too familiar with the eager tourist with his battery of equipment slung around his shoulders. Most people dislike being stared at, and yet many show no distaste at being singled out for the attention of the baleful eye of the SLR. This readiness to pose can bring its worries to the photographer. There are places in the world, indeed, where it is quite usual for the subject of a photograph to demand payment for his services, and it is difficult to avoid acceding to his request.

Sometimes it is wise to ask permission before photographing someone, though this can cause embarrassment where the prospective subject has a

shy disposition. Many experienced travel photographers decide to be patient, and keep the camera in its case for quite a while as they win the confidence of the subject. A friendly smile is often followed by a brief chat, assuming that there is no insuperable language barrier – in fact, if you use the native language this will probably break the ice quite happily. If your prospective subject is busy, perhaps painting a boat or setting a table in an outdoor café, it might not be necessary or advisable to involve him or her in conversation. Just produce your camera and suggest with gestures that you would like to take a photograph, and in all probability your subject will smile and agree.

On the other hand, some people dislike or even resent being photographed. Near the Byzantine castle above Paleokastritsa in Corfu, I was making my way with my camera along the winding path when an old man in a field gave me one glance and shuffled off into the shrubbery. Maybe he just didn't like the look of me, but I prefer to think he distrusted the camera. In some remote areas of the world, indeed, the inhabitants go as far as to fear the 'evil eye' of the camera, believing that the lens can do them bodily harm. It goes without saying that it would be folly for the traveller to insist on taking photographs in such circumstances.

There are, of course, ways of taking photographs unobtrusively, and two of these have been mentioned already: setting your camera for an average distance with wide-angle lens and casually taking the occasional photograph, perhaps without even looking through the viewfinder; or retreating to a safe distance and using a long-focus lens. If you have recourse to either of these procedures with an unwilling subject, it is advisable to act with care. The last thing a travel photographer should do is to cause offence to people in their own country. With local children, any difficulties are of a different kind. High-spirited children do unpredictable things, sometimes putting on absurd expressions for the camera which would be photographically unacceptable in an adult, but which could be

A haunting and appealing study of Hanka, a sad-eyed little girl in Western India. This photograph has been widely used for charity purposes. Supplied by courtesy of Guy Stringer, Director-General of Oxfam.

perfectly satisfactory, indeed highly amusing, in a child. It doesn't matter if the young subjects beam at the camera; the intimate result can on occasion be just right, perhaps in a tight close-up with a medium long-focus lens setting.

There is a special sort of difficulty in taking photographs in areas of poverty and deprivation. The photographer's aims might be very laudable; he might wish to cover 'the whole country' rather than merely the bright surface presented to tourists. His distressing pictures of slum children in Naples or an emaciated baby on its mother's lap in Calcutta could well have the effect of arousing compassion – and better still, action – on the part of people at home. But the fact remains that deprived people are often sensitive, and may want to remain in the background rather than act as a centre of attention.

However, if the travel photographer's motivations are genuinely ethical, and if he uses care and discrimination in his selection of subjects, he could be doing nothing but good. He might wish to give publicity at home to certain disturbing aspects of social life in the Third World. Perhaps he has encountered these by chance during his travels; or perhaps he has travelled deliberately in order to encounter them and document them in photographs. The photograph is often the ideal medium for this kind of message. Most thinking people have certain cherished beliefs and convictions, and it is only human to wish to disseminate these to others. Every picture tells a story, and a vivid photograph or series of photographs can convince where words might be ineffectual.

An outstanding example of this kind of social commentary was that organised between the World Wars in the USA by the Farm Security Administration. The appalling living conditions of impoverished farm workers at that time were photographed by an energetic and talented team, and publication of those photographs in magazines

and newspapers resulted eventually in the enforcement of a humane assistance programme. A more recent instance of the influence of travel photography on the course of history occurred in the Vietnam War, where photographs and films of the terrible events taking place had such an effect on American public opinion that many believe they played no small part in the final decision to withdraw. Photographs and films of tragic events in Ethiopia and other distressed areas such as Kampuchea have also had incalculable effects on public attitudes. Reputable charity organisations such as Oxfam have long ago learnt the very great value of the work of good photographers on location in many parts of the world in helping to build a public awareness of the needs of deprived people. It should be added that many people who start out with the intention of simply taking vivid photographs in conditions of disaster, famine and war, with no very deep social or ethical purpose, end up by being profoundly involved in the cause of the unhappy people they have been photographing.

Nature and the camera

Nature has provided the world with a profusion of beautiful colours, shapes and textures in the flowers and plants which are to be found everywhere. To the traveller with a camera and colour film, this is a gift to be exploited on many occasions. Flowers provide a superb background to innumerable pictures, but in addition flowers themselves have always formed subjects for fine photographs.

Plants and flowers
The visitor to the Netherlands who happens to have timed his visit for early summer will be able to witness the spectacle of the bulbfields. Great masses of resplendent blooms stretching to the far horizon are there to be admired and photographed, once a viewpoint has been found in that flat country – perhaps from the top of a convenient windmill. But there is the vital factor of colour blend and harmony to consider. It is no part of the purpose of the bulbfield owners to set out their plants to please the photographer. The question is, does all that vast tract of red or yellow tulips make a picture? Or does it merely amount to monotony?

The prospect is somewhat better in an extensive formal flower garden or horticultural estate. Here it is likely that care and artistry have been devoted to planting the flowers in a way that is delightful to the discerning eye, that colours have been deliberately mingled and matched to the finest possible effect, and that excellent viewpoints have been provided. The subject is ready-made for the photographer, and all he has to do is record it with his camera. His task is to capture the hues and patterns to best effect, utilising the contours and the natural and architectural features of the neighbourhood to form a pleasing setting for the masses of plants and flowers: in fact, to create a picture.

There are few technical problems in taking this kind of general floral scene. A wide-angle lens setting, 35 mm or smaller, serves in many cases to strengthen the image, with flowers a couple of metres from the camera and a church spire on the distant horizon appearing equally sharply in the photograph. For optimum clarity many photographers would choose ISO 64/19° or 25/15° reversal film, with clear or diffused lighting from the sun directed from one side, providing a certain amount of modelling for the nearest flowers. There are other photographers who would not even contemplate taking such a picture. To them, each single flower or plant is much more pleasing and interesting than hundreds of blooms in a solid mass. In any flower garden there are opportunities for composing a picture comprising one floral item, with perhaps human interest to complete the scene. Many cities and towns have fine parks with botanical gardens, containing glasshouses in which there are no restrictions on photography. In Glasgow Botanical Gardens, for instance, the daylight entering the tropical plant-house is perfectly satisfactory for available-light photography of the exotic flowers and plants to be found there.

In most cases the travel photographer is concerned with plants of the wild variety rather than in gardens. There are many wonderful Alpine meadows resplendent with beautiful blooms, often of a minute size. In early summer we found a glorious array of hues and shapes among the wild flowers at Mürren in the Bernese Oberland, and high on Monte Baldo above Lake Garda: and of course very many other holiday regions are filled with floral colour at the appropriate season. I can vividly recall the enchantment of the blossoms on the shores of Lakes Maggiore, Como and Lugano, of bougainvillea around the entrance of our small hotel in Puerto Pollensa in Majorca, of resplendent bright yellow gorse high above the five lovely bays of Paleokastritsa in Corfu, and of oleanders almost everywhere on the island of Rhodes. Travellers to East Africa, India and Australasia and the Far East

know of many favourite and spectacular floral locations.

With a standard lens at closest focusing distance it is possible to photograph a single flower if the latter is of a fair size – say the yellow flag iris. It is very important that the setting should not distract. With light-petalled flowers, the background should if possible be dark to set off the blooms, and there should not be confusing detail anywhere in the picture. A certain amount of 'gardening' might have to be done – that is, clearing away plants or grasses that come in front of the main subject. This should not, of course, damage in any way a picturesque environment. Lighting should not necessarily be bright and frontal. Many of the finest floral effects involve diffused lateral sunlight. Translucent petals illuminated from behind can also look very attractive, with the plant outlined with a thread of light.

The best way of ensuring that the main subject stands out clearly from the background is to use a long-focus lens setting and a wide aperture. This procedure is a familiar one, normal with many subjects, but particularly with flowers. The telephoto lens setting gives a more limited depth of field, and this effectively throws the background out of focus, transforming it into a pleasing blur, in contrast with the crisp in-focus delineation of the flower which is the main subject. In some cases the presence of long grasses in the foreground may not be obtrusive, and you could find that including a few close-up out-of-focus stalks adds to the atmosphere of your picture.

Other circumstances can contribute to the pleasant mood of a flower photograph. A hazy morning or a sunset glow can transform a record shot into a picture. A study of a flower in a wild woodland glade, or beside still water or a running brook, could be more evocative than a photograph of a similar flower in a formal garden. To many photographers the fascination of flower photography comes with the use of true close-up,

Pages 74–75: a splendid scenic shot of Mount Baker, part of the Cascade Range in Canada. A small aperture has been used to ensure detail in the foreground, and excellent use has been made of reflections. *Chris Bonar.*

or macro, techniques. There are several ways of achieving macro shots with the SLR camera. You can use a macro lens, and some zoom lenses have a macro mode. There are two alternatives, economical and suitable for the travel photographer – supplementary lenses and extension rings. Details will be found in the final section of this book.

With the aid of one of these devices you can make an edelweiss, a wild rose or the stunningly beautiful grass of Parnassus the subject of a delightful picture to fill the frame. You can focus approximately through the reflex lens, then move slightly back and forward till the flower snaps into focus in the viewfinder. See that adequate light reaches the flower, and that the camera is held still. I once found that my wife's hand, held behind a tiny blue Alpine gentian, enhanced the effect and provided scale for a macro shot. Flowers look especially attractive if the sun shines on them after a shower of rain, and there is every reason for you to take advantage of the sparkling effect of water beads on the petals. In dry weather the effect can be simulated by the judicious sprinkling of water, and – once in a blue moon – this artificial device can be justifiable.

Tame and captive creatures
Rhodes town on the Mediterranean has many delightful corners which are favourites with photographers and artists, with stonework and light and shade, and arches and alcoves and verdant foliage, often combining to form enchanting scenes. You can spend many a happy creative hour there with an SLR camera. The Street of the Knights was empty one afternoon (it was siesta), and the slow emergence from a shady alley of a typically lean white stray cat somehow seemed to complete the picture.

People living in faraway places sometimes have esoteric pets, and these can on occasion be subjects of unusual pictures. In some Eastern European and Asian streets there are captive animals to be seen,

such as monkeys or even bears, which some like to photograph; though you might be reluctant if there is an element of cruelty in the confinement of a freedom-loving animal or bird. On the other hand, this might be your very motivation if you wish to publicize their plight. This could apply to the caged birds on sale in the Ile de la Cité market in Paris. It applies even more to bulls in the ring in Spain, photographs of which can play an important part in campaigns against that cruel sport.

Working animals are an altogether different matter. There is nothing finer than the prospect of a pair of stalwart Clydesdale horses pulling a plough in a Scottish field; but of course the sight has become extremely rare with the onset of the ubiquitous tractor. Nevertheless it is well worth finding out, if you are a visitor to Britain, whether animal power is still being used anywhere in the area. There are signs here and there of a revival. If you do find animals working in a field, try to get effective camera angles. On the isle of Raasay some time ago, I obtained a striking shot looking up from ground level, at standard focal length, as the two horses hauled the plough diagonally towards me. Incidentally, the stud farm in Styria, in Austria, where the Vienna Spanish Riding School horses are bred, is well worth a photographer's visit, as is the horse-breeding Camargue district of France.

In many countries other working animals can be seen. Patient plodding donkeys and mules can be photographed in many parts of Greece. Those hard-used creatures are often exploited for the sake of the tourists. In Lindos, my favourite spot in Rhodes, some visitors are taken up to the superb Acropolis on the backs of uncomplaining donkeys. After its descent to the traffic-free village, each donkey, if it is lucky, has time for a breather in a shady corner, and I secured a touching study of one leaning against a wall, fast asleep on its feet. That picture never fails to draw sympathy from viewers. Donkeys are similarly used in many other parts of Greece and Turkey, such as on the stony track up to the Cave of Zeus in Crete; and other four-legged

A beautiful close-up of a water liley, taken with a 135 mm lens. The dark water provides good contrast to the brightness of the petals. *Raymond Lea.*

A comma butterfly, colourful side up, poised on a thistle. It is vital when taking this kind of close-up to ensure that the subject is in sharp focus, as the depth of field at short distances is very limited. If the background is consequently rendered as blurred and hazy, this is all to the good. *Chris Taylor.*

An unusual shot of oxen and cart beside a field of sunflowers, taken in the Central Anatolian region of Turkey. *Archie Reid.*

A lively study of black bear and cub, taken from the safety of a vehicle and using telephoto lens. Banff National Park, Canada. *Chris Bonar.*

friends are employed on the steep and tortuous tracks leading down to the Grand Canyon of the Colorado.

A favourite photographic subject is a horse or donkey looking over a fence or gate at the photographer. There is an intrinsic friendliness about most of these animals which seldom fails to attract, and this attitude on the part of the innocuous animal often tempts you to bring your camera really close. The danger in this is that you might forget the distortion inherent in close shots. A horse or donkey has a long body, and if its head is directed towards you at close quarters, and if you are using wide angle in order to include its entire body at close range, you are almost bound to get an unpleasantly distorted picture. It is worth remembering this if you want to photograph pony-trekkers.

In many Eastern countries the traveller will find animals such as oxen and water buffalo playing their essential parts in the economy. In Indonesian paddy-fields, the water is a vital and characteristic part of the environment, and it is a good idea to keep a look-out for possible reflections to complete a pleasing composition involving an animal. In the streets of Calcutta, bony white cattle are quite likely to enter your picture: they are an inescapable feature, respected and even revered.

Working dogs can be featured in many fine photographs. There are splendid opportunities where sheep-shearing is taking place, perhaps in Wales or Scotland or the Lake District. Animal movement here can be sudden and unexpected, calling for readiness on the part of the photographer. Do not neglect full-frame studies of those fine sheepdogs: a picture can be taken from close range at a standard lens setting, or else from further away at moderate telephoto. After an energetic manoeuvre, the Scots collie or English or Welsh sheepdog is likely to sit placidly panting for a while, its red tongue lolling, allowing time for you to focus and frame carefully.

Semi-domesticated creatures are often to be found in parks, even in large cities. A peacock is a glorious bird in full plumage, and again a long-focus lens is ideal. Squirrels are delightful creatures; long focus is essential, and also a modicum of patience. There are other places where wild animals from another country have recently become domesticated, and a good example is in the Scottish Cairngorms, where you can get right up to a small contented herd of Scandinavian reindeer. In Lapland, of course, you find reindeer herds large and the Laplanders colourful.

To some travel photographers, a zoo is a sort of Mecca. In no other circumstances can you get so easily within range of dangerous or elusive creatures, and if you come across a zoo in a distant country it is probably worth a visit with your camera. Your aim is likely to be to find creatures not present in zoos on your home ground. A regional zoo can be rewarding: Innsbruck in Austria has its excellent Alpenzoo, which contains only creatures found among the mountains of Central Europe, like the ibex, the lynx, the bison and the brown bear; and some interesting Scottish species may be seen at Kincraig in the Cairngorms.

Many photographers make an effort to eliminate from their zoo photographs any evidence of caging or confinement, and this is not too difficult. An essential is a choice of focal lengths. With a telephoto setting you can photograph through a fine wire mesh, which goes so far out of focus that it practically disappears. The tendency nowadays is towards the open-type zoological park, with bars kept to a minimum, often replaced by narrow pits giving unrestricted views and providing the animals with an environment as close as possible to the one from which they were taken. One admirable result is that the creatures are more contented, and less inclined to be unhappy and restless.

Nature reserves and national parks
Among the more gratifying trends in our violent world is a lively interest in the protection and

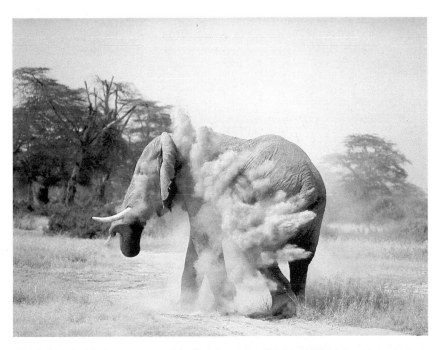

An elephant taking a dust-bath in Amboseli National Park, Kenya. The dust-bathing habit results in elephants often taking on the colour of their environment. *Chris Bonar.*

confrontation with a gentle and timid roe deer or perhaps a colourful kingfisher.

Many nature reserves in Britain are established and cared for by such organizations as the National Trust, the Nature Conservancy Council, the National Parks Council and the Scottish Wildlife Trust. The aim is simply to prevent the encroachment of mechanised civilization and at the same time to offer access to those who are genuinely interested in wildlife. Extensive stretches of beautiful coasts and fine woodland and mountain scenery are managed by these public-spirited bodies, and the protected areas are full of undisturbed photographic potential.

Another recent trend is for the conventional zoo, with its confined creatures, to be superseded to some extent by the wildlife park, pioneered in Britain by such open zoos as Whipsnade, and extended and modified more recently by owners of certain stately homes. These wildlife parks are, however, a somewhat mixed blessing. In the best of them, the animals are provided with excellent open spaces for free and natural movement and grazing, but the untroubled life of the fauna often means that they are nowhere to be seen, or else that they can just be glimpsed far from the motor track, dozing contentedly among the long grass and shrubbery.

It is obvious, then, that to obtain satisfactory pictures in a safari park you require a long-focus lens. It is best to take photographs with the car engine switched off and the lens resting on the window edge. Far from being threatened in any way by predatory beasts, you will probably be fortunate if any approach your vehicle. The usual exceptions are apes and monkeys, which have a regrettable tendency to clamber around and scratch your paintwork!

Some reserves, of a quite different kind, are dedicated to the protection and rearing of particular bird species, and among the finest

cherishing of the natural environment, both for the general benefit of mankind and for the survival and well-being of wild creatures. Provisions for public access and for recreation in beautiful areas range from small picnic sites and nature trails to extensive forest parks and vast game reserves, and the traveller with a camera has every reason to be grateful to the relevant authorities for the splendid facilities these offer.

It is always worthwhile to take your camera with you along even a short and undemanding nature trail. Signposts and numbered boards are sometimes there to direct the less knowledgeable to features of interest, whether they be plants, rock formations, young trees, badger setts, woodpecker borings or osprey nests. At the Falls of Clyde Nature Reserve near my home, wayside botanical treasures and strange fungi can be photographed from close quarters with the aid of macro equipment, and a photographer's visit early on a misty morning can be rewarded by sudden

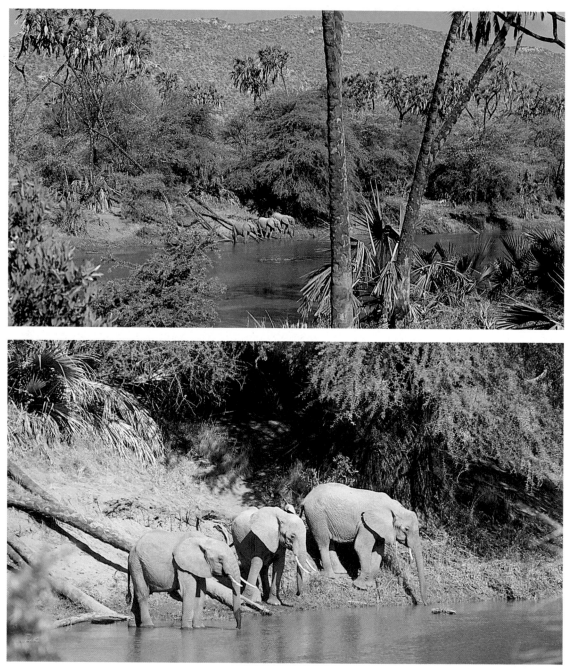

Elephants drinking from the Uaro Nijero River, Samburu National Park, Kenya. All three photographs were taken from the same viewpoint on the same occasion, using wide-angle, telephoto and standard lenses in turn. *Chris Bonar*.

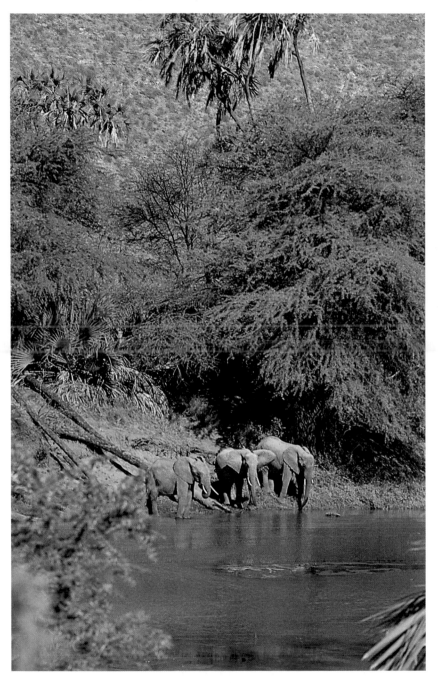

examples are wildfowl refuges in England such as Martin Mere, Slimbridge and Peakirk, operated by the Wildfowl Trust. It is possible at Slimbridge to approach and photograph during the winter thousands of white-fronted geese and scores of Bewick swans. At Peakirk you can easily obtain a large number of frame-filling telephoto shots of exotic ducks and geese of every hue and in every conceivable posture.

Europe contains a very large number of fine national parks and game reserves, and full descriptions and information about access can be obtained from the appropriate Tourist Boards. Many are notable for their exotic wildlife, others for their beautiful flowers and trees. My own favourite is highly spectacular in its own way: the marvellous Plitvice National Park in Yugoslavia has sixteen woodland lakes linked by sixteen waterfalls of surpassing beauty, including one unique area where seven high waterfalls meet; fine shots can be obtained from the boardwalk and from clifftops. In a rather different category is the type of national park to be found in African countries and in India and Australia. There the distances are vast and facilities for the well-equipped photographer are first-rate.

In Kenya, safari tours have become an accepted part of the country's economy. Large numbers of camera owners book for these package holidays, and find that the opportunities are frequent for photographing at surprisingly close range some of the most fearsome (or timid) of wild creatures. Long-focus lenses are almost obligatory for good pictures. These tours are usually based on lodges within a vast wild area, and small buses take you and your fellow-travellers by recognised routes into lion, elephant, leopard, buffalo and rhino country. The Tsavo, Mara and Tsamburu National Parks provide a fine cross-section of contrasting species and habitats.

Zambia is another country which offers splendid photographic safari tours. Some of the more

experienced travellers prefer the adventurous 'walking safari' organised in that country, where you sleep in tents instead of in hotels, and do a good deal of your photographic investigation of the game herds on foot, accompanied by experienced guides. For wide-angle spectacle, the Serengeti reserve in Tanzania is hard to beat. Perhaps less well-known, but nevertheless highly exciting, are the great wildlife sanctuaries of India. A visit to the Nanjar Valley Nature Reserve or to the Sasan Gir Sanctuary would be unforgettable, and the best-known of all is the Corbett National Park. In such places you will see not only exotic and colourful birds and flowers, but also many elephants. The great challenge is to secure a good photograph of a tiger. Other fine nature reserves – no fewer than 487 – are to be found in Australia, with spectacular rock formations, unfamiliar creatures and exotic flowers.

Probably most travel photographers planning a first safari will opt for one of the package tours, and there is much to be said for this. However, there are those who would scorn such an idea, disliking the atmosphere of 'performance for the tourist' that is undeniably present. It is possible to travel independently to a centre and there to hire a guide on a personal basis, and for those who must have the real thing this is worth serious consideration. It is the ideal way.

Some of the grandest national parks in the world are in America. For spectacular scenery they cannot really be surpassed, though for wildlife they do not equal the African parks. Facilities for the travel photographer in American parks are first-class, whether he wants comfortable accommodation in hotels or prefers to rough it (comparatively) by canoe or in a motorised caravan or tent. The Yosemite Park in California is full of breathtaking natural wonders, as are the national parks at Banff, Mount Rainier, Jasper and Yellowstone. The photographer who seeks scenic splendour need look no further than any one of these. And of course many will not rest until they have seen and entered and photographed the Grand Canyon, and perhaps taken a wild and wonderful journey along the Colorado river. My friend Gordon McKnight, who undertook the latter adventure with others on an inflatable raft, obtained some really exciting pictures of an unforgettable trip.

Approach to wildlife

Traditionally, wildlife photography consisted of recording on film the outward appearance of living creatures, familiar or rare. It was akin to portrait photography in that every effort was made to delineate faithfully the physical characteristics of the animal – head, limbs, body, and covering of hair or scales or skin. This was all that was expected of the wildlife record photographer, and such photographs have been valuable to the zoological student and the interested layman, especially in cases where access to the actual animal has been impracticable. I recall in my childhood poring over a set of photographs in an old volume of 'The Children's Encyclopedia' depicting gorillas in the wild, and reading with fascination the caption which stated that these fearsome creatures had never yet been caught alive. Photography was the only means by which we could know what they looked like.

The wildlife photographer today usually has a very different objective. He seeks rather to record photographic evidence of a creature's behaviour, with particular reference to the immediate environment. The animals or birds or insects are photographed at some normal activity – perhaps feeding or nest-building or stalking or mating or defending territory – and the creatures' surroundings are often an integral part of the picture. Generally the interested public finds such photographs very attractive, whether the animal is as familiar as a seagull or as exotic as a loris. Activity of some sort is the keynote.

Some travel photographers endeavour to go a good deal further. A considerable degree of ethical purpose can be discerned in many wildlife

photographs, especially in these days when nature conservation is a widespread public concern, and pollution and cruelty are twin enemies. Animals are not seen by this kind of photographer as merely cuddly creatures, but often as victims of human greed and indifference (or perhaps of the vagaries of nature in the raw). Photographs of seals being clubbed to death, or of elephants slaughtered by poachers for their tusks, are not pleasant to look at, nor are they meant to be. The moral purpose of such photographs is clear.

Many travel photographers, however, set out to involve wildlife in their pictures in a totally different way and for a completely different purpose. Their motivation is artistic and creative, and the objective is to compose satisfying pictures in which wild creatures are involved in some way, probably blending or contrasting with objects in their immediate neighbourhood. Shape and shadow and line and colour and texture are the concern of the creative wildlife photographer, and his photographs are often extremely pleasing. Whatever your favoured approach, and whether your intended subject is to be a robin at your garden nesting-box or a tiger at the edge of a Siberian forest, you will first have to give consideration to two vital matters: the appropriate equipment and how best to use it; and the location and habits of the animals you wish to photograph.

Sooner or later every photographer whose aim is the capturing of wildlife on film discovers that the compact 35 mm camera, with lens of fixed focal length, is convenient to carry but inadequate for some of the situations which crop up in the wild. There are many conditions in wildlife photography which require the accuracy of a through-the-lens viewing and focusing and exposure system, and others which demand manual override. Some means of macro photography is also called for; some the smallest creatures are among the most fascinating. Most vital of all, not a day spent by the travel photographer in the environment of wild creatures passes without the need for a choice of

focal lengths, from wide-angle to medium (or even extreme) telephoto. In these days of rapid improvement in lens quality, a wide-ranging zoom lens comes into its own when you are on safari.

For the beginner in wildlife photography, the location need not be far from home. It is surprising how many fine photographs involving animals, reptiles, birds and insects can be taken in your own neighbourhood. But whether you are near your home or far afield, it is important to find out initially as much as you can about the creatures you are hoping to see, and about their habitats and habits. Preliminary reading can help greatly in the discovery of seasons and times of day when wild creatures are likely to be about. This amounts to the acquisition of a certain amount of specialised knowledge beyond that of a mere photographer, and this is indeed part of the fascination of this type of photography.

It is no use expecting a photographic journey in search of wildlife to be in any sense a swift operation. Any rapid movements you make, even the raising of a camera to your eye, can send a roe deer darting off into the undergrowth, and it will probably not return. Admittedly there are other wild animals which are supremely indifferent to the photographer's presence, or indeed to sudden movements. The dozens of seals basking in the sun on the small rocks near Kylesku in the Highlands merely stared disdainfully at us in our motor-boat as we filmed and photographed them, passing within three metres of them, and later the herons in their heronry up on a nearby cliff-face seemed to care even less. But these are exceptions, and most wild creatures are timid and rapid in their movements. The photographer has to be quiet and slow, and yet always ready with his camera.

The practised photographic stalker has learned through experience to move like the proverbial Red Indian. If you are in a scrubland area and trying to get within photographic reach of a group of deer, you have to move very slowly from tree to tree

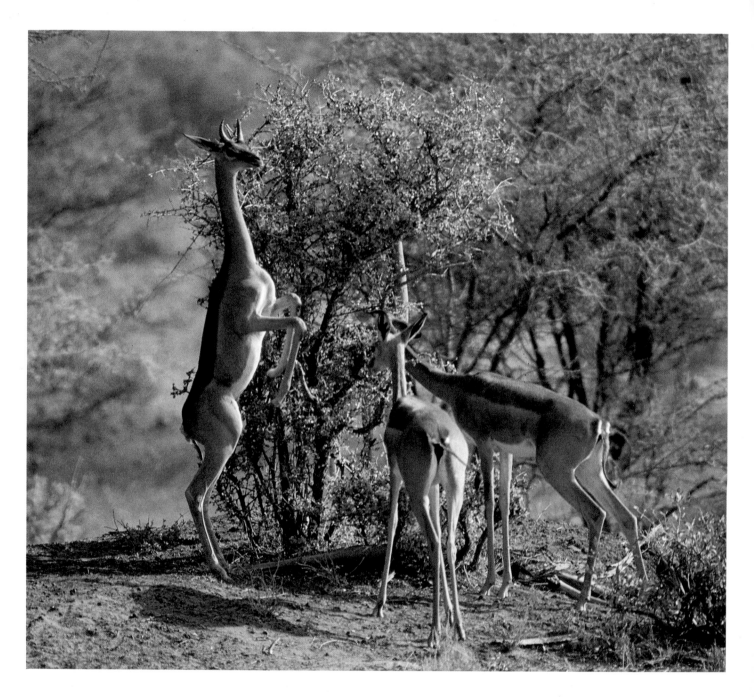

Left: a trio of gerenuk in Samburu National Park, Kenya. These graceful creatures sometimes behave in odd ways: this one is reaching for food at the top of the bush. Use of telephoto lens throws background effectively into unsharpness. *Chris Bonar.* Right: a premarital sparring match among giraffes in Kenya. The victor's reward seems totally uninterested. *Chris Bonar.*

A safari vehicle parked beside Lake Bogoria, Kenya. The lifting roof provides a first-rate viewpoint for photography. Steam can be seen rising from a hot spring, and in the far distance is a flock of flamingoes. *Chris Bonar.*

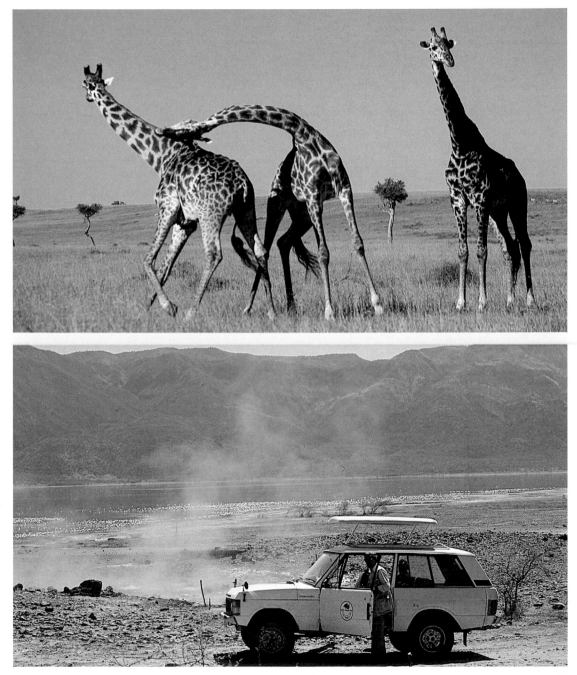

while the animals are occupied in browsing or have their heads turned away for other reasons. As soon as you sense that they have stopped their natural activity, you stop too: freeze and wait until the animals resume their preoccupation. When you do move, avoid standing on dry twigs, and if you do snap a twig, freeze and wait again.

Your movement towards the wild creatures should be in a well-planned direction. You should be downwind of them all the time, and you should never let your shape be visible above the skyline. In the African parks, it is strongly advised that you remain within a vehicle for safety's sake. Always remember that although some animals, like the buffalo and the rhino, have poor eyesight, their hearing is nearly always acute and their sense of smell can be phenomenal. (It is also vital to bear in mind that both of these animals, and many others, are on occasion extremely swift and dangerous.)

In many regions the best time of day for animal activity is also the best time for picture quality, with regard to both lighting and colour. The wildlife photographer generally avoids the middle of the day, when the animals are often having a sensible siesta and the sunshine is hard and unyielding, forming contrasty shadows. It is, however, sometimes possible at midday to photograph a pride of lions dozing in the shade of a large spreading tree without including any sunlit area in your composition; there could be plenty of reflected light to give shadow detail, and contrast will be low. But often the subdued and directional lighting in early morning or late afternoon provides moulding and detail of texture, together with a slightly warm colour tinge which is very pleasing. In an African game reserve, an ideal venue where many animals and wading birds gather each evening is at a waterhole, where photographic opportunities are legion.

Photographing wild animals
The unpredictable nature of many wild creatures is a sufficiently good reason for you to go about with your camera at the ready. Although it does not take very long to focus an SLR camera, set the aperture, and adjust the zoom lens to the best focal length for the occasion, even those few seconds can sometimes be too much: the marmot, antelope or adder is quite likely to be out of the scene by the time you are ready. However, with an aperture-priority automatic camera already focused at 4 or 5 metres, with aperture at f/8 and focal length at 50 mm, you will at least be likely to capture the animal on film, though it may not be properly framed. Then a few seconds later you could be ready for a second shot, if the creature is still there, and on this occasion take time to fill the frame satisfactorily, with the focus exactly right.

It is wise to keep checking your camera as you move around the location. As well as winding on and returning the focus to an average setting after taking a near or distant shot, keep a weather eye on the number of frames left on your film. It is highly exasperating to arrive at Frame 33 when you have just spotted a crocodile approaching your boat. If you anticipate this sort of possibility, it is probably a good idea to wind back the film into its cassette and change it, even if there are four or five shots still to go, rather than miss a whole sequence of choice pictures. In comparison with the cost of your camera and lenses, film material is extremely cheap.

When your subject is in your viewfinder, it is often sensible to be quite profligate with film material. You could bracket a number of consecutive photographs, with slightly different focal lengths, apertures or shutter speeds. Alternatively, even without alteration of camera settings, you might find it advantageous to take four or five similar shots of a live subject; perhaps nearly all will turn out to be satisfactory, with the animal's posture differing interestingly in each. In fact, with reversal material there is another benefit in taking several shots in rapid succession. When you get home, these repeated shots can be regarded to some extent as a source of spare pictures for your friends, or for lending out, or perhaps for publication, and the

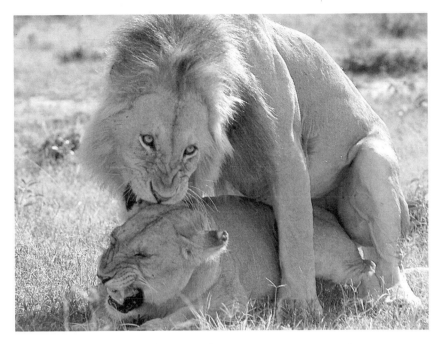

An intimate moment in a Kenyan National Park. It goes without saying that a telephoto lens was used. *Chris Bonar.*

quality of each is certainly going to be superior to the quality of processed duplicate transparencies.

It is useful to know precisely how much of a deep scene will be sharply in focus, and this is where the modern aperture-priority SLR camera scores. Normally the focusing on the ground-glass screen is carried out at maximum aperture, because this produces in the viewfinder the utmost brightness and the most critical focusing. But it does not tell you the whole truth. When you release the shutter, the iris moves instantly to the taking aperture you selected, which was probably not the aperture you used for focusing. Thus there will be more depth of field in the actual photograph than you saw in the viewfinder. The modern SLR camera, however, is fitted with a lever which enables you to preview the actual depth of field if you wish, just before you press the shutter release; and this is a great help in structuring a photograph, as long as lighting conditions are reasonably bright.

If you are in the wilds, you will naturally have given thought to your means of transport. It is not always convenient or safe to travel on your own two feet all the time, although this may be the only way in wooded or mountainous areas. In India you could find yourself having a privileged viewpoint on an elephant's back. However, in many American or African nature reserves you will naturally take advantage of the motor transport which is available, often a Land Rover or minibus type of vehicle, which can bring you to the habitat of the most interesting animals in the minimum time.

Very few animals in the wilderness regard a vehicle as an enemy, especially where tourist transport is seen every day. It is advisable, however, that you remain in the car when taking photographs, unless you are on foot safari with an experienced guide. People are accepted by animals in most cases as part of the vehicle, and you should photograph (preferably with the car engine stopped) either from an opened window or from an open roof. This is wiser than opening the door, and dire warnings about bears in American parks mean what they say. In the African plains an elevated position in the vehicle has the advantage of enabling you to view over the long grass.

If you are photographing animals in their own environment, the multiple focal lengths available to the SLR camera owner will come into their own, and in fact are essential for good results. At a wide-angle setting, you can give a fine impression of the neighbourhood, with effective solidity and differentiation of planes. With care, you could take a short-focus picture featuring a small creature in the foreground, a long sweep of river beyond, and a distant range of mountains – all in the sharp focus which is one of the properties of a wide-angle lens. A short-focus setting would also be appropriate for a picture of a migrating herd, taken from an elevated position.

However, probably most of your photographs taken in the wilds and involving animals will be at a

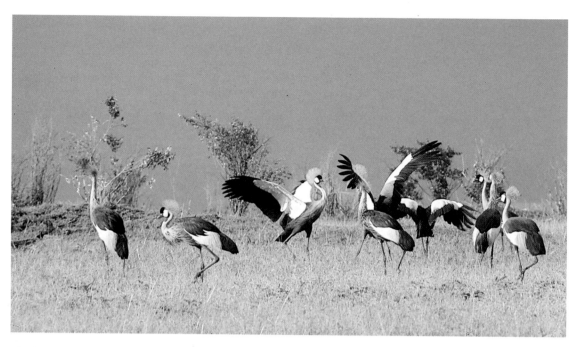

A group of crowned cranes displaying, just before a storm, in Mara National Park, Kenya. *Chris Bonar.*

telephoto setting. 150 mm is a very useful length, and 300 mm could be better still in the wide open spaces. You will be able to keep well back from a fierce or timid creature, and the lens will magnify its image, perhaps sufficiently to fill your frame. The limited depth of field which is characteristic of telephoto will give further possibilities in structuring your scene: you can bring certain parts of the scene, in front of and behind your subject, into sharpness, allowing the rest – perhaps grasses in the foreground and bushes in the background – to subside into unsharpness. This is valuable if the subject is a creature like a giraffe or a lion, endowed with efficient camouflage.

There are certain minor difficulties about photography of wildlife at a long-focus setting. There is a tendency with the longer lenses to encourage camera shake, on account of their length and weight and magnification. This has to be avoided with the aid of a camera support or by a fast shutter speed, or both. A rule of thumb states

that the slowest practicable shutter speed has the same number as the focal length being used. For example, at a focal length of 125 mm your shutter speed should not be slower than 1/125 second, and so on. This is only a rough guide, of course, and much depends on your steadiness of hand. A support would be useful for a long lens if you were walking in open country.

For most purposes, there is no need for the average travel photographer to aspire to a massive and expensive extreme telephoto lens, of around 750 mm focal length. Nevertheless it is true that the possession of one of these monsters, or a more portable catadioptric (mirror) lens, will give scope for many exciting shots, such as a picture of a mountain goat on a distant Alp. A cheaper alternative is a 2× teleconverter, which doubles the focal length of your existing lens.

For a series of photographs in rapid succession, such as of a lion licking his chops and stretching in

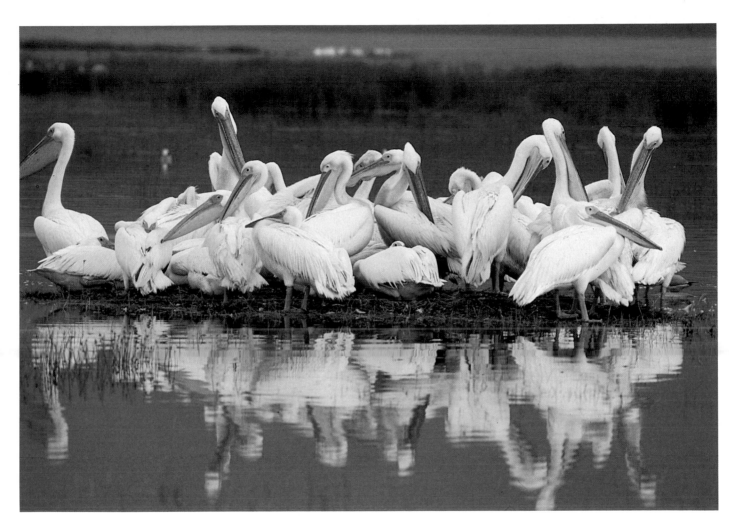

A near shot of pelicans on a
tiny islet in Lake Nakuru,
Kenya. The reflections add
appreciably to the effect.
Chris Bonar.

the sun, a winder or motor drive can be useful. The main disadvantage of a motor drive is that it is noisy, and for some types of wildlife photography this could be enough to scare the subject away. Some quiet creatures, in fact, find even the sound of a reflex camera mirror snapping back into place at close quarters to be too much.

Various types of macro equipment (described later in this book) are invaluable for those who want to enter the fascinating world of little creatures – lizards, beetles, spiders, butterflies and the like. I have often been glad of macro facilities which have given me, with no difficulty, frame-filling pictures of such subjects as a Croatian frog and a Greek lizard and a bee on a Scottish wild rose. In the fabulous Valley of Butterflies in Rhodes there are plenty of chances of photographing one out of hundreds of thousands of those colourful creatures at close quarters.

Photographing birds

Many people who travel with a camera have aspirations towards photographing birdlife. Unfortunately it is an indisputable fact that bird photography can turn out to be extremely exacting. Many beautiful and attractive birds, like the glorious kingfisher, are very small and at the same time very hard to approach. The owner of a non-reflex camera soon finds that any bird more than six or seven metres away can hardly be seen in the tiny viewfinder; and in any case birds make such swift and sudden movements that bird photography with this type of camera becomes impracticable. The fact is that bird photography demands prior investigation and planning, and calls for equipment beyond the scope of the casual snapshotter.

While a light and portable camera is desirable for the travel photographer with an ornithological bent, it is even more important that there should be a choice of focal lengths. For most purposes again, then, a 35 mm SLR camera is a prerequisite. A wide-angle lens is often appropriate, and there are

occasions in low lighting conditions when a standard lens with a wide aperture can be helpful; but the great majority of bird photographs are taken with a telephoto lens (modest or extreme), or else with a zoom lens conveniently covering a range of fairly long focal lengths. Telephoto enlarges both the photographed subject and the image in the reflex viewfinder, and this circumvents one major problem confronting the user of a compact camera.

Most bird photographs are best taken with fairly fine-grain film – such as ISO 64/19° for transparencies or 100/21° for prints. A faster film could be useful if you wanted to set very brief shutter speeds, but the resulting slightly coarser grain and loss of detail would be noticeable in a big enlargement on paper or screen. The rapid movement of most birds does call for a fairly brief shutter speed, however, and many bird photographers never use a speed slower than 1/250 second.

Some species, like swans and pigeons (both favourite subjects), are almost domesticated, and others are friendly to the point of impertinence, like those colourful chaffinches which always want to investigate me wherever I am camping in Britain. With more timid bird species, a slow approach is the secret of success. One of the pleasing things about bird photography is that while many birds are rapid and jerky in their movements, their general habits are usually quite predictable. If you take the trouble to find out about the birds you intend to photograph, you will then just have to wait at an appropriate time for their appearance at a feeding or breeding ground. If from a cliff-top you see a couple of gannets diving into the sea from a height, it is quite certain that there will be others, and it is a matter of waiting. Perhaps even more interestingly, territorial and courtship rituals of many an exotic bird are so formalised and seasonal that they are like scheduled stage performances. This is one of the great attractions of a visit to an Indian or African national park.

Where birds are seen in large numbers, for example when they are gathering for migration, a standard or wide-angle lens can be employed successfully. All of us have seen a field or a large tree crammed to overflowing with small birds, and this communal assembly can be the subject of a striking picture. Seabirds are often gregarious to the point of severe overcrowding on rocks or cliff-faces. On Handa Island in Scotland I have been able to fill a wide-angle frame with masses of kittiwakes, fulmars, razorbills and guillemots.

Birds flying in formation are always impressive, especially if there is perhaps a ready-made mackerel sky background. A ridge of trees on the skyline could complete the picture. Colonies of colourful flamingoes can be seen in the French Camargue, and pelicans gather in large numbers on the Danube delta in Romania. One of the most impressive of all bird sanctuaries is the one at Bharatpur in India, where you can photograph considerable numbers of such splendid creatures as white ibises, painted storks and Siberian cranes. It is when birds are in smaller numbers, or in isolation, that problems can arise. A slow and patient approach is essential, and the scattering of small quantities of appropriate food is a help.

For a clear picture of a perching bird, you will naturally want to use a telephoto lens. Circumstances might bring extra difficulties. In Raasay when I saw a kestrel perching on a telephone wire, I realised that the Coolin ridge across the water on Skye was precisely behind the bird. I bracketed a number of exposures at a range of zoom-lens settings. The outcome was that one picture was just right, with the kestrel quite prominent and a fairly clear mountain ridge in the background. But I also liked one taken at a longer zoom setting with the bird in sharp focus and much enlarged, and the mountains towering and impressive but quite hazy in outline. It is often a matter of taste.

Sometimes you can approach surprisingly close to birds that are resting (or nesting), without using the bird hide of the specialist. On a cliff-top near Duncansby Head on the north coast of Scotland, I found myself reclining in the company of three puffins, only a few metres away. Moving very slowly, I set and aimed my camera, and at 150 mm focal length those colourful and amusing creatures filled the frame very satisfactorily. On the Niederhorn high above Lake Thun in Switzerland, a pair of black Alpine choughs perched unconcerned on a fence two metres away while I got a good shot of them at 50 mm focal length; and the green Justis valley beyond formed a pleasantly out-of-focus background. Incidentally, if you remain within a car you can often get quite near to timid birds and photograph them from the road.

One of the best areas in Scotland for the bird photographer is the Cairngorms, where a prolonged stay at the camp site can be most rewarding. There can be seen ptarmigan and dotterel on the heights, merlin and peregrine up at

When you have made your approach to a bird of prey and taken an initial photograph, it is worth waiting with your camera ready, just in case something interesting happens. In this case the bird's mate arrived. *Chris Bonar.*

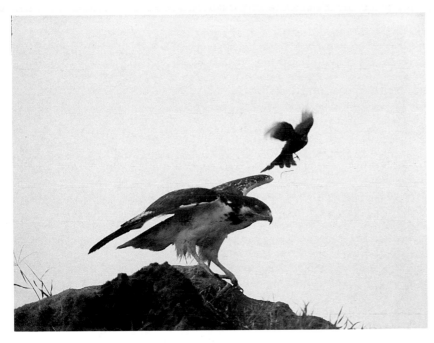

the crags, and rare delights such as the crossbill and the crested tit among the pine trees. With the aid of a zoom lens, perhaps 35 to 105 mm, many varieties of birds can be photographed without much trouble in that delightful area. A welcome annual visitor is the osprey, which can sometimes be seen in its territory beside Loch Garten (swooping down for a fish if you are very lucky). There, as elsewhere in the Grampians, a 300 or 400 mm lens would be a distinct advantage.

It is when you want to photograph a bird in flight against the sky that you meet the real challenge. Obviously you will use a telephoto lens; but the trouble is that the longer the focal length, the more critical will be the focusing. How do you focus when the bird is past before you have even framed it in the viewfinder ? It is helpful if you establish yourself near the bird's territory. If it passes you periodically on its way to the nest, your framing and focusing, preferably with a zoom lens, can be done during two or three of these regular low passes overhead. Then, leaving your camera focused and with the zoom appropriately set, it will be a matter of awaiting the bird's next appearance. Hold it in your viewfinder until it comes into critically sharp focus, and then release the shutter. Automatic exposure is not satisfactory in this case, as the bright sky will cause the bird to be underexposed; override by one or two stops, or else expose for your hand. Out of several attempts, you will surely achieve at least one that is just right. For the specialist, a winder or a motor drive would be a most helpful accessory.

Some of your best bird photographs can be totally unpredictable. Legend has it that the origin of the fabulous site at Delphi was the meeting of two eagles from the ends of the earth. At Delphi I looked up and there were two eagles. My movie camera was already set at maximum telephoto…

Coping with the climate

When you travel with a camera, your most frequent encounters with nature could be simply confrontations with the vagaries of the weather. Many desirable places, such as Norway and Austria and Iceland, have climates which are far from predictable. For the travel photographer this variability in the weather should not be regarded as entirely unfortunate. It presents a challenge and an opportunity for creative photography which is absent from regions of eternal sunshine.

A cloudy sky can be much more interesting to look at than a sky of steely unbroken blue. What would the great landscape painters have done without clouds ? Clouds can make a picture in themselves, and there are those who derive great pleasure from photographing cloud compositions of remarkable beauty and dramatic effect. A cloud study can often be improved by the inclusion of a section of the earth – perhaps a thin but interesting line along the base of the picture, with a windmill or church spire or thorn tree or mountain range to break the evenness and add scale.

The high and feathery type of cloud known as cirrus is very pleasant to look at, especially when the sun shines through its thin cover. There are also fine halo effects which occur from time to time, and these are worth capturing with your camera. Cumulus clouds, resembling cotton-wool, have a beauty all their own. And dark stratus clouds can be impressively sombre and filled with foreboding for an atmospheric picture.

Changeable weather can provide unexpected bonuses. If a deluge is impending just after a sunny spell, there may be a few minutes when the sunshine is bathing the landscape in highly saturated colour while the clouds immediately over it are deep inky black; the contrast in colour and brilliance can be really startling. The alert photographer does not run for cover until he has photographed the ominous scene. Similarly, after heavy rain, if the clouds show signs of breaking up to reveal the blue sky, a photograph can be most pleasing. An additional effect can be caused by the sun back-lighting a dark cloud with a rim of intense

A geyser in Yellowstone National Park, USA. The cloud effect helps to make this a really dramatic picture. *Chris Bonar*.

Looking down from a lofty position on the Isle of Capri, Italy, in conditions of pleasant heat haze, we noticed the three men providing scale and human interest, framed by two jars. I used automatic exposure and focused at infinity.

brightness; and a photograph of a single, double or triple rainbow can be spectacularly effective. Automatic exposure of a clouded sky will normally give a satisfactory result, as long as you do not wish to have much detail in the foreground, and provided that your foreground does not take up more than a small portion of the picture. If you want to intensify a contrast between white clouds and blue sky, it is worth trying the effect of a polarising filter, which deepens the blue of the sky appreciably.

Low cloud effects in valleys or over lakes can be very attractive. When we climbed Ben Nevis one Easter, beautiful Glen Nevis below us was filled with morning mist, which slowly rose like a curtain as we ascended. A series of photographs recorded a spectacular transformation scene. I photographed a comparable effect from Monte Baldo high above Lake Garda, with a white cloud hanging low over the attractive little town of Riva during the sunny morning.

Mist softens the shapes around you in a ghostly way, and many photographers welcome a misty morning as a fine opportunity for creativity. It is probably as well to increase your exposure by a stop or so, and to take several bracketed shots half a stop apart. Fog is a rather different matter, but it can be exploited effectively in a city if the conditions have made it necessary for cars to use headlamps, and shops to be lit up during the day.

It is when the rain, sleet or hail comes on that many of us gloomily put our cameras away and seek indoor activities. Sometimes this is a mistake, as rainy scenes can be highly successful in photographs. The first priority if you are contemplating braving the elements to take pictures, even if only for a matter of minutes, is protection for your equipment. Of course you should not let the camera or the lenses get wet. Perhaps this calls for a companion to hold a cape or umbrella over you while you photograph. Your film should preferably be fast, so that you can get

acceptable depth of field without too long an exposure. A wide-angle lens setting will also help to give you sharpness in all parts of your picture.

It is a good plan to show some of the effects of rain, rather than the rain itself: deserted streets, water puddles, hurrying buffeted people with slanted umbrellas, and so on. If you are among the hills in the rain – as is unfortunately quite likely in many mountainous countries – you find that it is perfectly possible to obtain clear and striking pictures.

Sometimes the rain seems to fit in with the landscape: one of my own favourite Skye pictures, at Sligachan burn, was taken during a torrential downpour. To photograph the falling rain itself, it is necessary to use a fast shutter speed – 1/250 or faster if you wanted to 'freeze' the individual drops. If, like myself, you cherish creature comforts, you could try photographing the rain through a large window. If the rain is actually falling on the glass, this could add to the effect.

A beech wood in the Chilterns, England, on a cold winter's morning. Often adverse climatic conditions give excellent photographic opportunities. *Chris Taylor.*

To those who regard photography as a fine-weather pastime, the idea of taking photographs during a storm might seem preposterous. Nevertheless, many a photographic masterpiece has been taken in tempestuous weather, and during a thunderstorm nature is at its most dramatic. To photograph forked lightning, your camera would have to be on a tripod, and a wide-angle lens setting used with an open scene, in dull conditions or at night, perhaps with distant trees or roof-tops on the skyline. Use a wide aperture, and fit a cable release. Often a number of lightning flashes happen in roughly the same vicinity, so frame your scene when you see a flash. Then open the shutter at the 'B' setting and keep it open until several flashes have occurred.

Each season of the year has its own attractions for the travel photographer. If circumstances permit, there are several advantages to be derived from an off-season vacation. In many places, high summer, like midday, is not the ideal time for photography. The grass after a long spell of sunshine can become unattractively brown and parched-looking. The intense light can actually detract from the pleasant effect of bright colours, and you might have to fall back on taking some of your pictures in the shade.

Winter is not necessarily a season to be avoided by the photographer. Although the light can be dim and the trees bare, there are many chances during the coldest season to capture fine pictures, when colours can be very delicate, shadows long, and surfaces and shapes clear and attractive. In the winter, too, the absence of leaves from trees sometimes reveals a view, and could, for instance, enable you to secure fine and uncluttered shots of a river from a wooded hillside. In the spring, things look altogether different from their appearance in any other season. There can few scenes more pleasing than a hill slope in the Alps or the Rockies with the fresh green of rebirth and hope everywhere. There is a sparkling clarity in a springtime photograph. Wild flowers are usually at their best, set against pale-green foliage. Even more

popular with many photographers is early autumn, with its bewitching atmosphere and russet and yellow tints. In some ways the fall is the best season of the year for the photographer. Light-blue sky, translucent golden or ruby leaves and deep-blue water are ingredients for many fine pictures. Photography in conditions of severe cold and intense heat will be considered in the next chapter.

Night photography

A sunrise or sunset colour slide almost invariably arouses a predictable and highly gratifying reaction. Most audiences love the glowing spectacle of one of nature's most beautiful visual effects, and the fact that people may have seen dozens of sunrise or sunset slides before in no way detracts from their pleasure. On the other hand, the blasé photographic expert, thoroughly sated with sunrises and sunsets, may regard this as the most tiresome cliché of all. There is surely no need for us to go as far as that. A wild rose is no less beautiful because there are thousands of them; and the sun's familiar colourful rising or setting is a worthy subject for any travel photographer.

Just before sunrise, the sky can become suffused with a faint golden glow, which becomes stronger and more vivid as the minutes pass. The effect is heightened in certain cloud conditions. Often a dispersing morning mist contributes to a lovely sunrise scene, and the presence of water in the foreground – seashore, wide river or placid lake – can contribute to a memorable composition.

Sunset effects are slightly different: often less misty, and taking on a deeper warm glow. The effect you achieve in a sunset photograph depends largely on your inclinations. You may wish to convey the peace and stillness of approaching night without submerging near objects into blackness. In this case, take your photograph well before the actual setting of the sun, and plan your picture to contain pleasant foreground objects and perhaps people, or maybe just a wet seashore gleaming in the fading sunlight. One of my most fortunate late evening

Caesar's Palace, Las Vegas,
USA. A handheld night shot
using a long exposure – 1/8
second – at *f*/8. *Gerald
Dorey.*

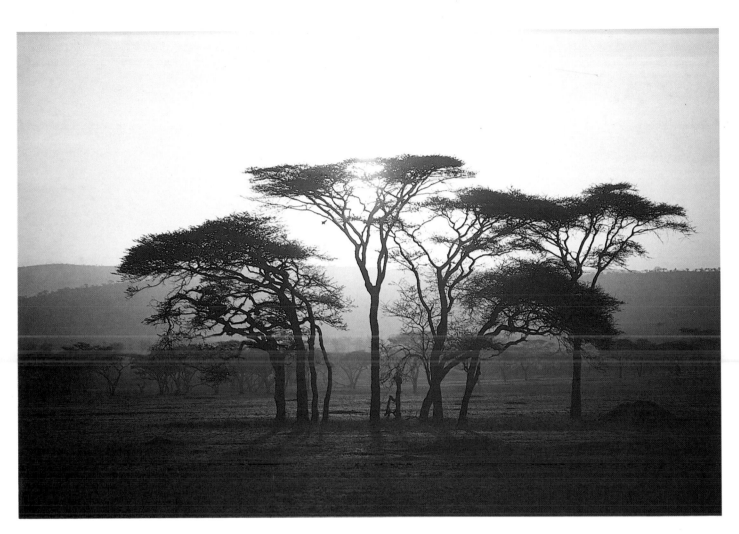

A particularly artistic sunset
effect with a silhouetted
group of thorn trees.
Serengeti National Park,
Tanzania. *Chris Bonar*.

The lovely bay of Ord, Isle of Skye, Scotland. The solitary fisherman and the silent watching group seemed to me to complete the placid evening scene. In the background is the dramatic ridge of the Coolins.

shots involved the latter with the addition of a splendid heron just taking off. Most sunset photographs are taken at a later stage, when the sky, with high clouds, has taken on its familiar but always enchanting reddish-gold hues. The sun is very low, or has perhaps just dipped behind a distant range of mountains. Include a recognisable shape in the foreground. One of my sunset photographs has a silhouetted angler as a point of emphasis, adding to the tranquil atmosphere.

Quite often a purely automatic exposure can produce a sunset or sunrise photograph which is just right, and this is most likely to happen if the horizon is no more than about a quarter of the way up the picture. To prevent disappointments, however, it is generally better to plan your exposure rather more carefully, bearing in mind your main objective. If you want to take advantage of what is left of the fading daylight and include foreground interest, do not let the sky take up quite so much of your composition. Exposing manually

(if you can), take a reading from the dim foreground, or else take a general central reading and give a stop or two extra. On the other hand, if the sky is predominant, take a manual reading from it and expose accordingly. The foreground will appear in silhouette. Remember that underexposure tends to heighten the dramatic colourful effect of a sunset. You could eventually find that several of your bracketed shots are pleasing in their own way; sunset exposures are not really critical.

You may be in some doubt whether to include the glowing sun itself. Much depends on cloud conditions, and a wide-angle lens setting will prevent the sun from dominating the picture too much. Some excellent sunset effects are produced without the presence of the sun in the picture. Sometimes the effect is enhanced if the sun is just disappearing behind a low cloud, and you have to choose the moment for shutter release carefully. You will not have too much time to ponder; the

setting or rising sun travels the distance of its diameter in about five minutes, and the event is over almost before you know where you are.

If you want a picture of a stained-glass window from outside a church, photograph at dusk when it is lit from inside. Take regular readings of the bright window and of the outside wall (at maximum zoom setting), and when the reading of the wall becomes lower than that of the window, set a shorter focal length to include the whole building, and take your photograph.

It is after the sun has set and darkness has fallen that a photographer has to employ different techniques. If there is a full moon in a cloudless sky, it might occur to you to try your hand at moonlight photography. There are, however, certain factors to take into consideration. You may want to include the moon itself in your scene, whereas fewer of us like to do this with the sun. The moonlit landscape is so faint that a long exposure is obligatory. The moon is travelling appreciably in relation to the earth, and this results in the shadows being less firm. If your exposure is over-long, the moon itself will appear as a rather peculiar short glowing sausage, instead of an orb. There is plenty of latitude in an exposure for a moonlit landscape. Use a tripod and cable release; try something like half an hour. If you want to make your subject the moon itself, rather than its effects, you will require a much shorter exposure: about 1/8 second should suffice. To present the moon as big romantic disc, use a long telephoto lens – perhaps 300 mm or longer. As you increase your distance from a foreground object such as a gate or a tree, that object's apparent size will decrease satisfactorily in relation to the size of the moon.

Most night photography is undertaken in city streets, and can be very satisfying. As with moonlight, fast film is beneficial, and a zoom lens is a great help in composing your pictures. Hand-held shots in well-lit streets are perfectly possible with ISO 400/27° film, and of course even easier with

ISO 1000/31°. With ISO 400/27° film, you can obtain a fine shot of a brightly-lit city square at $f/4$ (often the widest aperture of a zoom lens), using a shutter speed of 1/15, 1/30 or even 1/60 second. As with moonlight and sunset shots, exposures are not highly critical, and experimentation with alternative shutter speeds, apertures and focal lengths will be worthwhile. Shop windows are generally easy to photograph at night, using the automatic exposure system.

If the city streets are wet, after or even during rain, your night shots should leap into life, with colourful reflections to add to the attractiveness. The same applies to quayside reflections if your town is on the coast. Floodlighting often provides admirable photographs. Fill your frame with the floodlit castle or church, using telephoto, and give a generous exposure – somewhere between ¼ second and 4 seconds at $f/4$, with ISO 400/27° film, should provide a good result. Many holiday venues offer spectacle in the shape of Son et Lumière presentations, and in colour the effect can be splendid.

For a wide-angle panoramic view of a city at night, it is necessary to give a somewhat longer exposure than in the city streets, since the lights are much further away from you. You could try bracketing around 8 seconds at $f/4$. Other worthwhile night subjects are fireworks (using time exposures, as with lightning) and bonfires and barbecues (with faces glowing attractively in the reflected light).

Special situations

It is a particular pleasure for most photographers to get out into the countryside. Whether your aim is simply to record the scenery of field and woodland, familiar or unfamiliar, or whether you have some more creative photographic purpose in mind, out in the country you have infinite opportunities to produce something of beauty with your camera.

Landscape photography
However, it is not always realized by the traveller that what is generally known as landscape photography is by no means easy. It entails some special problems, and has been described as the supreme test of the photographer. All too often you admire a superb wide vista, bring out your camera, and are later confronted with a photograph which conveys little or nothing of the magic which you experienced. The reasons for this disappointing occurrence are tied up with the nature of perception. The human eye is seldom at rest, and scans a scene unceasingly – focusing accurately and with magical rapidity on the mountain range on the horizon and on the bed of primroses close at hand, on the smoke curling up from the cottage chimney in the middle distance and on the pony grazing in the meadow, on the distant vapour trail of a passing jet aircraft and on the face of a companion nearby. No camera can be made to attempt this kind of optical miracle, and the photographic view is fundamentally different from the view as accepted by the human eye and immediately processed and analysed by the human brain.

The camera is highly selective and your task as a photographer is to extract from the wide and varied scene a segment which is itself pleasing and satisfying in shape, texture, colour and inherent interest. This calls for expertise rather than teaching, and most people learn to take countryside photographic landscapes simply by taking them.

There are, however, certain basic principles accepted through the centuries by artists and photographers which are well worth bearing in mind.

The traditional landscape, as exemplified by the best of pictorial calendar photographs or picture postcards, observes to a greater or lesser degree certain rules of composition. After having taken a number of such pictures, you can decide whether they satisfy you and your friends, or whether you want to strike out into fresh territory and break some of the rules. Those rules are few and quite simple. Exact symmetry, we are told, is to be avoided in a landscape; there should be a centre of interest, but it should be placed ideally just over a third of the distance across the frame (at the Golden Section of the classical artists). Your main subject should where possible be balanced by a minor feature. The eye can be led into the picture by a pleasing line, such as a wall or a winding road. There should be no complete blockage in the centre of a picture, such as a tall tree or the horizon; again a third of the way across the frame is acceptable. Other rules, about restful horizontals, disturbing verticals, strong diagonals and so on tend towards pedantry and need not unduly concern the average travel photographer.

The rest is a matter of commonsense, discernment and experience. The interest of the picture should be within the frame and not awkwardly overlapping the edge. A moving object, be it deer or train or cyclist, should be photographed with a greater space in front of it than behind it, to avoid the impression that it is leaving the scene. A human figure should be looking into the picture rather than out of it. There should be a feeling generally of harmony rather than discord; this harmony applies to colour as well as to shape. Extraneous objects, especially unsightly ones such as dustbins or broken fences or ugly telephone poles, should be avoided by careful choice of viewpoint and focal length. In general, simplicity is better than proliferation of detail in a landscape, and the scene as you have photographed it should invite exploration by the viewer.

The sky can play a decisive role in the structure of your landscape. From one viewpoint you can take several entirely different photographs according to how much sky you include in the composition. If the sky is relegated to a thin strip across the top (and this is not necessarily undesirable), the viewer's attention is to some extent diverted down to a near object, perhaps a stream or a clump of heather; if the sky takes up nearly all of the frame, on the other hand, with a high mackerel cloudbank, the feeling may become quite pleasantly ethereal. If you tilt your camera down far enough to exclude the sky altogether, you are creating a picture that is different again, concerned only with an interesting object nearby. It goes without saying, by the way, that the horizon in any photograph must be parallel to the base of the frame (unless some special bizarre effect is intended); if it is not level, things should be rectified by cutting or masking, according to whether you use negative or reversal film.

Light and shade are vital ingredients of a countryside scene. A sunny vista of a wide valley can be quite lacking in appeal, whereas the same scene taken from the same viewpoint with shadows of small cumulus clouds dappling the slopes can be lively and interesting. The shadow of a small building or bush in the foreground could provide a necessary base for your picture. Keeping clear of the middle of the day will often give you the interesting shadows and modelling you need, and shadow patterns, perhaps cast by a fence or avenue of trees on a country road, can turn out to be the main motif of your composition.

Generally one of the prime aims in landscape photography is clarity, and this can be achieved by the use of a short focal length and a small aperture – as well as by the steady holding of the camera and smooth release of the shutter. A very strong feeling of distance and of a third dimension can be conveyed if you set a wide-angle focal length and

Pages 102–103: a startling landscape at Fylingdales, Yorkshire, England. The futuristic spheres of the nuclear early-warning system are in stark contrast to the tranquillity of the moorland. *Neville Newman.*

ensure that a foreground object – perhaps an open gate – and the distant trees are equally sharp, with an appropriate and interesting area in the middle distance. However, a telephoto setting is often vital if you want to isolate a subject from its surroundings.

The placing of a person in your landscape is quite critical, and sometimes you just have to wait patiently until the angler or shepherd or child has taken up an acceptable position in your scene. Colour is a most important and delightful factor in photography of the countryside; but this does not imply that colour should necessarily be prominent or highly saturated. The conventional red-coated companion in the landscape can help to give an impression of depth and scale, but the device should be used with discretion. A garish element can distract unpleasingly from an otherwise restful scene. Often colour in a landscape is most effective if it is restrained – almost monochrome, but not quite. Colour variations in a countryside scene can be important to the composition. A mixed deciduous forest on a hillside can display pleasing shades of green and brown, providing variety where in a single-species forestry plantation there might have been only a solid bank of dark green.

Forests and woodlands are frequently well worth the landscape photographer's attention, no matter how far or near the trees are. A small copse on a grassy slope can be as appealing as a long line of trees stretching to the crest of a hill. A beech avenue is splendidly impressive, and if you want to get away from the conventional you could tilt your camera up towards the treetops. If you expose for the sky the branches will form a pleasing silhouette, but if you want to provide detail of leaves and tree-trunks you can expose for the avenue and leave the small patches of sky to look after themselves.

Among the mountains
The kind of photographic equipment you take with you to the mountains depends on your climbing objectives. There is a lot to be said for cutting your camera outfit right down to essentials. The average modern inexpensive 35 mm compact camera has a fixed standard or wide-angle lens, and this type of camera may be suitable for some of the photographs you would want to take among the mountains. A more positive advantage with a basic camera is that it is a simple instrument to operate in trying conditions, and is always ready for action with the minimum of adjustment. It does not get too much in the way if you are a mountaineer manoeuvring up a difficult pitch, and if it is smashed during an ascent or descent, the disaster is not quite so traumatic as if it had been a Hasselblad.

However, it has to be faced that for many purposes in journeys among the mountains, even the best fixed-lens 35 mm camera is pretty inadequate. A wide-angle or standard lens may be fine for general shots establishing the environment and indicating the route from valley to summit. If the foreground and the middle distance are both interesting, a wide-angle shot will show them up clearly and in an almost three-dimensional way. But the user will probably find that the mountain-range backdrop seems to have shrunk into something trivial and devoid of interest.

The hill walker, ridge hiker or mountaineer who wishes to make creative use of photography during his travels will never regret having invested in a good-quality 35 mm single-lens reflex camera, preferably a lightweight model with automatic metering and manual override. Many situations in the foothills, on the slopes or among the peaks cry out for a long-focus lens, and the only problem at the outset is the conflict between a good focal-length range and sheer bulk. Ridge hiking and mountaineering both involve the use of a rucksack and two free hands, and one thing to avoid in difficult situations is having a heavy equipment case, with fragile contents, swinging to and fro.

A moderately long-focus lens is an essential for the mountain photographer. From a distance, the

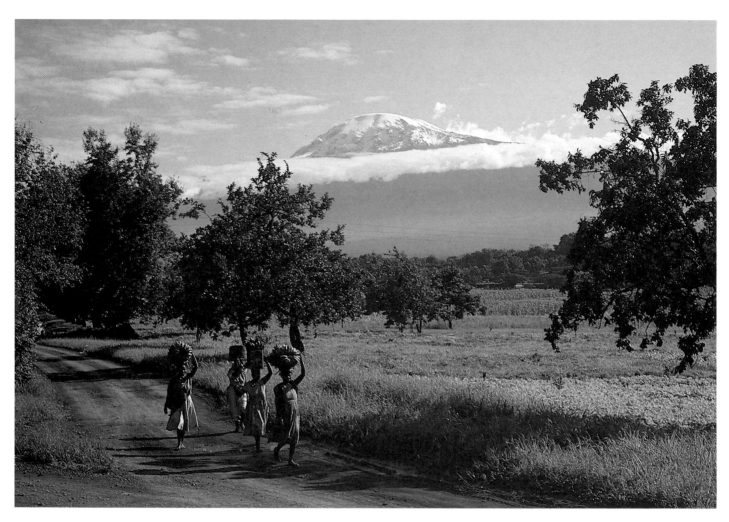

Mount Kilimanjaro seen
from Moshi, Tanzania. The
women typically carrying
head-loads of bananas form
an interesting foreground to
the fine snowclad peak.
Chris Bonar.

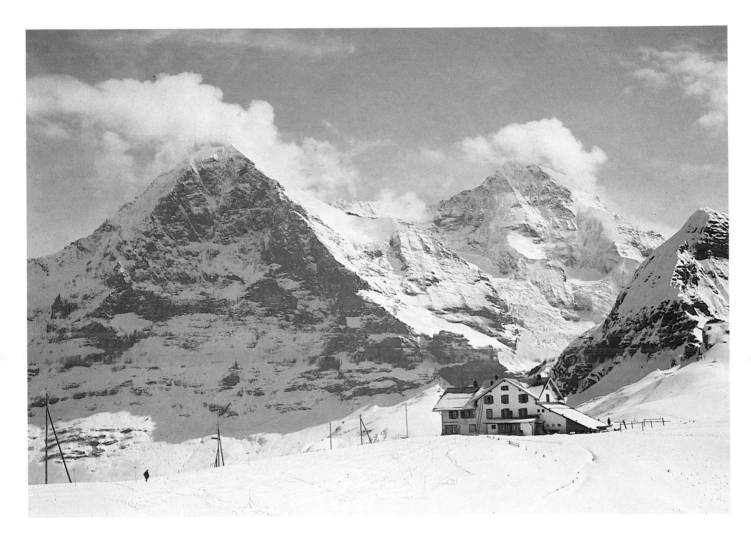

After ascending in the cable-car through thick mist, we suddenly emerged into the blazing sunshine, to find the magnificent Swiss peaks of Eiger, Mönch and Jungfrau rearing up in front of us. Automatic exposure, 50 mm lens.

mountain peak which is your objective assumes impressive proportions in a photograph if you have used a telephoto lens. Many find that 135 mm is a useful focal length for this purpose. In a limited number of instances 300 mm or more might be valuable, but with this you are encountering problems of weight and size, not to mention camera shake. A tripod is doubtless out of the question.

A good choice for use during a fairly energetic mountain excursion, and hence aiming at a compromise between weight and versatility, is a 35 to 105 mm zoom. This type of lens is not too long or heavy, and covers most requirements among the mountains. A suitable place for the camera in steep terrain, where there is a certain amount of rough scrambling and even personal risk, might be in the top part of your rucksack, with padding around it. A front pocket of a cagoule is another good place, again with adequate padding.

It is not always easy to photograph a mountain. From the valley looking up, the peak may not seem too impressive, and often from the lower slopes all you can see is a bulge about a third of the way up which effectively conceals the summit. The further up the mountain you get, the more elusive the peak seems to be. From the summit itself, the view is probably breathtaking; but represented in a photograph it can appear strangely tame and lacking in interest. It is often found that the ideal viewpoint from which to photograph a mountain peak is halfway up a mountain on the opposite side of the valley. It may seem slightly mad to ascend half one mountain before tackling another, but photographically the idea is sound. From that height a mountain looks its best, with pleasing proportions and adequate clarity from valley to summit. In this case a standard lens setting might be advisable. If your base is in a village in the valley, you could take a leisurely walk halfway up the opposite mountain (or use a cable-car).

In mountain photography, human figures are often an asset – perhaps a line of climbers far away on a ridge. This not only gives a good indication of scale, but also conveys something of the vulnerability of the mountaineer, and of the potential menace of the mountains. Closer views of a fellow-climber can be highly impressive, especially if you can contrive to get the human climbing figure and the distant valley floor or mountain range equally sharp. Check your depth of field and ensure overall sharpness; it is not advisable with this kind of shot to focus on infinity.

Directional rather than flat lighting helps to add solidity and drama to a mountain scene, and the warm glow of early morning or late afternoon can be a colourful addition. An impression of depth and distance can be provided by aerial perspective. Near objects have a different appearance from those far away, being darker and clearer and less hazy; distant colours are paler and have a tendency towards blue. These receding tones can be an attractive feature of a photograph of mountain slopes or ridges in the distance. But don't be disappointed if an extreme telephoto shot of a distant valley seems pallid and lacking in contrast. You have magnified the hazy distance.

The world's mountain ranges provide us with splendour and spectacle, and we all have our favourites. Some of my happiest memories of travel with a camera have been among the mountains of Europe: a snowy corrie sweeping down from us near the top of Ben Nevis; Mount Parnassus rearing up majestically above the sparkling spring at Delphi; the grandeur of the Coolin ridge above Glen Brittle; the distant limestone peaks of northern Yugoslavia from a rocky ledge in the Austrian province of Carinthia; the wild stony prospect from Ben Macdhui in the Cairngorms; the effect of gazing at ridge beyond ridge after scrambling to the summit of Säntis in north-east Switzerland. Colour transparencies can bring back such scenes in their full glory.

A mountain which is alive and threatening can form a spectacle of a different order. There are many dormant or active volcanoes in various parts

A fine view of Geiranger Fiord, Norway, from lofty position. *Glen Aitken.*

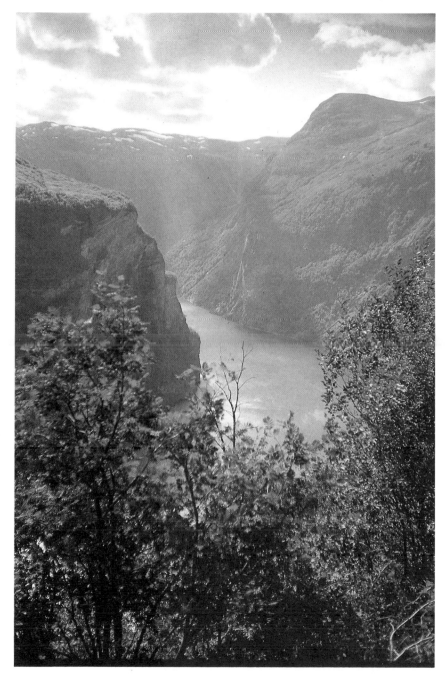

of the world which photographers can visit without too much discomfort or risk. When descending the hot and gritty scree into the core of Vesuvius, you realise that a volcano is not an ideal place to take delicate photographic equipment. Sulphurous acid smoke is highly corrosive, and in some instances it would be foolish to introduce a camera into such an atmosphere. In other places, volcanic action is much more violent and colourful, and indeed perilous. It is a matter of keeping a respectful distance away and using an extreme telephoto lens if you want to capture something of the spectacle and menace of the earth in an angry mood.

Rivers and valleys

A river can be counted on to make a significant difference to a photograph. If it is not the principal motif of a composition, it is likely to play an important part in the structure, maybe leading the eye into the picture, and certainly adding interest and life to the landscape. For the traveller with a camera, a river is full of photographic potential, whether it is tiny or vast, youthful or mature, peaceful or turbulent.

In the mountains where the water first trickles from the rocks, a pleasant picture can be taken from a distance of a couple of metres, with perhaps purple heather overhanging the sparkling spring in the light of the sun. In the next part of the river's life, the typical shape of the valley which it has carved out for itself is steep-sided, like a letter V. Often this shape can play a role in a photographic composition if the V is seen against the sky. Sooner or later the stream finds its way through a village, and traditionally people have built their homes and roads in such a way that the river has been allowed to take its course unimpeded. Here and there you find a set of stepping-stones or a wooden footbridge, or perhaps a ford for horse traffic and wheeled vehicles. In those leisurely days of the past, rivers were treated with respect and even love. In many an old village the most delightful corner, and most worthy of a photographer's attention, is where people have habitually crossed the river.

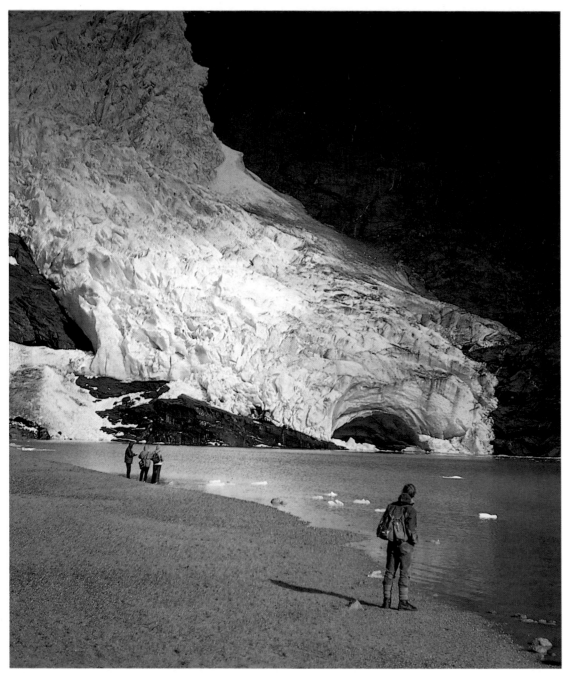

Left: a spectacular shot of the snout of the Briksdaal Glacier in Northern Norway. The greenish colour cast adds to the rather gloomy and menacing effect. *Glen Aitken.*

Right: the problem with a famous cascade like the Victoria Falls, in Zimbabwe, is to find an unfamiliar and yet pleasing viewpoint. Here both the foreground and the background are of interest, with the delicate flowers pleasingly poised in front of the dark cliffs. *Chris Bonar.*

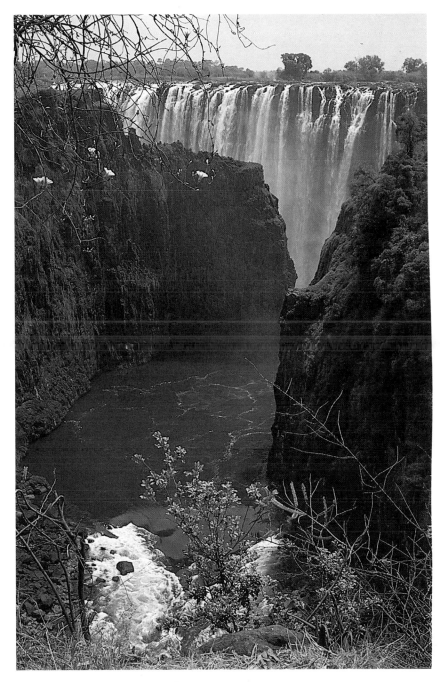

In lofty mountains, a young river sometimes makes its sluggish way from a high icefield in the form of a glacier, which can be photographed from an elevated viewpoint. The lower valleys carved by glaciers are normally U-shaped, and the most famous of these in Europe is at Lauterbrunnen in Switzerland. My best shots of that beautiful valley were taken from near the high village of Mürren. A typical attractive feature of a glaciated valley is the series of small 'hanging' valleys at the sides, each with its own veil-like waterfall tumbling straight down over the edge; a good example is the Trummelbach Fall in Lauterbrunnen valley.

The stage soon comes in a river's life when its width and depth necessitates the building of wide and strong bridges at convenient places for the passage of road transport, and many of these, as we have seen in a previous chapter, are of great aesthetic appeal to the artist and the photographer. Often at a bridging-point a pleasant small town has grown up, and often the river is the focal point of community life. As you sit on a grassy bank beside the river, or lean over the stone wall of the bridge, your eyes are drawn to the swirling, sparkling, living water. It is a scene which never seems to pall, full of delightful material for the photographer.

The river's appearance varies according to the way you look at it. Viewing down-stream, the impression is generally one of placidity and smoothness; viewing upstream, you see urgency and liveliness, with the water breaking and splashing over rocks and boulders, and this impression is strengthened if you are looking into the sunlight. If you lie right down at the water's edge and peer through the rushes, the scene is different again. The camera should be used appropriately in each case. Automatic exposure ought to produce a satisfactory result if you are viewing with the sun behind you, but shooting into the light usually calls for a slight increase in exposure, as well as for the use of the lens hood. A suitable shutter speed for photographing a rippling stream would be 1/60 second.

For the close view of part of the water's surface through the reeds, focus has to be carefully set. If the nearby reeds are out of focus, the result can still be satisfactory, as long as your view of the water is not too much impeded. It is worthwhile experimenting with shutter speeds. Much depends on the degree of turbulence of the water's surface; and if the stream is so placid that reflections can be discerned, a very brief exposure could give an attractive and unusual effect. If you are at a place where a spider has been at work, the web could play a part in your scene. With a wider view of a stream, animal or bird life could add interest to the composition, and often the association of trees and water can produce visual delight.

A river changes its character appreciably with the geology of the countryside through which it has to pass. Near my home, after the River Clyde leaves the hills and meanders through sandy pastureland, it reaches an area of hard rock, through which it forces its way. At one point the river plunges through a deep and narrow gorge, and after a period of heavy rain the water is wild, brown, foam-flecked and turbulent – a scene much favoured by photographers. A short distance further on, the river plunges down over the fine cascade known as Corra Linn, once the delight of Wordsworth and Coleridge.

Waterfalls were always favourite subjects for photographers. From a low level, the sight of a huge volume of water plunging over a rocky cliff is irresistible, and an obvious theme for a picture or for many pictures. It may be difficult to decide on a shutter speed, and it is interesting to bracket several experimental settings. One temptation with a focal-plane shutter is to use the fastest available speed, probably 1/1000 second, on account of the high velocity of the tumbling water. The result of this, however, is that you 'freeze' the foam and bubbles to such an extent that the waterfall no longer looks natural. Even a speed of 1/125 or 1/250 second gives a result which to many is unsatisfactory. Photographers generally aim at

The photographer has here deliberately contrived a smearing effect of falls and rapids by giving a long exposure (¼ second). Sharpness of the rocks has been achieved by resting the camera on a bean-bag at water level. Monochrome. *John Woodhouse.*

blurring the falling water to a certain extent, giving an impression of rapid movement downwards past the static and sharply-outlined trees and rocks, and 1/60 or 1/30 second is often regarded as a good compromise. For a very ethereal effect, you could try using a long exposure, say 1 second; for this you must of course have a firm base for your camera – a rock or railing, or preferably a tripod.

There are occasions when a waterfall is transformed by severe winter weather into something quite different and extremely striking: it is worth going a long way to photograph a frozen cascade.

When I photographed the lower fall at Rosenlaui, Sherlock Holmes's spectacular place of doom in Switzerland, I was fortunate enough to capture on film a fine clear rainbow, and this could be a bonus for you too at any waterfall caught by the lateral rays of the sun. Among the world's great waterfalls, some of the less exploited are nevertheless

tremendously impressive. The loftiest of all, at a place of breath-taking splendour, are the Angel Falls in Venezuela. In Europe I have seen no waterfalls more enchanting than the sixteen sylvan cascades at Plitvice in Yugoslavia.

Some rivers are attractively busy for long distances with industrial and pleasure traffic, and the Rhine, the Danube and the Volga are good examples. A mature river often becomes the genuine heart of a metropolis, and we closely associate many great cities with their wide rivers, often teeming with boats and people. London's Thames has well-known and fascinating pictorial aspects throughout its length, and the Seine has provided lovers of Paris with many a romantic scene. In the Far East, life on – or even in – a great river, where it passes through a city, can be the theme of colourful photographs filled with human interest.

When a mature river has brought down such vast quantities of silt that it has built a wide delta, as is the case with the Nile, the Irrawaddy, the Mississippi, the Rhone, the Danube and many others, the flat area can become a precious heritage of wildlife, and any of these deltas is well worth a photographer's visit.

Still water and the sea

A waterway is usually a placid and pleasing feature of the landscape, whether it is a man-made canal in north Germany, a sheltered creek in the Canadian backwoods, a stretch of the Norfolk Broads, or part of the Florida Everglades. If the water is very calm, with no wind to cause ripples, a reflection can play a vital part in a photograph. From a vantage-point on the bank of a Dutch canal, you could devise things so that the waterway leads the eye into your scene with an old windmill and a few wooden houses on the opposite shore reflected pleasantly on the surface of the water.

With some canals, including those in Britain which have come back into use through the efforts of preservation societies, the human element will probably play some role in a successful photograph. Old canal barges are often refurbished in a delightful and highly colourful way, and canal people, whether working professionals or vacationing amateurs, are generally in evidence, to add interest to the composition. Some canals, such as the Crinan Canal in the West of Scotland, are inherently picturesque, gently winding their way through pleasant woodlands and meadows, and in summer it is just a matter of waiting at a scenic spot for a canal boat of some kind to appear round the corner and participate in your picture. My favourite Crinan Canal photographs were taken at various lock gates, where I found lively activity and the beauty and serenity of the neighbourhood combining in a harmonious way.

Lakes (inland lochs in Scotland and loughs in Ireland) have long been favourite subjects for photography. They often have tree-clad indented shores and an extremely picturesque setting; and whether you are at an elevated viewpoint above the lake, on a beach beside the margin or in a rowing-boat on the surface, there are always plenty of chances for taking fine pictures. During a camping trip with our two canoes to four European lakes, we found to our delight that some of the wild waterfowl ignored our presence in the boats and participated happily in many photographs at fairly close range; at standard focal length I had no difficulty about camera shake.

Another lakeland paradise is the north of Italy, where some of the most charming lakes are small ones which are not household words to the tourist. A photographic exploration of the region by car, bus or bicycle can be most rewarding. In Scotland, Loch Morlich in the Cairngorms is splendidly nestling among glorious mountains. In England, the Lake District has become so immensely popular that it is much better to visit the area off-season; you will find many of those famous and pleasant lakes photographically well worth visiting. I have a particular liking for the rather despondent Wastwater and the more verdant Derwent Water.

Kitchener Island, the
surprising fertile oasis in the
River Nile, as seen from a
felucca. 50 mm lens.
Edward Archer.

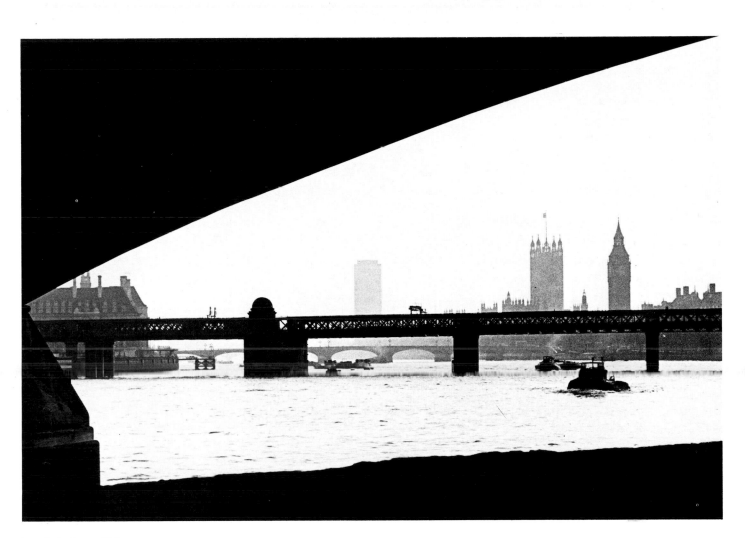

A study in shapes. Taken
from under Waterloo
Bridge, London, using a
55 mm lens. Monochrome.
Raymond Lea.

Practically every country in the world has its beautiful lakes, and although (like me) you might be keeping the lakes of Kashmir and Western Canada in the back of your mind as essential destinations for some future date, there is probably no dearth of lakeside beauty much nearer your home area.

At certain times of day and in certain climatic conditions a lakeside vista can be uniquely enchanting. A misty morning without a breath of wind can give you a setting of etheral loveliness, reminiscent of a Japanese painting; on the other hand, the ripples caused by a playful breeze which has just sprung up could be the making of a fine picture with an entirely different mood. Reflections of the houses of an old lakeside village, such as Hallstatt in the Austrian Salzkammergut or Gandria on the Swiss shore of Lake Lugano, have an appeal that is irresistible. Still water of an entirely different sort is to be found in certain mountainous countries such as Norway and New Zealand. Where the sea has filled long and winding valleys, the resulting fiords can be breathtaking in their splendour. The water is often very calm, and the steep-sided valley placid and gorgeous. Fine colour photographs can be taken from boats or from some of the little landing-stages during the trips along the Nord or Sogne fiords in Norway.

Where the land meets the sea, the photographer has a first-class selection of viewpoints and creative possibilities. From the coast, you can compose pictures involving precipitous cliffs in Cornwall; secluded coves like Lulworth in Dorset; wild breakers at Sandwood Bay in remote Sutherland; flower-girt sandy shores and weird wind-sculpted rocks in Britanny; or the overwhelming beauty of Paleokastritsa's five tiny bays of Corfu.

To take just one example of outstandingly picturesque sea and shore, the Amalfi coast, south of Sorrento in Italy, has many viewpoints from which matchless scenes can be photographed. Certainly some of these views, such as the favourite one of Positano village from the motor road, have become rather hackneyed, and it is up to the individual to decide whether the cry of 'Cliché !' should be allowed to deter him from taking his personal photographs there. A little inland, from the lofty hanging gardens of Ravello, a less familiar aspect of the coast can be captured with the camera, with floral and arboreal foregrounds of great charm.

Small boats are available in that area, and shots of the coastline from one of these can be very attractive. To contend with the movement of the boat, it is advisable to set your shutter at a fairly fast speed; 1/250 second is regarded by many as the slowest in such circumstances, and 1/500 or 1/1000 second would be safer. In a rocking boat, even using a fast shutter speed, you have to be ready for sudden motion. Probably the best stance for you to take up is with feet astride and not leaning against any part of the craft; wait for a lull between sways. A standard focal length should cope with most situations. See that your horizon or coastline is dead level.

Despite your unstable stance, you could experiment with modest telephoto, and also with contre-jour, with perhaps the sun just hidden behind a jagged rock or natural arch. From Alghero in Sardinia, a small boat is available to bring you right up to fantastic geological formations; and from Puerto Pollensa in Majorca you can be taken below the towering limestone cliffs of Formentor.

Other fine small-boat excursions are offered from many resorts along most of the Mediterranean coasts. From Rhodes town, one of the most delightful of all excursions takes you southwards along the east coast, with a pause for a picnic and for a refreshing swim off the boat at a tiny hidden sandy shore, and culminating at Lindos, that most splendid of all Greek landlocked bays. From the island of Korcula or from Dubrovnik on Yugoslavia's beautiful Adriatic coast, you can sail to Mljet, a fantastically gorgeous wooded islet with

The Columns, Ogof
Ffynnon Ddu, Wales.
Underground photography,
using bulb flash behind the
figure, and weak electronic
flash in front.
Monochrome. *Chris
Howes*.

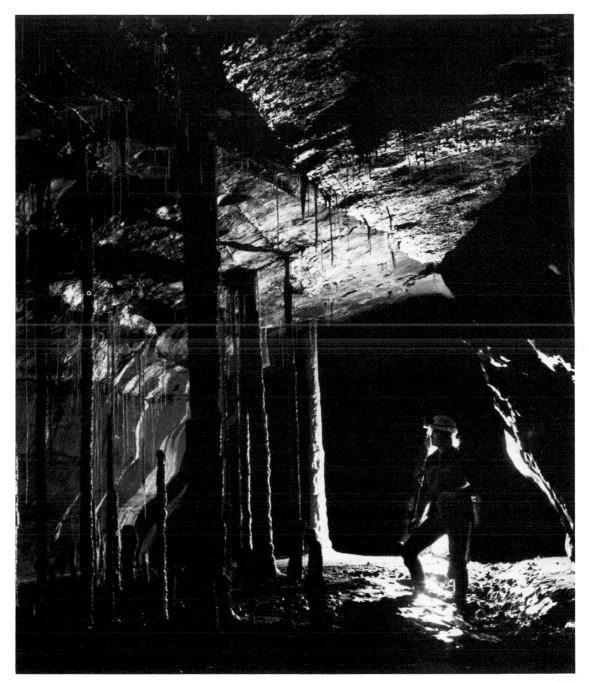

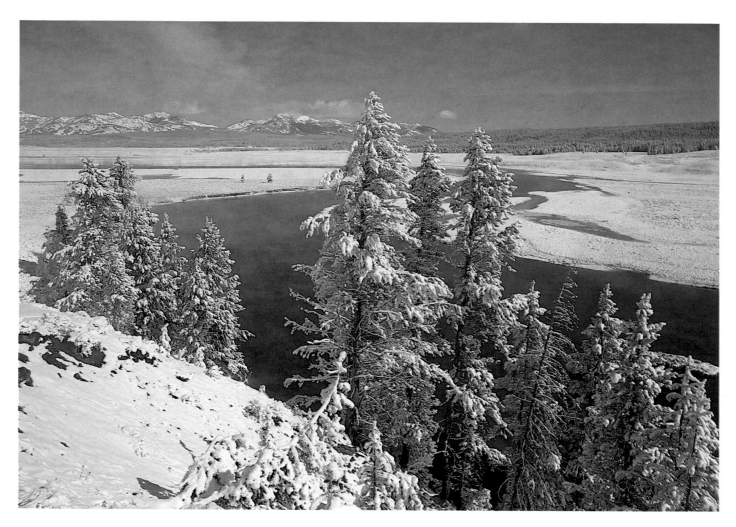

A wide-angle view of
Hayder Valley, Yellowstone
National Park, USA, just
after an autumn snowfall.
The general blue cast is
accurate and effective.
Chris Bonar.

An exciting shot taken on
board an inflated motor
vessel on the Colorado
River, USA, during an
adventurous expedition.
Very brief exposure has
'frozen' the spray. Camera
protection can be seen on
the left. *Gordon McKnight*.

a tranquil and secluded lagoon. The challenge in boat excursions is to see something different – to express your personal interpretation of a beautiful scene.

Out on the open sea, photography can involve a protracted quest for a worthwhile subject. A seascape has to have a centre of interest somewhere: a passing steamer or yacht, a school of porpoises not too far off for the range of your telephoto lens, a tiny enchanted island, a fine cloud effect at an early or late part of the day. It could be that your finest opportunity for creative ocean photography occurs during a wild and fearsome tempest. Bear in mind that if your camera becomes immersed in salt water, it will be a complete write-off, unless you plunge it at once into fresh water and immediately afterwards hand it in for dismantling by an expert. Even then, it could still be a write-off. But of course you will have insured it.

Beneath the surface
These days there is an increasing number of photographic enthusiasts eager to get literally under the surface of things around them and record on film what they find there. You might be given your first taste for beneath-the-surface photography when you photograph a hot spring in Iceland, a geyser in Wyoming or volcanic action in Chile. There is a curiosity in most of us about the strange world beneath our feet, and if circumstances make it possible for us to take a camera there, many of us do.

To some, caving seems a curious recreation, involving a disproportionate amount of discomfort and peril. However, the fact is that thousands are captivated by it, and many who try a visit underground with a caving club emerge with the resolve to return at the earliest opportunity. Not only must the cave explorer be protected against cold and damp and against slippery slopes; his photographic equipment is just as vulnerable. For convenience, many use compact 35 mm cameras fitted with moderate wide-angle lenses and simple

flash units. An alternative is a light automatic SLR 35 mm camera with a wide-angle lens, say 35 mm focal length. Caves can be either very damp or very dusty – perhaps both in different areas of the same system – and your camera underground should ideally be protected, while not in use, in an old ammunition box with adequate padding. Silica gels will help to keep down the dampness.

In underground areas the standard lighting procedure is to use flash, preferably off-camera to provide moulding. With close work, such as photographing the structure of a grotesque stalagmite, one flash unit can be adequate; but of course in a large cavern or beside an underground lake things are quite different. If you are in one of those vast underground cave complexes fitted out with pools of light from mains supplies, and if (as is unfortunately not always possible) you have permission to photograph with flash, an excellent idea is to supplement the artificial supply with the 'painting with light' technique already discussed in the section dealing with photographing church interiors. The resulting colour photographs can show an attractive variation in colour temperature, with ruddy-hued pools of light and cooler general illumination from your repeated use of flash during a time exposure. For this, of course, a tripod is essential. The travelling photographer who is not such a specialist can use simpler methods in caves that are commercially illuminated. In several underground limestone cave formations I have found that using my automatic SLR camera with its 35 to 105 mm zoom lens, if I lean against a rock and hold my breath this is sufficient to give me acceptably sharp available-light photographs with fast colour transparency film.

In Europe there are many fine examples of limestone caves, including notably the Postojnska Jama in Yugoslavia, and the Krizna Grotto in the same country with its fantastic subterranean lakes; also many spectacular cave systems in Majorca, Germany, Italy, Switzerland and Greece. Then there is the amazing Eisriesenwelt (World of the Ice

Giants) in Austria. In many other parts of the world, vast and wonderful cave systems are to be found, in varying degrees of 'civilisation': some with electric lighting through large sections, some with coloured floodlighting, some with orchestral concerts from rafts on underground lakes, others open only to the serious explorer who takes along his own lighting and expertise.

In another category are those like the caves of Lascaux in France, where the incredibly artistic paintings from prehistoric times have been in such danger from contamination that the caves have had to be closed to the public except for specialised visits. In some instances a cave is entered from the sea rather then from the land: one example is near Alghero in Sardinia, where a boat takes you to the entrance. At the mouth of a cave, photography is more successful from outside than from within: the contrast between the darkness of the cave interior and the brilliant sunshine outside is too much, except perhaps towards dusk.

Snow and ice
If you live in a so-called temperate zone, and if you brave the elements and get up early on a hard frosty morning, you are quite likely to find a special quality of light – bright and sharp despite a thin haze. The familiar outlines of fence and hedge, of street lamp and birch tree, are metamorphosed by the crystalline white covering of the frost. If you have a macro lens or other close-up facility, try approaching very near to a frost-covered familiar object such as a leaf or a door-knocker. For sharp detail a suitable reversal colour film would be ISO 25/15° or 64/19°. We all know too that intricate frost patterns are a familiar window-pane phenomenon, and these can be photographed successfully from fairly close.

Other attractive cold-weather subjects are composed of ice. Suspended from a homely gutter above you, there could be a long clear icicle, which can form the subject of an effective picture. If you are beside a stream in the country during severe weather, you can discover scenes of real beauty by getting down on the bank and focusing on the ice at the edge of the water, especially if the ice is at the melting stage, and if the sun is making it sparkle and gleam. Strange and attractive patterns are often formed on pond ice. Sometimes there are bubbles of air trapped below the ice surface, or leaves and small fallen branches lying on top, or else patterns formed by skaters or wildlife on the upper surface.

A fresh covering of dazzling sunlit snow summons many keen photographers out into the open air. Familiar trees and bushes take on a completely new appearance, with softened and rounded outlines not quite concealing the reality underneath. However, it has to be realized that all is not straightforward in snow photography, and if you put your trust in the sophisticated exposure system of your camera in these circumstances you can be somewhat disappointed in the results.

Since an automatic light meter is designed to take an average brightness reading, the fact that snow reflects much more light than, say, a clear blue sky causes the meter to be deceived, and often the snow will be underexposed, appearing as an unattractive grey instead of a sparkling white. If the snow in your scene is directly lit by the sun, you should try an extra one or two stops. As a matter of fact, exposure difficulties in snow are such that it is also possible to overexpose in certain circumstances. Clearly the wise course, if you want to be quite sure of a promising subject, is to take several bracketed exposures: one at the indicated automatic reading, one stop under and two just over. For pleasing renditions of people's faces in the snow, take a reading from the palm of your hand, or else go close and let the meter register flesh tones; then use manual override.

When the sun is at a low angle, it forms long and attractive shadows on the white snow surface. These conditions clearly reveal interesting rough textures – or maybe, if you are very fortunate, bird or animal footprints. Colour can be subtle or vivid

according to the mood you wish to convey: muted pastel shades among the snow can be most effective, but on the other hand a lively shot of a person tobogganing benefits if that person is wearing a brightly-coloured pullover or anorak.

Scenes involving snow incorporate a good deal of ultra-violet light invisible to the human eye, and in addition there is a visible blue cast discernible in shadows in the snow. A UV filter cuts down the former; alternatively, a skylight filter reduces the latter as well. Some photographers, however, regard cutting out the visible blue cast as undesirable, since it is part of the scene. It is a matter of taste.

If you want a really strong emphasis of the blueness of a clear sky to contrast with the white of the snow, you could use a polarising filter at various settings – you can observe the effects through the viewfinder. If you are very adventurous, by all means try the effect of moonlight in the snow, or of a two-second exposure in a brightly-lit snowclad city street. With a fast shutter speed, you can photograph snow falling; in fact flash can be used effectively in the darkness during a snowfall. There are abundant opportunities for fine photography at a winter sports centre high above the snowline. You will doubtless heavily feature much lively and colourful human activity in such a place, and a good viewpoint is from a ski-lift or cable-car.

It is when you decide to travel far afield to an environment of permanent snow and ice that you have to consider preparations more carefully. In the high snowclad mountains, the comments about mountain photography already given in an earlier passage apply. In addition, you have to protect your equipment against the extreme cold. This applies even more strongly in polar regions.

It is no longer likely that you will have to turn in your camera for special relubrication before travelling to a cold country. Modern lubricants – and modern electronic camera circuits – generally

cope with Arctic or Antarctic temperatures satisfactorily. However, batteries are a more doubtful factor, and the most reliable for icy conditions are silver oxide and manganese alkaline. Cold has a deleterious effect on battery life, and you should take spares with you, in a warm inside pocket. When you wind on your film in the camera, do it slowly and without jerking, as it is quite possible to damage or even break a film when the cold has made it temporarily brittle. In addition, fast winding can cause an electrostatic charge to be set up, and this can result in marks on the image. Motor drive is thus not desirable in cold regions.

Lenses suffer temporarily when subjected to quick changes of temperature. When you come into a warm atmosphere after being out in the cold, moisture can condense on the glass surfaces, and you have to allow plenty of time for acclimatisation, perhaps an hour, before photographing indoors. A good plan is to put the camera into a polythene bag while you are outside. Enclose with it a small quantity of silica gel to absorb moisture, and seal the bag. If you intend to go out again soon afterwards, just keep the camera in the sealed bag. When out-of-doors with a warm camera, be careful that no moisture in the form of snow reaches the instrument. The snow could melt and enter crevices, then freeze and expand, doing severe damage. For your own protection, wear thin woollen gloves when handling the camera outdoors: it can become so cold that contact with a metal part could cause injury to your hands. For comfort you will probably want to have thicker gloves on as well, which you can remove temporarily while shooting. In very severe conditions, preset focusing might be found necessary. The best place to keep your camera is in a pocket – not necessarily right under your pullover, since this can cause condensation problems.

Many frigid areas of our world, once considered the exclusive domain of scientists and professional explorers, have become practical possibilities for

the ambitious photographic enthusiast. There are wild and extremely beautiful scenes, featuring glaciers, icebergs, mountains, plants, trees, birds and animals, to be found in the far north of Scandinavia, in Alaska and the Yukon, in Greenland and in Antarctica. The people of polar regions have a way of life that fascinates most of us. For the intrepid traveller, a camera on an excursion to Arctic or Antarctic regions is not a luxury but an absolute essential.

In the tropics

To many of us, deserts and jungles are far removed from our photographic spheres of interest. To some others, the tropical regions of the earth cast a bewitching spell, and are photographically enticing to such an extent that they return to them again and again. The murderous heat and biting cold of the desert, and the sweat and insects and lashing rain of the primeval forest, do not deter the travel photographer who has been genuinely captivated by tropical enchantment.

The extreme heat of the desert calls for just as much concern for the welfare of camera and photographer as does the extreme cold of the Antarctic. The camera should never be left in the tropical sun, even for a minute, and it should be a matter of habit to stow the camera away under a jacket or in the car boot after use.

Protection from the burning rays of the desert sun is even more vital for film than for the camera. The difficulty is to find a place where spare film can be stored until required. A hotel may have a refrigerator which you are permitted to use, but great care has to be taken to acclimatise the film when you remove it, as is the case with polar conditions. The indispensable accessory is silica gel desiccant in small bags, and you should have a good supply of this with you, packed along with your camera. It is a good idea to send home your exposed films by letter post at the earliest possible time, rather than either trusting to local processing stations or keeping the films till your tour is over.

On location in the desert, a picnic coolbox with frozen sachets, of the kind used by campers, is an excellent item to have with you. Alternatively, you could keep equipment and film material in a box which is protected from the heat by being wrapped in a wet cloth. The professional type of aluminium photographic equipment case is often used in the tropics, as the reflective surface keeps down the internal temperature to some extent. Ideally, camera cases should not be black, nor should the camera itself. Some photographers go to the length of burying film and equipment in a box half a metre down in the ground, where temperatures are more stable. This applies by day or by night, since the nights in the desert are generally very cold.

Dust and sand are constant enemies. Grit should be removed frequently and gently from lenses and crevices in the camera, by means of a blower and a soft brush and tissues. Lens cap and equipment case, and skylight or UV filter, will be used as a matter of course, but in addition it is wise to make special provision for extremes. Many photographers make a habit of wrapping the camera in a clean cotton cloth immediately after use in desert conditions. As far as possible, film should not be changed in the open air but indoors, or perhaps in a changing bag.

A desert is not necessarily a featureless expanse of level sand. Some deserts, in Australia for instance, have strange and gaunt red rocks standing starkly here and there; others, such as the Sahara, have high rock-strewn mountains; some, as in the west of the USA, have giant mesas, buttes, towers and arches, made hauntingly familiar to us by John Ford; and where a desert has only sand, the wind has often whipped this up into huge advancing crescent dunes. All these spectacular features are potential subjects for the photographer in search of the unusual. Much depends on the angle of vision which you select: a monument rock may look its most menacing if it is photographed from a very low angle against a relentless sky made more intensely blue by the use of a polarising filter.

As in snow photography, care should be taken in the use of the automatic exposure system, and there is again a danger of underexposure. Sunlight from a low angle, early or late in the day, accentuates the dramatic effect of a desert feature, emphasising the simple shape and bringing out the texture of the sand in the foreground. A familiar sight in the desert is a series of narrow parallel sand ridges formed by the wind, and with a wide-angle lens setting you can arrange things so that the ridges sweep away in a long curve from the foreground into the distance.

An apparently monochromatic desert can become colourful if you photograph when the sun is very low, and the effect is often breathtakingly beautiful on a big screen at the eventual show of slides. If there is some sparse vegetation, such as a thorn bush, this can take up some of your foreground, adding considerable interest to the picture. Reptiles and mammals and insects find a way of living in many deserts, but these creatures are usually fairly small and elusive. Most of them appear only when the light is getting dim, and they can scuttle away very briskly while you are setting your lens. Such pictures generally call for long focus rather than macro facilities.

Those who travel to humid equatorial regions have to care for their equipment and film even more meticulously. Added to the effect of the burning sun is the potentially disastrous dampness, which can cause the growth of mould on film, on camera cases and even on lenses. Silica gel drying agent should again be used; if it is the type which is indicator-dyed, it should be exchanged for fresh supplies when it becomes pink. The gels can be used again when their colour has reverted to the original blue.

Generally in extensive equatorial forest areas there are rivers, used by the local inhabitants as the principal mode of transport, and from a river like the Congo or the Amazon there are opportunities of seeing and photographing wildlife on the banks.

124

Otherwise, a forest clearing, perhaps the location of a native village, is a good photographic base. There are few problems of temperature variation in the jungle as are found in the desert; but tropical forests and swamps make up for this by providing a proliferation of unpleasant insects and dangerous reptiles. Reliable guides are a necessity.

Jungle and swamp photography is exacting, but with perseverance and patience you can capture on film many really wonderful and startling specimens of animal and bird life. Mammals and insects in the jungle are mainly small in size, and hard to find and photograph. The creatures are also notable for their highly effective camouflage, and you have to search patiently as well as know about their habitats. The great reward comes when you discover an incredibly beautiful butterfly, lizard, hummingbird or snake, at a respectable distance from you but within reach of your long-focus lens.

Exploration and expeditions

If as a photographer you have become attached to a group of people intending to set out on some sort of expedition, simple or elaborate, you will have a good deal of advance planning to do, to a large extent in connection with the equipment you are to take and the procedures you will carry out to protect it. These matters have been touched on already in this book.

One essential prerequisite for the expedition photographer is a good deal of experience in whatever physical activities are anticipated. Almost certainly you will be called upon to join the others in arduous tasks – working at a faulty Land Rover engine in the Australian desert; helping to ford a torrent in the Indonesian jungle; repairing a torn section of a canoe in the Grand Canyon; helping to deal with a recalcitrant sail in gale conditions at sea – so it is more than ever vital that you have photographic techniques at your fingertips. Use of the camera has to be second nature, and you cannot afford to make any mistakes or to keep the team back. Before setting out, you will have decided on

the best apparatus to take, the best protection for it, the best lens to have fitted ready for action, and the best type of film material to cope with the opportunities and challenges in prospect.

The expedition photographer will make optimum use of good vantage-points for recording the group's progress. Often you will have the exacting task of getting just that little way ahead of the main party: up the side of a steep valley along which the rest are due to pass; down beside the swift river to photograph as they cross the rickety footbridge overhead; even looking down from the mountain summit as the others scramble up to follow. It may perhaps be possible to make special trips to photograph progress from the air. In fact, one of the most important ways of exploring our world is from an aircraft, hired specially for the purpose. This is not always impossibly expensive: in some remote parts of the world, such as the north of Norway and Finland, the wilds of Alaska and the Yukon, and the forests of New Guinea and Queensland, air travel is commonplace and economic.

Most expedition photographers, whether in the air, at sea or on the ground, use 35 mm single-lens reflex cameras and colour reversal film. The eventual colour transparency is doubly valuable: it is the form of photograph most acceptable to book and magazine publishers, and it is the best possible medium for displaying the achievements and experiences of the team to large audiences. Using either reversal or negative material, it is possible to make high-quality big enlargements, and to set up, in an exhibition centre, wall displays with clear explanatory wording; but this can only be regarded as a rather impersonal second-best. No enlarged colour print can approach a first-class projected slide for sheer impact. The sale of photographs to publishers after the expedition can benefit the funds of the project substantially, as can a series of slide shows in cities and towns, with commentaries by some of the participants.

125

Ways and means

The reader of this book will doubtless have already chosen a camera, probably long ago, and will have become so familiar with its basic operation that he is able to use it almost without thinking. Nevertheless, for the relative beginner and also for the enthusiast wishing to widen his scope, it might be useful at this juncture to gather together a few points about photographic apparatus as related to the needs of the traveller.

Choosing a camera

Any camera which is in good working order may be used successfully by the travel photographer. However, some types of camera are much more appropriate than others for circumstances likely to be encountered in travel. Important factors to be taken into consideration when you are selecting equipment for photography on location include reliability, portability and versatility. As regards reliability, there is the general principle that the more you spend, the more you get; but there are exceptions to this, some inexpensive cameras having a high reputation for good design and sturdy construction. Comparative tests in the magazines are worth studying, and a recommended dealer should be able to help the prospective purchaser.

When you are making purchasing decisions, you should keep in mind your photographic and travelling objectives. If your needs are strictly limited, with your photography confined to fine weather and straightforward situations, and if you have no ambitions about making photography a major consideration in your travels, and are not concerned with photographic creativity, then there is no point in investing heavily in sophisticated equipment. We see everywhere the tiny snapshot camera with its satisfied owner: it is an instrument which fills the photographic requirements of

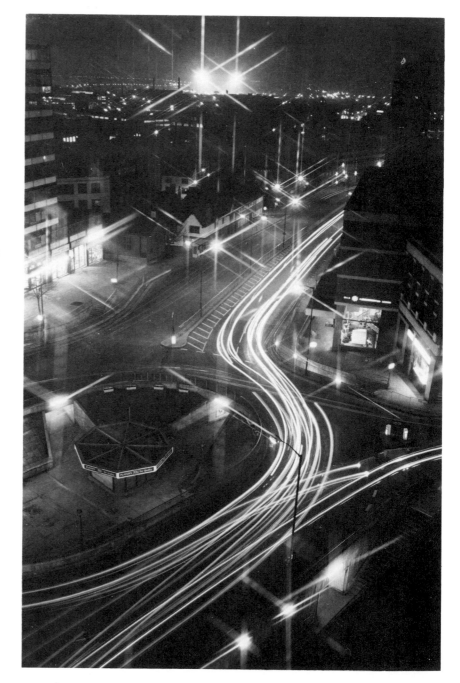

Left: a 10-second time-exposure shot, taken at dusk so that details are retained in the shadows. Long exposure renders headlamp beams as streaks, with vehicles invisible. Starbust filter, 35 mm lens. *John Woodhouse*.

The most popular film size, 35 mm. It is used for two formats, full-frame and half-frame as shown.

Several formats are covered by 120, 620 and 220 roll film. The large picture sizes are popular with professional photographers because of the high image quality, which 35 mm cannot attain.

Simple cartridge-loading films, 110 and 126. No threading is involved in loading the camera. The cartridge is dropped in and the back closed. The very small size of 13 × 17 mm has proved successful.

Perforated 70 mm film, which can be used in some 6 × 6 cm cameras.

millions of users all over the world – in fact, for the vast majority of people who travel with a camera. This simple point-and-shoot device has become so highly perfected in design and construction that there can be little possibility of something going mechanically wrong. There is also very little chance of error on the part of the casual photographer, and we must not lose sight of the fact that these days the average commercial colour print enlarged from a sub-minature negative, processed automatically by mass-production methods, is found by the user to be perfectly acceptable. At best, it has to be said, the end-product can be so good that it may cause a raising of eyebrows among photographic cognoscenti.

Until recently, the snapshot mini-camera was designed around a lightproof double cassette containing a roll of colour negative film. The square-format camera taking 126 film was superseded to a great extent by the 110 design, providing 12, 20 or 24 exposures with rectangular format. The situation has been radically transformed by the emergence of the disc film, which has had outstanding success with snapshotters. This provides 15 rectangular frames on a disc instead of a roll, each frame even smaller than the 110 size, but resulting in images not noticeably inferior to 110 pictures, owing to the use of new fine-grain emulsion techniques. Disc has one advantage over sub-miniature roll film: because of sophisticated camera design, incorporating automatic exposure control and automatic electronic flash, there are fewer wrong exposures, and hence there is less wastage.

A travel photographer, far from scorning the concept of the mini-camera, sometimes carries one as a second instrument, valuing its extreme compactness and readiness for action. The cheap sub-miniature camera has been found to be appropriate for tricky moments in mountaineering, in pot-holing and in candid work. If you are attracted by the idea of a small camera, but would like to produce somewhat larger pictures, there is

15 exposures

8 mm

10.5 mm

Kodak disc cameras have a film format even smaller than 110. However, it is claimed that the system design produces better picture quality.

the half-frame 35 mm camera to consider; a bit hard to find now, but really remarkably small, and capable of enlarged prints or good transparencies with fine detail not obtainable from the sub-miniature. The latter was never intended for the person who wanted big enlargements, or transparencies rather than prints.

Far and away the favourite type of camera for the serious travel photographer is the full-frame 35 mm, and there are many reasons for its overwhelming popularity with those who look for quality results. There are two basic designs. Each takes film in a cassette, providing 12, 20, 24 or 36 exposures on a roll, each picture 36 × 24 mm in size, in colour for prints or slides, or else in monochrome for prints. The two types of camera differ fundamentally in their methods of viewing and in their lens systems.

The simpler 35 mm camera, the compact or viewfinder model, can be nearly as pocketable as the sub-miniature. It has viewing separate from the taking lens, which means that what you see is not exactly what the camera takes. This parallax effect can result in 'cutting off heads' if you forget to allow for the optical deficiency. Usually a viewfinder camera has one fixed-focus lens giving a moderately wide field of view. This renders it suitable for general photography covering many

Ease of use coupled with versatility make the 35 mm single-lens reflex the most widely-used style of camera among serious photographers.

The 35 mm compact with its fixed lens and auto functions can produce good-quality snapshots, but it is not recommended to the serious photographer.

The rollfilm single-lens reflex combines the advantages of the 35 mm format SLR with a larger format.

no apparent difficulty, managing to stow the camera away in a polythene bag and seal it before plunging into the Mediterranean. Some viewfinder cameras have focusing lenses; there are a few others of a much more sophisticated design which have rangefinders, interchangeable focusing lenses and provision for parallax adjustment according to distance.

The second type of 35 mm camera, the single-lens reflex, is far more versatile than the viewfinder camera, and is so appropriate for every need of the traveller that this book has concentrated on it. It is assumed here, in fact, that any person who wishes to get the most out of travel with a camera is almost certain to come round to purchasing a 35 mm SLR camera, if he has not done so already. While it is somewhat bulkier than the smallest viewfinder camera, its weight has decreased noticeably in recent years, and the owner of a modern 35 mm SLR camera seldom feels like complaining when the advantages are so obvious. Through-the-lens (TTL) viewing and focusing means that what you see is precisely what the camera takes. A good choice of lenses and other items of equipment is available for every 35 mm SLR camera. Other advantages are manifold, and should be evident to anyone who has read the book up to this point.

There is an alternative possibility for the perfectionist. Medium-format cameras produce 120-size negatives or transparencies, much larger than those from 35 mm, and these should logically be superior in definition. Some medium-format cameras offer a facility (at a price) whereby you can use lightproof film holders to interchange two kinds of film at any stage. These cameras are bulky, however, and for this reason are not often the choice of travellers wishing to avoid undue burdens. They are also expensive. It is generally accepted, too, that the quality of film and processing is now so far advanced that it is often impossible to tell from a full-page book illustration whether the original transparency was 35 mm or medium format.

situations, particularly views and groups, and the wide-angle lens has good depth of field, making it largely unnecessary for the camera to have a focusing lens. The lens in a simple compact camera is normally designed to give adequately sharp focus from about a couple of metres to infinity. A friend of ours in Corfu carried one up with him on a four-minute speedboat paraglide, and took half a dozen very acceptable photographs up aloft with

You might consider the purchase of an instant camera as an addition to your outfit. This enables you to give personal photographs on the spot to people you meet on your travels. The instant photograph has also become regarded by some as a palliative for presenting to an inhabitant of an undeveloped country in return for services rendered. In addition to your camera, you should have a lens hood, a lens brush and cleaning tissues, a skylight or haze or UV filter, and a case for camera and accessories.

Looking at lenses

One major decision must be made at the outset by the purchaser of a 35 mm SLR camera. It is customary for the dealer to sell the camera complete with lens, and nine times out of ten this is a standard lens with a focal length of about 50 mm. There is no doubt that this can cover a large proportion of the photographer's requirements, having the same all-round uses as the lens of a viewfinder camera. The standard lens supplied with an SLR camera is quite likely to be the very finest optical product of the manufacturer, with a superb performance. Its maximum aperture, probably $f/1.8$, will be very useful for available-light photography, and if you want to photograph in dingy circumstances this aperture will make viewing and focusing easier.

Despite this, it is worth taking a little time to consider before settling a deal including a standard lens. Your supplier will probably be willing to sell an SLR camera either without a lens at all or with a lens of your own choosing. Lens quality has improved appreciably in recent years, and it is no longer necessary to insist on a standard prime lens simply because of its optical superiority. Many alternative lenses produce results with good contrast and definition. The other note-worthy point is that swift progress is being made in film-emulsion technology, and fast films are no longer objectionably grainy. Thus a very wide maximum aperture is not such a necessity as it once may have been.

However, if you have already purchased an SLR camera with a standard lens, this is not a matter for regret, and it is likely that the lens will serve you well and provide much satisfaction, as well as having the advantage of compactness. Nevertheless, if you are going to get your money's worth out of your camera, you will eventually want to have one or two additional lenses. Throughout this book you will have come across many instances where the traveller is advised to use either a short or a long focal length, rather than a standard one. In many situations, in fact, a 50 mm lens alone would prove to be quite inadequate for really successful photography. This applies particularly to photographing nature in all its aspects. It applies equally well to photography of buildings, mountains and sporting events, and perhaps most of all to frame-filling portraiture, which should be at long focus if you wish to remain on speaking terms with your subjects afterwards.

A good set of lenses for the travel photographer might consist of the moderately wide-angle 35 mm, the standard 50 mm and the moderate telephoto 135 mm; and through the years this sort of outfit has become almost traditional. There was always a slight nuisance involved in changing from one lens to another, especially in difficult geographical or climatic conditions, and there was always the possibility that an ideal focal length for a certain subject could be in between two. This is where the variable focal length or zoom lens comes into its own. This type of lens had a shaky start, since its optical quality was liable to be doubtful. That no longer applies, and the best zoom lenses from camera manufacturers or the major independent lens manufacturers leave little to be desired in quality. Many zoom lenses give admirable results, especially at apertures around $f/5.6$ or $f/8$, and there is an increasing number which cope well with exposure even at the widest and narrowest apertures. One minor objection to the zoom lens is that it often has a maximum aperture of about $f/4$, and this could be considered rather inadequate for low-light focusing. In most situations encountered

by the travel photographer, however, $f/4$ proves to be quite sufficient; if you wish to photograph a very dark scene, perhaps of an interior or a street at night, you can use the camera focusing scale.

The advantages of zoom lenses have been stressed many times in this book. They enable you to select precisely the visual angle you require in order to frame your composition pleasingly. At maximum telephoto setting, focusing is comparatively critical, and you soon appreciate the facility of focusing at the long-focus end and then immediately framing your subject. Zoom lenses save an inordinate amount of time, whether or not you are in tricky circumstances. With a zoom lens you can deliberately shoot from a distance which gives a certain desired perspective effect. A zoom lens can also help you to decide quickly on a manual exposure setting without having to walk right up to your subject.

A good choice of zoom lens for all-round use by a travelling photographer might be a moderate one covering a range of 35 to 105 mm focal length. I keep a lens of this type fixed to my camera most of the time, and it is so compact (85 mm in length) that I can stow the camera away between shots in a small-size rigid shoulder-bag, with its lens, hood and filter attached. For special circumstances, you might well later on opt for a longer telephoto lens to add to your outfit. To keep weight down, some might prefer as an addition a small $2\times$ teleconverter, rather than the long telephoto lens. The converter is fitted between camera and zoom lens and doubles the focal length. Lens quality is adequate at medium apertures. These are, of course, only suggestions, and for the purchaser there is a bewilderingly wide range of equipment to choose from.

This does not by any means exhaust the range of options open to the SLR camera purchaser. Many zoom lenses incorporate a so-called macro facility, enabling the photographer to get in really close to a small object. If the zoom lens which you fancy –

perhaps one you prefer for reasons of optical performance and compactness – does not have this macro facility, you have several alternative possibilities. One is to purchase a macro lens (with fixed focal length) at the outset. This will give you high-quality results both for normal purposes and for very close shots. The simplest macro device is the supplementary lens, which you attach to the front of your prime or zoom lens. This enables you to get close to your subject, and does not require additional exposure. Two or three supplementary lenses, of different magnifications, may be used at one time to increase the enlargement; but the snag is that this degrades the image to a certain extent.

For rather better quality of image combined with economy, you might use extension tubes or rings. These fit between lens and camera, and again may be used singly or as a pair or a set of three, according to the enlargement you require. If you buy the automatic kind, you will still be able to focus at maximum aperture and then take at the aperture you have selected for the photograph. Although tubes cut down slightly the amount of light reaching the film, this is allowed for in a TTL exposure system. An elaboration of the tube method is the bellows, which is much more versatile but is designed for the specialist in the studio rather than the travel photographer on location. One other type of lens, the perspective-control or shift lens, is designed mainly for the person who specialises in the photography of buildings. This type of wide-angle lens can be decentred so that you obtain parallel verticals rather than converging ones in a photograph of a tall building. The device is understandably expensive, and other ways of dealing with keystoning are dealt with in an earlier chapter of this book.

It is customary for a photographer to keep a skylight or haze or UV filter permanently fitted to each lens for protection. As this adds an extra glass surface, it is advisable to keep a lens hood fitted permanently as well, to guard against flare; a

rubber one can be doubled back for compactness when the camera is put into its bag. Make sure that the corners of a wide-angle image are not vignetted or cut off by the hood; if so, then you can probably draw back the rim of the hood to a certain extent when you are using a short-focus setting.

Essentials and options

Even a person with modest photographic aims is quite likely to find a tripod useful, and this does not have to be an impossibly weighty item. It will come into its own if you undertake night photography, remote-control shots, photography by available light in churches or cathedrals, experimental time exposures in a busy street, self-portraits, small-aperture deep landscapes, or some kinds of nature photography.

A tripod is a natural partner for an extreme telephoto lens, such as 750 or 1000 mm, whether this be of the normal type or the shorter and lighter catadioptric (mirror) design. The very fact that the latter weighs less than its traditional counterpart makes it more than ever necessary for a firm support to be provided. Users have found that 1/250 second is just about the minimum safe shutter speed for hand-holding a catadioptric lens. Such is the magnification of this lens that even a tripod-mounted camera can give you a blurred picture, and your tripod would have to be a sturdy one and hence a heavy one. Another trouble with a mirror lens is that it has a fixed small aperture, such as $f/8$, and this can require a slow shutter speed. Clearly the catadioptric lens is for the specialist.

One way of increasing your chances of obtaining a sharp image is to use a flexible cable release in conjunction with your tripod. A good alternative is your camera's delayed-action mechanism, which has the incidental effect of reducing vibration. Delayed action enables you to take the customary self-portrait, or the scene involving youself looking into a landscape, or the group picture including yourself. It also enables you to take pictures from all sorts of odd viewpoints.

Camera-steadying devices are important with long focal-length lenses. They include tripods and minipods, as well as pistol grips and shoulder grips.

One item which has come to be regarded as an essential accessory, or even as an integral part of the camera, is a flash unit. Since the virtual demise of replaceable flashbulbs, which have been largely superseded by electronic tubes, using flash has become second nature to many photographers, from beginner to expert. The simplest of sub-miniature cameras normally have provision for small flash units, and the disc camera is designed to use the flash facility automatically when necessary.

The real advantage of a flash unit for photographers is that it enables them to use fine-grain film in low-light circumstances. The owner of a good 35 mm SLR camera often aspires to flash equipment that is rather more versatile and powerful. One of the disadvantages of flash in portraiture is that the reflection of the light in the eyes of the subject can be noticeable and displeasing in the final photograph. This may be avoided by using a special flash unit with a tilting 'bounce' head, and the latter has another advantage in that the reflected light from a white ceiling gives a less harsh and contrasty image.

Normally a flash unit is temporarily fixed to the camera and synchronised by means of a convenient 'hot shoe' on top of the camera, but somewhat more natural results with better modelling are obtained if your camera has provision for connecting the flash unit by remote lead. The flash unit can then be fixed on a bar alongside the camera, or else held by the camera operator or by an assistant. The person who wishes to specialise in portraiture rather than in straightforward travel photography can investigate the practicality of using more than one flash unit, and a multiple system can serve many purposes for the specialist, including photography in large buildings or in underground caverns. Flash may be employed in good lighting conditions outdoors, for the purpose of filling-in dark shadows. For this, a flash unit is generally set to a larger aperture than that of the camera. To obtain natural-looking results with fill-in flash, some trial and error is advisable.

The duration of an electronic flash is much shorter than the normal duration of your camera's shutter opening, and there has to be precise synchronisation between the two. One of the few failings of the SLR camera is that in flash photography its focal-plane shutter must generally remain open for 1/60 second or longer, or else only part of the scene will be exposed; and this slow shutter speed must be borne in mind when you are using outdoor fill-in flash technique. A viewfinder camera with a leaf shutter can use shorter shutter speeds.

With flash, the exposure is determined by the duration of the light, and not by the shutter speed. The only adjustment you have to make is of the aperture, which you set to suit the subject distance. The normal way is to use a simple calculation involving the 'guide number' of the flash unit. Modern flash units work automatically by means of a sensor, which measures the light reflected from the subject and ingeniously cuts off the flash as soon as the subject has received the amount of light needed for correct exposure. With some cameras using 'dedicated' flash units, an indication in the viewfinder informs you, after each shot, whether the exposure was precisely accurate or not.

Now that very fast films have appeared on the scene, giving good definition and little evidence of grain, the number of occasions when flash is essential has decreased markedly. With a film of ISO 1000/31° speed it is quite feasible to photograph automatically in conditions hitherto considered altogether too dim for available-light photography. This applies even more to a camera with a fast standard lens – $f/1.8$, for instance, or the more expensive $f/1.4$ or $f/1.2$. Perhaps here we have a case for thinking again about initial choice of equipment. Some feel that with the arrival of really fast film, the wide-aperture standard lens will come back into favour as an alternative to the automatic dedicated flash unit. The trouble is that there is no system at present available making it possible to replace a partly-used fine-grain film in a

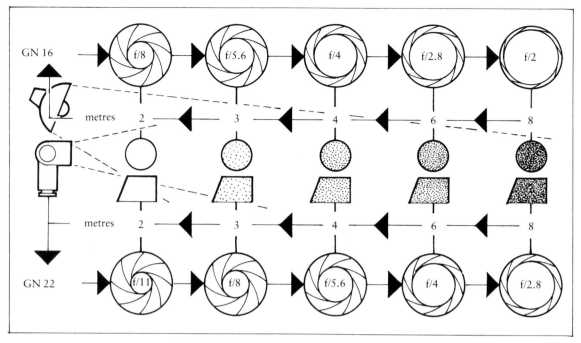

The inverse square law is used with flash and tungsten lights to turn a 'guide number' given for a particular light and film-speed into the required aperture at any set distance. To find the aperture needed, divide the distance into the GN.

matter of seconds with a film of high speed – except, of course, a second camera body.

There are many special filters available which alter the colour balance of your picture, or give small shiny objects an attractive though artificial sparkle. There are also special 'fisheye' lenses, which create distorted ultra-wide-angle images extending through 180 degrees. A polarising filter can be useful in cutting down unwanted reflections, and in intensifying the blue of the sky for dramatic effect. Your decision whether or not to purchase any of these specialist accessories depends entirely on your photographic outlook.

Much ingenuity in recent years has been directed towards the design of cameras with some form of automatic focus. With one auto-focus system, used mainly in inexpensive cameras, the camera emits a signal light beam and measures how it bounces back from the subject. Another method is particularly successful with high-contrast subjects

in good lighting, and is based on the camera measuring the contrast level in the subject.

A third method, the so-called zero-in system, measures the light passing from parts of the subject through opposite halves of the lens, and this method copes satisfactorily not only with high-contrast subjects but also with those of rather low contrast. This system brings the auto-focus lens swiftly into sharp focus, and gives an audible indication that all is ready; you then press the shutter release. The focus measurement is taken from the small central microprism section of the viewfinder image; this means that you can focus on a subject placed in the centre of the composition, then move the camera round slightly so that you have subject at one side in a more pleasing position. Focus will remain fixed till you release the shutter.

Further remarkable facilities are available if you combine zero-in auto-focus with a winder or motor drive. In fact, you can set a winder so that the

subject, perhaps a hummingbird or a fox, actually fires the camera the moment it comes into focus. Or you can use a motor drive so that the camera keeps on firing several times a second, just as long as the subject remains in focus. There is not yet a device for selecting a pleasing composition and doing away with the photographer altogether....

The end product

Many a person with a hobby is so addicted to 'hardware' that he seems to regard the apparatus he uses as more important and interesting than the end-product. This is all too apparent in certain camera clubs, in which more excitement is engendered at a 'bring your camera' night than on the occasion of a visiting speaker. We are often reminded by expert photographers that the classical painters did not spend hours comparing brushes. Nothing is more important than the picture, and the actual form of this final product of the travel photographer's endeavours is worth a good deal of consideration.

The great majority of photographs taken these days are in colour, and the end-product takes the form of a paper print, enlarged from the original negative by a commercial processor to a standard 'enprint' size. The surprising thing is that such a large proportion of the prints produced with little or no intervention from the human element are perfectly satisfactory, with good colour rendering and sharpness. They are supremely convenient to carry about in pocket or handbag. It is small wonder that colour prints are more popular than any other kind of photograph.

If you choose to be with the majority and use colour negative film, handing over the entire developing and printing process to a commercial firm, this does not automatically free you from all humdrum tasks. There is something profoundly unsatisfying about a large cardboard box full of prints of varying vintage and quality and featuring a miscellany of subjects. With the best will in the world, it is possible for any person, soon after returning from a period of travel, to stow batches of processed prints away in a drawer to be attended to at a more convenient time – which never seems to occur. Prints can pile up alarmingly through the months (or even years) until it is hard to identify or date them. The time to sort out your prints, then, is just as soon as possible after your homecoming. The best place to keep any collection of prints is in an album. This need not be an expensive item: in fact, you can economise by using a simple loose-leaf A4 notebook with blank pages. But most people will prefer to buy an album made for the job.

Your first tasks are to arrange your pictures in approximate chronological order, then to submit them to a rather ruthless weeding-out process. This is where you discard any photographs which are defective – out-of-focus shots, pictures spoilt by camera shake, shots in which the subject has an unfortunate expression, pictures with excessive flare, and so on – unless the subject-matter is so vital that quality takes second place. You will also probably discard all but one of a set of bracketed shots, each of which was taken at a different aperture or lens setting. If a number of differing shots have been taken of the same subject during a holiday – perhaps of a bay or a mountain – you will want to weigh them all up and pick the best for your album, relegating the remainder either to an envelope or to the waste-paper basket.

There is no need to stick rigidly to a chronological arrangement in the album. If at various times you have taken photographs in one area, you will probably want to put these pictures on the same page. You could have made a point of photographing one scene in contrasting climatic conditions, or even during the four seasons, and the point will be brought out if you bring the prints together. Naturally a series of photographs taken during one excursion will be most effective if they are set out together on one or two pages. There is sometimes the possibility that you can place contrasting or incongruous subjects in witty juxtaposition.

If your processor returns all photographs with white margins, you will perhaps agree with me in preferring to cut all these off. The same applies to curved corners. You will often want to cut further, in order to remove extraneous objects from a picture, to improve subject placing, or to suit the format to the shape of the main subject. The fact that every photograph comes in a standard size and format does not mean that they must all remain that way. A large proportion of photographs positively benefit by judicious and careful trimming. Cutting must of course be perfectly straight and at right angles. If a horizon is a trifle askew, the use of a set-square and a knife to trim the picture will work a real transformation.

The planning of each album page so that four or five pictures with a common theme are set out together is quite a pleasurable task. Leave spaces for brief notes and dates. If your album is not one of those ones with special transparent plastic pages, you can fix your prints in place by the use of a small piece of double-sided self-adhesive cellulose tape in each corner, or by means of a special adhesive brush. If you have an artistic bent, you could improve things significantly by adding here and there small line drawings to complete a page. Often a simple sketch-map will give interest and meaning to a set of pictures taken in a faraway place.

Many travel photographers like to retain, at least for a time, all the strips of negatives, although they may be quite ruthless in discarding prints that are less than perfect. Each short strip of film can be put in a separate transparent wallet, and all the negatives from one film can then be put into an envelope, with particulars written on the outside. More elaborate systems can be devised if you take large numbers of photographs. The number of each picture should be written lightly in pencil on the back of the print to correspond with the negative. It is important to store your photographs, whether loose or in albums, in a cool and dry place. Where there is humidity, use packages of silica gel and airtight containers.

You may want to give pride of place to some of your best photographs as a modest display on the wall of your study or sitting-room. Specialist photographic processors will devote particular care to making big enlargements to your specifications. It is advisable to place your framed pictures so that the sun never shines directly on them. Colour dyes are liable to fade if subjected to bright sunlight over a period of time.

Many photographic enthusiasts regard the printing of their own colour enlargements as one of the most fascinating aspects of the hobby of photography. A common procedure is to decide from commercial enprints which pictures are worth special enlarging treatment, and to undertake this in the home. Modern methods have simplified the process greatly, and any owner of an enlarger can carry out the task without undue difficulty. If the head of your enlarger does not have a filter drawer, you will have to change it for a colour enlarging head. You will want a processing drum, which makes it possible for you to process your colour prints in daylight. Also buy a set of colour filters, and the appropriate chemicals and paper. Detailed instructions are readily available from suppliers.

Recent advances have attracted many more photographers into the field of home colour-print processing. These innovations involve special apparatus, and enable you to make colour prints without the need for exact temperature control and without even a washing stage. Only one ready-mixed chemical is involved, and a print can be processed completely in a matter of ten minutes. At the moment, however, the apparatus for this rapid system is quite expensive, as are the prints. The quality of the enlargements is excellent.

Finally, it should not be forgotten that good black-and-white enlargements can be extremely pleasing, and that the process is cheap and straightforward. Interesting creative work on a monochrome picture may be carried out in the home darkroom.

Colour transparencies

The colour print, with its advantage of sheer convenience, has one inescapable flaw. Even at its very best, a colour enlargement on paper cannot be compared for clarity, brightness and faithful colour rendering with a good colour transparency. The basic reason for the superiority of the transparency is that it uses transmitted and not reflected light.

The person who travels purposefully with a camera, and whose aims extend somewhat further than securing record shots for the family album, uses reversal film as a matter of course. The professional travel photographer has little alternative: he stores his hundreds of photographs not as negatives and prints but as mounted slides, properly indexed, knowing that publishers of magazines and books prefer to work with transparencies because the results on paper are better and are easier to obtain. Film manufacturers offer a wider range of speeds and types of film for transparencies than for prints. The normal way for the traveller to show to the public his photographic record of a journey to unfamiliar places is by projection of slides on a screen, rather than by setting up a series of display boards with expensively-made big colour enlargements and descriptive captions.

If some prints or enlargements are really needed, this offers no difficulties to the user of reversal film. Commercial processors produce enlargements from positive transparencies on request. For the person who does home colour-print processing, either negative or positive film may be used. With some processes, the positive transparency is preferable. Well-exposed transparencies with fairly low contrast give the best results.

So if you anticipate that you might wish to show a selection from your travel photographs to a number of people simultaneously for optimum effect, or if you have a private dream that one day a publisher might be persuaded to accept some of your colour photographs for publication, or if you simply want to see your colour photography at its very best – then the choice is really taken out of your own hands. You will opt for colour transparencies from reversal film. The fact that you will probably be saving money is an incidental bonus. You can simply send away your exposed roll of reversal film or hand it to a dealer for processing, or else you can process it yourself if you don't object to dabbling in chemicals. On the whole, the results from commercial processors are uniformly acceptable. I have found that some of the transparencies which I processed myself twenty years ago have suffered from loss of colour quality, while all those commercially processed are as perfect as they were at the start. (Admittedly, this may reveal something about my insufficiently meticulous processing methods at the time, or about variation in brands of film).

Transparencies are returned from a processor unmounted, or as slides mounted on card or plastic. Card mounts are not very durable, especially for use in some automatic projectors, and you may prefer, as I do, to remount your best pictures in inexpensive plastic mounts. Here you have a choice: you can use glass mounts or glassless mounts. The advantage of mounting each of your transparencies between two pieces of glass within the plastic mount is that the film is protected from finger-marks and some other kinds of damage. It is worth noting also that a glass-mounted slide will not 'pop' out of focus when heated in the projector.

However, to offset this there are reasons for not choosing glass mounts. If, as is likely, some moisture is trapped between conventional slide glasses, the rainbow phenomenon of 'Newton's rings' may occur where the transparency touches the glass, and this effect is clearly visible on the screen. It is very difficult to ensure that no dust is trapped between the glasses, despite careful brushing before mounting. In fact, too much brushing creates static electricity which attracts more dust. In time, bacterial fungus has a way of growing between glasses. You can minimise

Mount for slides on 35 mm film. The aperture can be for half- or full-frame pictures.

Simple hinged plastic or card mount. The two halves are closed to hold the transparency and sealed with adhesive coated on one half.

3 cm square mount for 110 slides.

A more elaborate type of plastic mount that may or may not be fitted with thin glasses. The two halves clip together.

Mount for 6 × 6 cm and 6 × 4.5 cm slides. The mask openings trim off a considerable amount of the picture, as can be seen by their dimensions.

Mount with glasses held in position with the transparency in between by a sliding portion of the mount.

Wholly glass mount in which the tranparency is sandwiched and sealed. The transparency is held in a paper or foil mask, the two glasses are placed under and over it and the edges sealed with gummed paper strips.

Slide spotting. Top: an easily seen spot is stuck at the bottom left of the picture when it is viewed right way round. Centre: the slide goes in the projector with the spot at top right looking towards the screen. Bottom: slides in their right order can be marked so that any slide out of order or missing is immediately detectable.

'popping' by gently warming glassless slides before a show.

Your decision about slide mounting depends, then, on several factors. You may be finally influenced by the cheapness of glassless mounts, or by the weight of glass-mounted slides, or, most important of all, by the danger that you – or the GPO – might drop a box of slides; fractured glass could ruin some of your precious transparencies. If your slide mounts are white on one side and black on the other, mount each slide so that the white side will be facing the lamp of the projector. There is a correct 'spotting' practice: if you are holding a slide the right way round and the right way up, mark a dot in the bottom left-hand corner, where your right hand would hold the slide if it was inverted for manual projection. Remounting your transparencies gives you the opportunity of improving a badly-framed image. Commercially produced aluminium masks are available in various shapes and sizes, and a picture can be transformed by a slight change of format, just as is the case with prints on paper.

There is no reason why the user of a 35 mm camera should slavishly accept the standard format (36 × 24mm) for every one of his pictures. My own feeling, in common with very many photographers, is that this stretched 3:2 aspect ratio – the 'dishtowel shape' – leaves a lot to be desired. To many, a 4:3 ratio is distinctly preferable. Fortunately, producers of plastic mounts have made available 32 × 24mm masks. I have found that with these masks many of my transparencies look much better. Incidentally, there is one good technical reason for using a 4:3 ratio. The least perfect part of a photographic image, as far as definition is concerned, is at each end of the picture, and trimming off the ends by masking is a simple way of reducing this effect of lens aberration.

There are two schools of thought about the use of vertical images on slides. It would seem sensible when photographing the Matterhorn or the Eiffel

Tower – or a friend at full length – to turn your camera and make the picture a vertical one. However, if your end-product is to be a slide rather than a print, a new factor has to be considered. The ideal way of showing transparencies is as projected images on a big matt white screen, and it has been found that a black border round each image contributes appreciably to the striking effect in a darkened room. However, if you show a mixture of horizontal and vertical transparencies, the screen must be square in shape, and there can be no black border round any picture. And each time, there are two large dark unused areas of screen.

Many experienced presenters of slide shows are in favour of using only horizontal pictures, and probably this is the less disconcerting way of showing an extended series of slides. This applies especially to the travel photographer, whether the coherence of his slides stems from their recording of consecutive events on a journey or from their illustrating a unified and developing theme. Television and home movie audiences never seem to feel the need for a scene to be shown vertically; this is of course partly owing to the fact that the aspect ratio is less elongated than that of conventional 35 mm photographs (5:4 on television and normally 4:3 on amateur movie film).

Slides must be indexed if you are not to be confronted with chaos in a very short time. I favour the procedure of numbering each slide chronologically rather than writing descriptions on slide mounts. For example, '78:21' would indicate that this is the twenty-first transparency from your seventy-eighth film. I enter each number and a brief description on a page of a loose-leaf notebook.

The usual objection to slides as opposed to prints is the undeniable hassle about setting up projector and screen. In most cases the trouble is worth enduring, and indeed it is to be hoped that your audiences think so. But if you are seated comfortably in your lounge with just two or three friends, you can always avoid the disturbance by

using a large-screen back-projection mains table viewer, which takes as little time to set up as it takes to produce an album from a cupboard. The image is bright and vibrant and colourful, even with full room lighting.

Audio-visual presentation

It is generally assumed that the basic difference between a photograph and a shot from a movie is that the photograph is a visual record of one isolated moment, while the film shot is a representation of movement and continuity. Many photographers, however, do not wish to be limited by this static concept of photography, and aim at reproducing an activity or a development as a sequence of photographs. A series of prints or slides can be taken of one subject at different stages, and the pictures can later be viewed in proper succession. Photographs may be taken at intervals of less than a second, with the aid of motor drive, of a baby or a dragonfly or a tiger; at intervals of three months to indicate seasonal variation as seen in a tree or a waterfall; or even at intervals of a year to indicate strikingly the growth of a boy into young manhood.

If you are attracted by the idea of photographing sequences, you will probably want to take the pictures in the form of 5 × 5 cm transparencies for projection. This leads many people naturally to a planned and coherent programme of slides. Boredom is to be avoided at all costs, and many travel photographers find that for a domestic slide show half an hour is ample and an hour can be too long. It all depends on the quality and planned flow of your sequence of slides. Fifteen minutes of hotch-potch can have an audience stirring restlessly, whereas an hour of carefully-selected coherence can have everyone asking for more. It has been found that about eight seconds is a good average period for a slide to remain on the screen. But this should on no account be regarded as a rigid rule: monotony will set in if intervals are too precise, and variation should be the keynote. Thus, it would seem that any kind of automatic

projection with equal time-gaps is not really advisable.

It is when you decide to add some sort of recorded sound as an accompaniment to your slides that your slide show takes on a new character. Your selected set of slides depicting scenes and events during your visit to Sri Lanka or your tour of Scotland may well benefit by the addition of really suitable music, played through a hi-fi system and faded up and down judiciously by hand in order to permit your off-the-cuff comments, matched to the audience. After some experience of this, you may decide that you would like to use some means of synchronising sound and vision so that you produce a complete audio-visual experience for your audiences, with the entire sound content of your presentation recorded on magnetic tape. In other words, you are contemplating a pre-arranged slide-tape sequence, rather than a casual slide show with music and commentary. This would, incidentally, enable others to present your packaged programme without your presence being necessary.

A number of projectors are available which permit slide changing operated by electronic pulses on recording tape, on a specially adapted reel-to-reel or cassette tape recorder. The principle is that on one or two tracks of the tape your sounds are recorded, and on a parallel track pulses are recorded which operate each slide change at exactly the right point. It is vital that any sound recordings you make are of high quality. You would be better with no recorded sound at all than with indistinct or over-recorded sound interrupted by clicks and hisses. Nowadays excellent sound quality can readily be obtained from a good cassette deck with hi-fi amplifier and speakers; but mixing voice and music, not to mention background sound effects, calls for a certain amount of technical expertise.

In a good audio-visual presentation, neither sound nor vision should dominate, but each should be complementary to the other. The problem

Slide viewers. For many purposes there is no need to set up a projector. Simple viewers make use of any available light source such as the sky, as shown at the top left. At the top right is a battery-operated viewer that can be operated from the mains with an accessory transformer. Such a viewer is independent of lighting conditions. Bottom left: a table projector giving a screen picture of adequate size for critical viewing. Bottom right: a slide viewer and sorting desk operated from the mains and allowing a number of slides to be viewed together and compared; indispensable to the lecturer who makes use of slide sequences.

confronting you initially is one of priority. Do you arrange your slides first and then look for suitable music and write a commentary, or do you start with an evocative recorded musical work and search for slides to fit ? It all depends on your style of presentation. Normally a traveller returning home with a set of slides covering his travels is likely to set to work first to edit a selected sequence from his slides, and only after that will he consider the sound track. It could well be, however, that you come home from a Greek journey with a cassette recording of some of that enchanting music, and resolve to pick a sequence from your slides to match the phrases of the Syrtaki. Each is a valid method.

Arranging slides in a pleasing and orderly sequence for slide-tape purposes is by no means a simple task. For this type of editing work you are best to use some sort of light box. This may consist of just a large sheet of plain glass with tissue paper lying on it to act as diffuser, and a lamp below; or you could construct a more workmanlike light box out of wood with a matt plastic sheet on top and a lamp inside. Alternatively, a light box can be purchased. Whatever device you use, you place your slides on top of it, and this makes the sorting process more straightforward than any other way.

If you simply want to synchronise a set of slides with a piece of recorded music, you will first have to play the recording through repeatedly while you look at one slide after another on the light box. Then set up your projector and your electronic synchronising system and press the pulse control every time you want a slide change. Once you have completed this, if you run the apparatus from the start the changes will take place automatically. (Music copyright clearance can be arranged through the Royal Photographic Society and other agencies, enabling you to re-record some commercial recordings legally.)

Adding a commentary calls for a good deal of thought. Not everyone who takes good photographs has the ability to write an economic and yet sufficiently flowing and informative commentary, and many regard the actual speaking of the commentary into a microphone as a task for a skilled specialist. The commentator should never describe what the audience sees; the ideal commentary is oblique rather than direct. The wording of the commentary should be that of spoken rather than written English. No travel photographer worth his salt will read verbatim extracts from the ponderous prose of the average guide-book or travel brochure. An unending flow of patter quickly becomes a bore; your comments should be selective, relevant and revealing. They should match the mood of the slide sequence without being too obvious, and they should contribute to the audience's pleasure and understanding in a friendly and unobtrusive way. As far as possible, your photographs should speak for themselves.

Sooner or later you may find that two projectors are definitely better than one. The fact is that audiences become unhappy if confronted with a lengthy succession of black spaces on the screen between slides, which is inevitable if you use one projector, and this is avoided by the alternate use of two projectors. The transition between one slide and the next is covered by a dissolve: that is, fading one slide out while fading a second one in. The durations of these fades may be varied. This is all carried out by an electronic dissolve unit connected to tape recorder and projectors.

It will be evident from this superficial account that recording even a straightforward music-and-slides programme, using a single projector, is fairly demanding for a person not accustomed to working with audio equipment. Using two projectors with varied dissolve transitions for an audio-visual presentation incorporating synchronised music and superimposed commentary could best be described as a fascinating project for the dedicated enthusiast.

Index

Italicised entries refer to photographs.